SIMPSON

IMPRINT IN HUMANITIES

The humanities endowment
by Sharon Hanley Simpson and
Barclay Simpson honors
MURIEL CARTER HANLEY
whose intellect and sensitivity
have enriched the many lives
that she has touched.

The publisher gratefully acknowledges the generous support of the Simpson Humanities Endowment Fund of the University of California Press Foundation.

Partial funding for this book is made possible through the Caryll and William Mingst/the Mildred E. and Harvey S. Mudd Publications Fund of the Autry National Center of the American West.

HOME LANDS

HOME
LANDS

HOW WOMEN MADE THE WEST

VIRGINIA SCHARFF

CAROLYN BRUCKEN

Autry National Center of the American West Los Angeles

in association with **University of California Press** Berkeley Los Angeles London

To partners

CONTENTS

2

WOMEN IN MOTION ALONG THE FRONT RANGE

3

WATERSCAPES OF PUGET SOUND

THE HISTORY OF WOMEN IN THE AMERICAN WEST IS LIKE THE HISTORY
of air. You could certainly write history without it. You just can't have history without it.
We begin, therefore, by assuming what so many historians have labored long and hard
to prove: that we need to know women's history in order to come to any kind of under-
standing of the Western past.

But historians of women have been burdened with the job of fitting their stories into
a well-worked narrative of Western history that begins with the coming of Europeans
and Euro-Americans to the West, a history that has mostly relegated women to walk-on
parts when it has not entirely written women out. It is as if Western history were a series
of snapshots of epic figures now seemingly exhausted, like the dust-creased cowpoke
staking his horse, throwing his saddle on the ground, laying his weary body down.

Imagine that the cowboy was too tired to notice that he had flung down his saddle
not simply on a flat place in the middle of nowhere but instead in the middle of some-
one's garden. Imagine that he jolts awake to the squeal of a ground squirrel surprised
into a snare. He hears a young girl laugh, looks around, realizes he's surrounded by
women digging roots, plucking berries. What he doesn't realize is that those women
have been gathering on that ground not just since early morning but for mornings
stretching back hundreds, even thousands, of years. Envision this scene, and you will
see clearly that the story of people in that place is a story of women creating and claim-
ing home places. The West was a home before it was the West.

Women's historians have cast an ambivalent eye on the traditional association of
women with homemaking. Some have tried to document, detail, and even glorify wom-
en's domesticity. Others have asserted that women, often as not, transcended the bur-
dens that bound them to the hearth; those scholars have looked at women's activities in
the world beyond the household. Still others have shown how women used the skill,
knowledge, and power they acquired at home to make their mark on the world at large.
We argue that claiming a home is a potent way of changing the world. Instead of wor-
rying that the association of women with home will trivialize women's history in the West,
we want to expand our definition of home beyond domesticity to encompass the process
of inhabiting places. In the name of home, women have done everything from gathering
food and building houses to speculating in real estate and running governments.

Places we now identify with the West have longer, deeper, and more numerous identi-

ties as homes. There have been plenty of fights over the West—not just embroiled historians flinging ink at each other, but outbreaks of violence that tear communities apart, and more wars of raid and trade and conquest than we can count. All of them have been conflicts over who has the right to call certain places "home." Indeed, home has been so powerful a factor in the making of the West that conventional stories of Western history rest heavily, and uneasily, on the erasure of some people's homes and the establishment of others'. "Oh give me a home, where the buffalo roam . . ."

That's the crux of our argument: that the West has been created both in tension and in tandem with the making and defending and reclaiming of home places. And within that argument, we make two points. First, imagining Western history from the standpoint of home gives us a new way of seeing the place we live in and love and worry about, and the desires and actions and consequences that have made us what we are. And second, looking at the West as home will reveal the centrality of women's history to the history of the American West.

Encompassing the social and emotional as well as the physical, the meaning of home seems to expand of its own volition as people move around, connect to each other, and make use of the things we find at hand. Marvelously, we humans have invented so many ways of designing our kin relations, connecting with and manipulating our environs, and claiming our home places, that knowing how people have made homes in the past requires us to learn a great deal about history. Even the range of families in the American West today, as Judith Stacey and others have explained, offers ample evidence of the endless varieties of homes humans have created here in the West.[1]

And so home, we begin to see, both encompasses and mingles the intimate and the environmental, the physical and the emotive, the close in and the gathered toward, the places we find refuge in or haunt, that which we are given and which is not of our own making, and the meanings and shapes we give it. What one group of people regards as the familiar or congenial or normal way of inhabiting place, others will find as strange as all get-out.

Although we need to stay sensitive to the myriad ways in which people have understood and made homes, we must also acknowledge commonalities and limitations. The West is a diverse collection of geographies and ecosystems, but each can be inhabited and domesticated only when people have access to water, food, shelter, and at least some measure of trade. Historically, any place that provides these resources tends to attract competition; people who claim a home place must provide for their own defense. Each subregion of the West testifies to successes and failures in securing the necessities of life, and each place bears the mark of human struggles in the form of ruins, reclamations, and reinventions of home places. Home, despite its appearance of permanence, is a tenuous and hard-won thing.

We invite our readers to imagine a new geography, to envision a map delineated by the boundaries of home places rather than by the aspirations and conquests of nations. Homes have preceded, shaped, accompanied, been altered by, and survived the making

of the American West. By envisioning people at home in places that have not always been the West, we not only expand the time frame of the history of the region, but we also expand the compass of its human history. For better and worse, the West has always been imagined as the domain of men: drifters, dreamers, hucksters, hellions, heroes. We welcome those figures to a larger and deeper history, but in order to see the reach of that history, we need to locate and understand the women whose stories stretch the boundaries.

We see the inhabitation, abandonment, and reclaiming of Western places not as an evolutionary process, not as a linear progression from savagery to civilization, or from nomadism to settlement, or from emptiness to fullness, or from Indian country to Anglo domination, but instead as many stories extending far into the past, reaching in different directions, still unfolding. Places once hives of activity are today untenanted. Other places, long inhabited by indigenous people, have been through all kinds of changes but are, at this moment, once again Indian homelands. And some forms of inhabitation once thought superior put such a strain on available resources that they make us wonder if other ways of making homes in hard places haven't much to teach us now.

This book is the companion volume to Home Lands: How Women Made the West, an exhibition produced by the Autry National Center of the American West. The exhibition asks visitors to think of the West as many people's homes over thousands of years, as a site of ongoing encounters among people whose actions are shaped by different notions of dwelling and family; divergent ways of using land and resources; and varying concepts of property, community, and history. While men, women, and children have all contributed to the enterprise of claiming home places, this book, and the exhibition that inspired it, puts women at the center of the business of claiming and maintaining homes in places, across cultures, and over time. We aim to show how women, as they have moved around, settled in, and moved on, have creatively adapted to and transformed their physical and social landscapes—dwellings, neighborhoods, villages, cities, and environmental settings—and how they have explored and mapped the mental territories that enable humans to craft culture.

Obviously, no exhibition could encompass every home place in the West. So we have chosen three long-inhabited places, places that reflect each region's remarkable cultural diversity, in order to illuminate women's varied histories in claiming those places as homes. In each case, we've chosen a significant resource through which women have made Western spaces into home places. The extraordinary collections of the Autry National Center, enhanced by objects loaned from other sources, enable us to not only tell but also show the history of women and of Western places.

In the first section we examine women's history in northern New Mexico, or, to use a geography with a longer history, the region known as Rio Arriba. Coming to grips with that long history, we argue, requires us to understand the convergence of cultures and inspires us to see how women have, for millennia, participated in that history by claiming home through their relationship to the earth.

In our section on the Denver and Front Range region, we address women's role in a long history in which mobility and settlement have been intimately intertwined. We look at women's relationship with transportation—as producers and consumers—from Plains Indian horse cultures, to the creation of urban communities with the coming of the railroad, to the contemporary Front Range automobile sprawlscape, in an effort to understand the expanding, kinetic geography of home and the meaning of women's movements in and around this place.

In the final section, we look at the ways in which women have encountered and transformed home places in Puget Sound through the resource of water. Just as water has shaped the lives of Puget Sound women, from indigenous peoples who fished and gathered from the rich waterways to European and Asian immigrants who came to trade and farm and exploit the power of water in myriad ways, so women's visions and works have shaped this place over time. To understand the historical power of women and water, we look at waterways, island landscapes, and the industrialization of water through the eyes of Salish inhabitants, Japanese and Scandinavian immigrants, and twentieth-century workers and civic reformers from various cultural backgrounds.

Admittedly, in choosing three places to illustrate our approach to the history of the West as a home and as women's place, we risk the criticism that our choices will be regarded as unrepresentative, arbitrary, even capricious. Pretty much everyone who has heard about this book and exhibition has a candidate for a place we should have explored: What about Monterey Bay, or the Black Hills, or the Great Basin, or the Texas oil patch? How can we leave out the sod house prairie, the gilded streets of San Francisco, and the Cherokee Nation, for heaven's sake? Such questions, we think, demonstrate the power of our methods and ideas: if they work in the places we've chosen, you ought to be able to try this, well, at home.

1

HOME ON EARTH: WOMEN AND LAND IN THE RIO ARRIBA

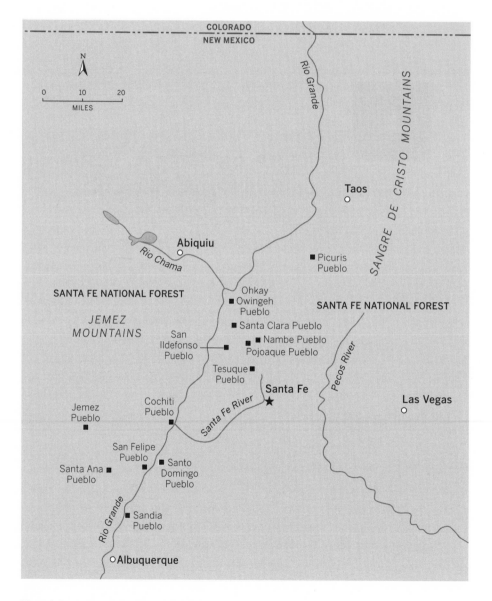

Map 1 | Rio Arriba and northern New Mexico

TO THE DIVERSE PEOPLES OF THE RIO GRANDE VALLEY, AN ARID AND perilous place stretching from what is now southern Colorado southward into New Mexico, the joining of fertile earth with water has meant nothing less than life. Over millennia, the northern valley, which the Spanish called Rio Arriba, has been a homeland to indigenous peoples—Tewa-, Tiwa-, Towa-, and Tano-speaking Puebloan peoples, Apaches, Navajos, Comanches, and Kiowas. In time, Spanish emigrants and the Mexican inheritors of cross-cultural intimacies would come to call the Rio Arriba home, soon to be joined by Americans of all kinds, and eventually by people from the four corners of the planet. Each group of inhabitants has brought a different understanding of the meaning of the place, and each has crafted a distinctive way of making use of what was at hand, even as the encounters among various peoples have shaped the lifeways of all who come to this valley.

The convergence of peoples along the Rio Grande has shaped both the land, on a grand scale, and that most intimate of spaces, the home. But we should be wary of reducing the idea of home to a sentimental symbol of warmth and comfort. *Home* is a value-laden term, and the realm of the household has meant vastly different things to the various peoples who have lived in what would become the American Southwest. For the women of New Mexico, home was anything but a haven in a stable world. Villages and nations fought over the right to make a home in this place. People joined together for defense, forged uneasy alliances, and created new families. In every case, women put their hands to the fertile and pliable earth to claim a home place, to sustain life, to make the present meaningful and the future a realm of human possibility.

CORN MOTHERS: STORING AND BUILDING WITH THE EARTH

For thousands of years, the American Southwest had been a place of people passing through. We have only archeological fragments and evidence left in the earth itself to help us piece together an idea of the first people to make this area their home, at least for a time, as they hunted and foraged across the region's deserts and plateaus in pursuit of migratory herds of game animals. As we do today, they set the course of their lives by solving the problems posed by their surroundings. The women among them prepared specialized campsites for shelter and way stations for butchering and processing meat

and hides. They developed unparalleled knowledge of the local terrain and animal habits, trapping small animals and gathering seeds, roots, and other wild plants to feed their bands. Although we tend to imagine gathering as a small-scale domestic activity, we should recall that this was necessary, backbreaking work under a blazing sun—too often for too little return. The foremothers of the Puebloans ranged large territories, and women's harvesting, as much as men's hunting activities, determined where bands settled. Small wonder that women worked to invent more efficient ways to feed, shelter, and nurture their families.[1]

Laguna Pueblo author Leslie Marmon Silko captured Puebloans' intimate connection to the earth. "Life on the high, arid plateau became viable," she wrote, "when the human beings were able to imagine themselves as sisters and brothers to the badger, antelope, clay, yucca, and sun. Not until they could find a viable relationship with the terrain—the physical landscape they found themselves in—could they emerge."[2] Scattered bands came together into the groups that archeologists labeled the Hohokam, Mimbres, Mogollon, and Anasazi. These peoples possessed distinctive material culture traditions and ways of living in the region's deserts and plateaus. They developed far-flung trade networks and complex societies as they mingled and traded with people across mid-America, embracing new technologies that were spreading slowly northward and eastward. Women and men began to devote themselves to the earth in new ways: to grow corn, make pottery, and build with adobe. Corn would become the foundation of a new way of living with the earth.

Women guided the domestication of corn throughout the Americas, experimenting with wild corn seed to breed strains that yielded larger, more nutritious ears. The origin tales of Pueblo corn mothers recount women's role in transforming hunting and gathering communities into agricultural people. In the Sia myth, the corn mother, Iyatiku, also known as Utset, led mankind from the underworld only to find that "their only food was seeds of certain grasses. . . . Utset desiring that her children should have other food 'made fields north, west, south and east of the village and planted bits of her heart, and corn was evolved.'"[3]

By A.D. 700, women in the Southwest had learned to select the seeds that did best in their climate and had begun to develop hybrids adapted to desert soils and scarce water. They developed more elaborate tools—stone metates and manos engineered to grind the dried, hardier kernels of corn into an edible flour (figure 1). As farming claimed more of women's time and energy, families began to build more elaborate dwellings near their fields. Agriculture increased specialization in men's and women's activities and gave new importance to households organized around female kinship.[4] And as food, in turn, became more diverse, predictable, and plentiful, women's health improved. Mothers were better able to survive the rigors of childbirth, children were more likely to grow to adulthood, and populations grew. The bodies of the people, and their capacity to survive and thrive, were intimately linked to women's ability to learn from, adapt to, nurture, and claim the bounty of earth.

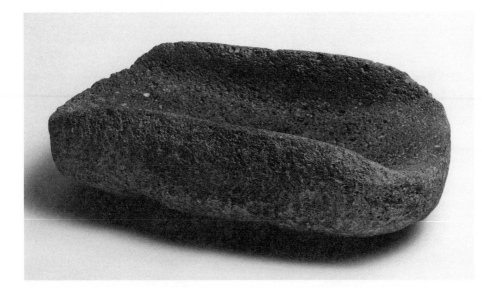

1 | Metate (grinding stone), A.D. 750–1150, Mogollon culture. Southwest Museum of the American Indian, Autry National Center; 573.G.21A.

Corn, along with beans and squash, inspired the people of the Southwest to create and seek out new ways to store and safeguard all that they grew and made, as well as the things they acquired through trade. As the ancestral Puebloans relied more on agriculture, they also developed new companion technologies, creating tools to carry, store, and cook the things they grew. Some women added pottery making to their daily round of jobs—more work for them, but a great help as they processed and stored food. Earthen pots, unlike woven baskets, could withstand the higher temperatures needed to cook ground corn and beans. Women learned to locate and mine the best types of clay, passing their knowledge on to their daughters. They experimented with materials from sand to broken pottery shards to temper the clay so that it would not crack during firing. They produced functional and beautiful pots, crafting shapes that satisfied a range of needs: storing and preserving seeds, cooking, ritual use, and gathering water (figures 2 and 3). Over time, in each village, certain women and their families began to focus on making pottery. Their work found a ready and expansive market. Archaeologists working at ancient Puebloan sites have recovered a remarkable diversity of ceramics, the remnants of a spreading network of exchange among scattered peoples knit together by trade and family ties.[5]

Women also used the gifts of earth to shape one of the most distinctive and enduring architectural traditions of North America, working together with men to provide shelter. They used the material closest to hand—earth—to construct walls. Drawing on techniques they had developed in making pottery, they built up adobe walls by applying handfuls of clay, with each layer allowed to dry before the next coat was applied. Their

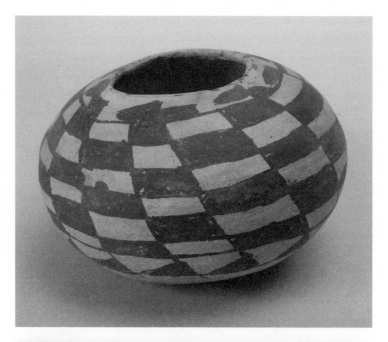

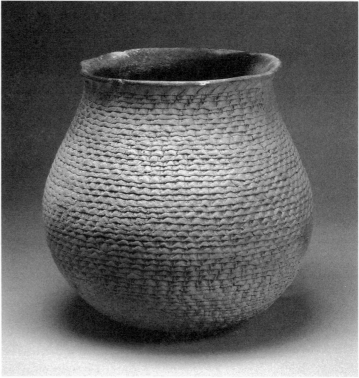

2 | Seed jar, A.D. 1200–1300, Ancestral Pueblo, Mesa Verde culture. Southwest Museum of the American Indian, Autry National Center; 900.G.32.

3 | Cooking pot, A.D. 1000–1300, Ancestral Pueblo, San Rafael, New Mexico. Museum of the American West, Autry National Center; 89.120.2.

dwellings, which archaeologists call "unit pueblos," were built with combinations of adobe, stone, and wood. They strung together rooms for storage, living areas for families, communal work areas, and religious spaces. Starting in A.D. 900, the great, multi-storied houses of the Anasazi appeared, signaling a new scale of organization around multigenerational extended-family households.

Centuries later, Spanish officers and priests would record their surprise at finding Puebloan women in the thick of construction work. Pedro de Castañeda de Najera noted in his report on the 1540 Coronado expedition that the Pueblo Indians of the Rio Grande "erect their buildings communally. The women are in charge of making the mortar and putting up the walls. The men bring the wood and set it in place" (figure 4).[6] But if the Spanish were shocked, Puebloans regarded women's building work as the stuff of everyday life and long-standing tradition. As Pueblo women told nineteenth-century ethnologists, their grandmothers and great-great-grandmothers had always built their houses in this way.

Women's innovations in agriculture, pottery, and architecture had bound people together in new ways and transformed the human connection with the environment. By A.D. 1000, the ancestral Puebloans occupied a homeland spanning a diverse, patchwork landscape of small farmsteads, transient camps, and satellite villages radiating out from a few large cities. The first permanent settlers of the Rio Grande valley were one such satellite—small groups of farmers and traders colonizing the far eastern frontier.[7]

Women and men who had learned to survive by manipulating and managing what the land offered now moved to take greater control of their surroundings. They cleared land to create fields and learned to manage scarce water resources. To this day, we can see evidence of the canals, stone dams, reservoirs, and ditches that the ancestral Puebloan people built to divert water to fields. Men cut down trees and transported the timber remarkably long distances in order to provide roofs and fires for the expanding homes and kivas of the cities. The construction of Pueblo Bonito in Chaco Canyon alone required some two hundred thousand trees.[8]

They were casualties of their own success. By the thirteenth century, Puebloan people were facing a serious deforestation problem as they denuded the land in their voracious use of wood for their homes, heating, and pottery making. When ancestral Puebloan farmers pushed their home places to the environmental limit, they faced an agonizing choice: die or leave. When fields became unproductive after a generation or two, the families that made up the village moved out. As archaeologist Stephen Lekson has explained, prior to the thirteenth century, "villages moved, coalesced, split, re-formed in response to local situations and local environments."[9] Collapsed walls and rooms were left to decompose and enrich the soil for the next generation. While women built homes with artistry, layering bands of color and selecting stones for size and texture for aesthetic effect, they did not build for permanence. Walls were thin, prone to collapse, and easily eroded over time by rain. As cultural landscape theorist J. B. Jackson remarked, Puebloan homes "were easy to build and easy to abandon."[10]

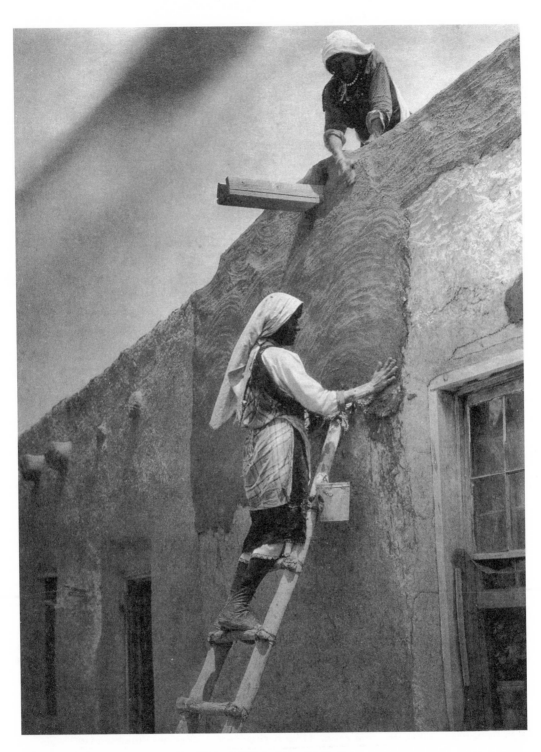

4 | "Replastering a Paguate House, New Mexico," 1925, by Edward S. Curtis.
Braun Research Library, Institute for the Study of the American West, Autry
National Center; CUR.1676.

In the end, in the face of too many people, too little water, and less and less arable land, the earth could not provide enough. Terrain stripped of trees and brush became more susceptible to erosion. And then came the devastating force of climate change. Water, always scarce, became ever more elusive as long-term droughts from A.D. 1130 to 1180, and between A.D. 1276 and 1299, withered the fields. Entire villages, decimated by hunger, disease, warfare, and violent competition for scarce resources, headed off in search of new homes. — *migration*

CONVERGENCE ALONG THE RIO GRANDE

Try to imagine the mass abandonment of the Colorado Plateau and the great migrations into northern New Mexico in the fourteenth and fifteenth centuries. The mind reels. What inconceivable suffering could have caused some thirty thousand people of the Colorado Plateau and San Juan drainage to leave forever the home places so painstakingly wrenched from the earth?[11] The great cities of Chaco Canyon, Mesa Verde, and Kayenta, once homes to thousands of people, stood vacant and naked to the hot sun and screaming wind as their inhabitants made their way, on foot, for hundreds of miles to the south and east. At the same time, remnants of the Mogollon people began moving north while newcomers, bands of migrating Athapascan people who would become the Apaches and Navajos, moved into the northwestern area of current-day New Mexico.

The peoples of the southern and western deserts also dispersed, moving into smaller ranchos or joining the rivers of humanity now converging along the Rio Grande and spreading through the surrounding valleys. The small farming settlements already established in the Rio Grande valley formed new, consolidated villages like Pecos and Arroyo Hondo. Looking to stake a claim on which to build new homes, the migrants traded, joined, and fought with the area's original inhabitants.

With the enormous influx of people into their homeland, the Rio Grande Puebloans reinvented themselves. The convergence of peoples with diverse skills and often fractious interests sparked violence and adaptation, new weapons and tools, and innovations in pottery and architecture. Inventions such as the slab metate, spiral-grooved axe, and loom weights made women's and men's work easier and more productive. Women and men continued to make adobe buildings, but they shifted away from the unit architecture of the past toward more permanent, integrated adobe villages with multistory structures and large centralized plazas that included spaces for men's weaving and women's corn grinding. Changes in material culture and social geography both reflected and galvanized other, lasting changes, including transformations in women's lives.[12]

Starting sometime in the fifteenth century, the women who converged in the eastern pueblos began to express themselves in new ways, through the familiar medium of earth, experimenting with more painted pottery and sharpening their regional styles. The precise, linear black-on-white style of Anasazi painting gave way to a growing use of red, yellow, and white clay slips, new glazes, and designs drawn from nature (figure 5).

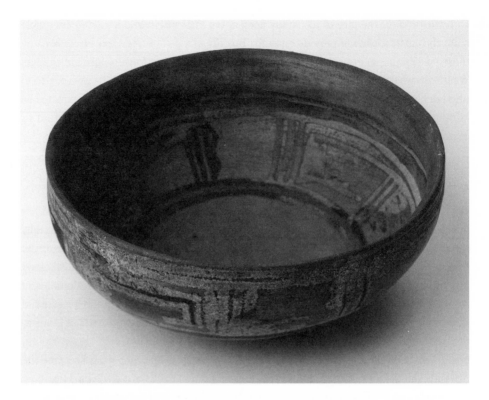

5 | Bowl with glaze and red slip, A.D. 1300–1600, Ancestral Pueblo, Rio de Los Frijoles, New Mexico. Southwest Museum of the American Indian, Autry National Center; 239.L.1.

Art historian J. J. Brody has suggested that such innovations in pottery reflect women's efforts to create unity out of diversity.[13] Brody understates the matter. If the glorious pottery of the Rio Grande pueblos reflects cultures coming together in creativity, the history preserved in the quiet repose of clay was the product of diverse peoples' uneasy proximity and endemic conflict, often marked by terrifying violence.

Migrating people quickly filled up the arable land, leading to competition for food and water. People joined together for defense and trade, forging uneasy alliances both cemented and disrupted by new contacts and innovations. The Rio Grande pueblos soon commanded the gateway to the plains and its buffalo herds, and by the sixteenth century the villages of Pecos, Taos, and Picuris had become the main points of inter-cultural trade. But being earthbound made Pueblo farmers vulnerable to their nomadic neighbors, and relations between Plains hunters and Pueblo agriculturalists ranged from the amity of trade, cooperation, and collaboration, to the uneasy interactions among unreliable neighbors, to the horror of war. Whether peace prevailed or violence broke out depended to some degree on the availability of game, the productivity of crops, the rituals of commerce, and the number of people competing for the land and

its bounty.[14] On such uneasy ground, the line between trading and raiding was thin, sometimes to the vanishing point, and this disappearing line was often drawn in blood, as men old enough to make war were usually killed on the battlefield. Pueblo, Navajo, and Plains raiders took women and children as captives to be traded as slaves or incorporated into their bands and villages as servants or relatives. Violence—against both men and women—infused the commerce between valley farmers and traders and nomadic plains hunters.

For a woman facing the ever-present threat of abduction, home was anything but a haven in a stable world. Carried off or traded away to live and serve those not her kin, she brought with her skills that created the possibility of home in a strange, perilous place. As she ground corn or shaped a pot, built a wall, taught her mistress or her daughter how to find clay, or perfected a new ceramic glaze, she did the work of claiming a home she might be torn from yet again, a home that might never really be hers at all. But for all the insecurity of her predicament, her very presence, her transfiguring hand on earth, was at the center of a new way of life converging on the Rio Grande.

WOMEN AND EMPIRE

When Francisco Vásquez de Coronado and his soldiers arrived at the well-defended Pecos Pueblo in 1540, they entered a world already shaped by turbulence, dislocation, and dramatic cultural change. They came under the Spanish crown and Christian cross seeking gold, slaves, and souls, but the armies themselves—and the world they encountered—complicated their plans. They brought with them a tool of conquest that revolutionized life among those they sought to conquer: the horse. As settlers followed soldiers, the phenomenon that historian Ned Blackhawk has called "the equestrian revolution" galvanized a new era of conflict and adaptation, village to village, household by household. In this new world, frontier bloodshed was less often a matter of organized battles and more often a fact of the instability of everyday life.[15]

Women—as wives, workers, and captives—held the key to creating sustainable communities, even as it seemed that the earth was snatched out from under them. As the line of Spanish soldiers moved up into the northern Rio Grande valley, the country they called the Rio Arriba, and fanned out from village to village across the countryside, the far-off empire redefined indigenous women as its subjects and staked its claim to their obedience through violence, threatened or real. Spanish accounts tell us that Pueblo and other indigenous women did what they could to shape the encounter, using what leverage they had over food, gifts, and sex. But they faced heavy odds. As the Franciscan friars recorded with disgust, Spanish soldiers routinely brutalized Indian women. In 1598, when the soldiers under Captain Don Juan de Zaldívar invaded Acoma, seized its food supplies, and raped a village woman, the inhabitants struck back. The Spanish army retaliated with lethal force. By the time the soldiers were done, some eight hundred Indian men, women, and children lay dead. Over five hundred women and children were

taken captive, as officers sentenced all surviving men and women over the age of twelve to slavery. To quell future resistance, soldiers cut one foot off each man over the age of twenty-five.[16]

The Spanish invaders assailed women's bodies, and the tribute system they imposed assaulted the foundations of female power and legitimacy: land and corn. Under the *encomienda* system, the crown awarded agents of the empire the right to demand tribute in the form of the Indians' resources and labor. The Spanish expected yearly payments of tribute, to be meted out in grain. In response, Pueblo women created a new type of vessel, to hold a half a *fanega,* the Spanish unit of measurement used to collect tribute. Each of these vessels, now known as ollas, could hold about a bushel of grain. Soon these new types of pots replaced seed jars and other early-type storage vessels whose forms had been in use for centuries.[17] When villages were unable to meet demands for corn, hide, or cloth payments, men and women were forced into service as field hands, cooks, maids, carpenters, gardeners, and weavers. Imperial officials and missionaries sought to impose a new working order, forcing women to weave and men to build homes. Where women had once been in charge of a family's seed and fields, missionaries put men in charge of farming. As missionaries intervened to regulate marriage, warfare and sex with Spanish colonists disrupted the Natives' clan lineages and earlier matrilineal land rights.[18]

The Spanish empire's first attempt to control the colony of Nuevo Mexico through war and tribute ended in failure. In 1680, in one of the largest and most successful indigenous resistance movements in the history of the Americas, the Pueblos expelled the Spanish conquerors from their lands. Although the revolt did not stop Spanish armies or Spanish customs from ultimately coming into the region, it did change the terms of encounter. When the Spanish returned to the Rio Arriba in 1692, the iron fist of military might broke ground for an arduous scheme to establish small agricultural settlements. The dream of gold gave way to the hope for more modest returns from agriculture and livestock—a conquest of encroachment, spearheaded by families. The politics of conquest became a politics of earth.

The Spanish government believed that families would provide a stabilizing force on suspect terrain, a permanent population with a stake in defending the empire's volatile northern frontier. Spanish recruiters enticed women of New Spain by offering goods and wages, along with cash to pay off debts and purchase supplies. These women risked everything in the name of conquest, with the hope of improving their lot in life. Vastly outnumbered by men, women nonetheless took part in successive waves of migration and colonization as wives, workers, heads of households, and servants. Many of these women were relatives or servants of soldiers or officials, and they tended to be poor, Christianized mestizas, of mixed Spanish and Indian heritage. In his 1763 painting *From Mestizo and Indian, Coyote* (plate 1), Mexico City painter Miguel Cabrera illustrated the complex cultural mixing that created *mestiza* families in New Spain and the northern frontier. In this idealized painting, he showed a tattered family at the bottom of the

Spanish _casta_ system, a racial hierarchy measured by one's degree of Spanish blood. It was just such families on the lower end of the system who most often chose the arduous journey and a difficult, dangerous life in new country on the far northern frontier, where they depended on suspicious, often hostile local people for labor and food.

These families brought with them new ways of living on the land. Ex-soldiers and their families could become stakeholders in communal grants, where they received the right to a small field, a house, and the land immediately surrounding their homes. The crown subsidized church and government services, and the community shared pasture and water. Spanish-speaking settlers soon created a distinctive new landscape of small family farms radiating in narrow bands from the rivers and ditches that diverted water to their fields and flocks. However, their ways of settling troubled Spanish authorities. In a 1778 report on affairs in New Mexico, Father Juan Agustin de Morfi criticized colonists who, he wrote, "flee from the company of their brothers and withdraw their habitations from one another, stringing them out in a line as fast as they can build them." Although Morfi lamented the settlers' preference for dispersal, they were responding, like Pueblo migrants before them, to the realities of the environment, securing their livelihood through grazing, irrigated farming, and trade.[19]

The Spanish government had returned a portion of land seized from the Pueblos as a collection of communal grants, but the Pueblos, weakened by disease and war, were too few to occupy or cultivate much of the land to which they were entitled. And even where they sought to stay, Hispanic colonists challenged their claims to the best river lands. The arrival of the Comanches and Utes into northern New Mexico early in the eighteenth century displaced Apaches and placed new pressures on Pueblo people. As bitter necessity forced Pueblo families to abandon their homes, Hispanic families moved onto the land. By 1700, only nineteen Pueblo communities remained.[20]

On their small, seemingly remote farms, Nuevo Mexicanas and Mexicanos wrested a tough life from the earth. They built their houses as defensible fortresses and pooled the labor of family members and neighbors. Families raised cattle and sheep, planted European grains like wheat and barley along with corn, and introduced new foods like grapes, almonds, and peaches. Women planted fruit orchards and vegetable gardens and cultivated and gathered medicinal herbs. Women and children helped men plow, hoe, harvest, and herd. When men were absent, women took up the heavy work of maintaining their families' irrigation ditches. Wives and daughters plastered their houses, baked bread, carded and spun wool, and cared for their families' health, even as they prepared and stored food for winter: salted and dried meat, roasted and ground corn, dried fruits and chilies. The work never ended.

Despite the arduous life, Hispanic women had the right to possess the earth they worked, and they enjoyed other legal rights and privileges not available to their contemporaries in other European colonies. Under laws going back to the fourteenth century, married women had the right to own, sell, buy, and bequeath land as well as portable property—in their own names—to their daughters as well as their sons. Their wills

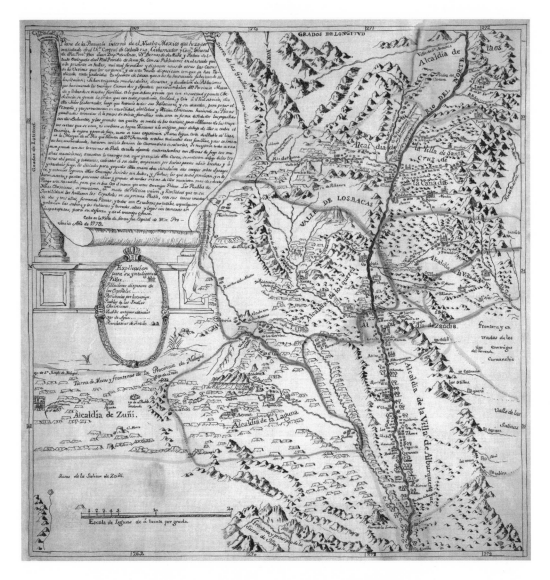

Map 2 | *Map of the Province of New Mexico, 1779,* by Bernardo de Miera y Pacheco. Courtesy of The Bancroft Library, University of California, Berkeley.

show us not only how much they valued their rights and possessions but also how they worked to ensure that their children would inherit all kinds of property, including land, orchards, buildings, and livestock, as well as such tools as digging sticks, hoes, axes, and plow points. They also clearly cherished their household goods. Many women brought with them and retained through marriage a dowry chest, whether plain wood board or deeply carved, that held textiles, clothing, jewelry, and coins (plate 2). This chest was often one of the few pieces of furniture in the household, and was passed

down from mother to daughter. The marriage chest, as valued and valuable as it might be, was but a symbol of much more extensive legal and property rights.

Why does it matter what women left to their descendants? To answer that question, think about the fact that real people do hard work, and consider the importance of the steel plow point. The wood plow the settlers brought with them was tipped with iron or steel and fastened to a handle that could be pulled by an animal or person. That iron or steel tip was a precious commodity on a frontier where worked metal tools were nearly impossible to obtain. In her 1747 will, Juanotilla, a *coyota*, a child from mestizo and Indian parents, living in San Buenaventura de Cochiti, passed on to her children such tools for survival: Spanish axes and hoes and an Indian digging stick. To her daughter she also bequeathed a horse, a saddle, and a steel plow point. In Santa Cruz de la Cañada, steel points were so valuable that the town's officials controlled their distribution and allotted them only to women. Small wonder that Spanish-Mexican women regularly mentioned steel plow points in their wills. Moreover, they tended to bequeath those possessions to their daughters, even when they had surviving sons. When women mentioned plow points and livestock in their wills, they were recording the material wealth they brought to their marriages, the work they did on their farms, and their strategies for survival in a perilous borderland.[21]

CAPTIVES AND COUSINS

On June 3, 1779, José Martin brought his infant child, María, to the parish priest for baptism. María Gertrudis Martin was the illegitimate daughter of Martin and an unnamed Pueblo mother. A few years later José married María del Carmel, and young María was reared within their household as a servant alongside their legitimate children and at least one other Indian servant, a Comanche female. María later accompanied her half-brother, Servino Martínez, to Taos, where she worked in his home as his housekeeper until her own marriage. As an adult, she set up her household as one of the many *genizaros*, detribalized Indians of second-class status, who by the end of the eighteenth century made up almost one-third of New Mexico's population. We can only wonder how María, and women like her, navigated the dangers, constraints, and opportunities they found on the frontier.[22]

Colonial encounters, whether peaceful or violent, were not something that happened "out there." Rather, they took place in that most intimate of spaces, the home, in the form of the daily clashes and combinations of bodies and minds. Some women contributed to household sustenance whether they wanted to or not. The labor of captives purchased at trade fairs in Taos and Pecos remained central to Spain's frontier economy. A large number of indigenous child "orphans" found their way into Hispanic households in the 1730s and 1740s. Some of these orphans were the products of rape or interracial unions, abandoned by their mothers and placed by the Catholic Church into Christian homes. Settlers purchased "rescued" Apache and Navajo slaves, often victims of Coman-

che raids, whom they brought into the household to be Hispanicized and converted. Two-thirds of these captives were women. As paid laborers and slaves, indigenous women worked side-by-side with Hispanic women, spinning cotton and wool for the family's bedding and floors, cooking and preserving food, and keeping house.[23]

Rio Arriba women created complex and unreliable webs of dependency in the face of insecurity and violence. Hispanic mestiza women, themselves the children or wives of interracial families, claimed higher status than the captive Native women they commanded. But like Pueblo and Plains Indian women, they too were subject to kidnapping and enslavement, all too frequently finding themselves transformed from keepers of households to spoils of war. As Comanche raiding of the northern frontier escalated, many women became the victims of slave raids and were forcibly changed from conqueror to captive.

By the end of the eighteenth century, women's new identities as New Mexicans took shape in a shifting homeland in which enemies, allies, and families had become intertwined. Rising levels of warfare, drought, and epidemics forged a new, often painful unity in the villages of the Rio Arriba. Equestrian peoples, including Navajos, Comanches, Utes, and Apaches, pushed into new territory and raided Hispanic and Pueblo villages alike. In 1779 the Santa Fe cartographer and military engineer Bernardo de Miera y Pacheco prepared several maps for the new governor, Juan Bautista de Anza. He recorded the large-scale violence and disruption of this period on one map by means of small images of ruined buildings indicating settlements destroyed by the enemy.[24] Spanish farmers, also hit hard by drought and disease, needed their Pueblo neighbors as allies. During the Comanche raids of the 1770s, settlers sought refuge inside the walls of Taos and Picuris pueblos. In times of hunger and war, multiethnic families formed a common defense.

The intimate contact between Indian and Hispanic women shaped a convergent history. Pueblo women had to reach their own accommodations with the Spanish settlers who increasingly encroached upon their villages and lands, who wanted to claim their bodies and souls. New languages, new foods, new concepts of property, and new approaches to the sacred had taken root in the soil.

Women contributed in many ways to the rich material culture emerging in the Spanish/Indian borderlands. Indian women responded creatively to the heavy workload imposed on them by household and empire. Hispanic homes depended on Pueblo potters for ceramic ware, and Pueblo women found a ready market among the colonists for other new pottery forms, such as bread bowls, soup plates, and candlesticks. Pueblo potters took designs from Spanish embroidery and wall paintings and incorporated them into their painted pottery. Coiled baskets woven by Apache women appeared alongside Pueblo pots as essential household goods. Captives working in Spanish homes created new weaving styles that combined new materials with indigenous techniques. Navajo women incorporated Spanish traders into their networks, weaving Spanish-style banded blankets, longer than wide, which they traded to Spanish colonists for dyes, knives, and bridles (plate 3).

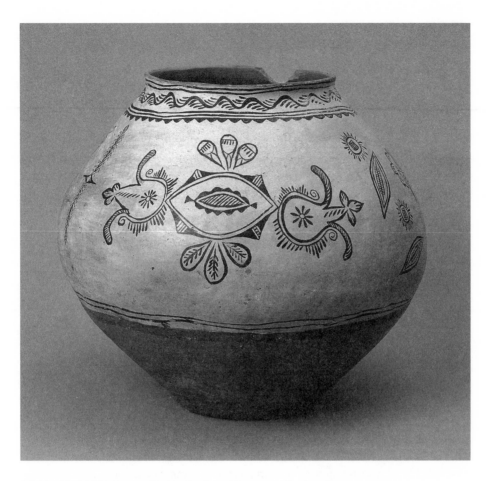

6 | Olla, 1730–1880, Tesuque Pueblo. Southwest Museum of the American Indian, Autry National Center; 1.A.232.

The Hispanic women who made the Rio Arriba their home likewise adapted to the exigencies of sharing a harsh place with those whose ancestors had occupied the terrain for millennia. Looking backward from the hindsight of the early nineteenth century, the American trader Josiah Gregg would observe that isolation had led the "early settlers of New Mexico to resort to inventions of necessity, or adopt Indian customs altogether."[25] Women had carried seeds and botanical knowledge on the journey north from Mexico, but they needed to learn the particularities of New Mexican soil, plants, and climate in order to survive. Many added to their own repertoire new plants and medicines used by Pueblo women. Women incorporated the indigenous technique of weaving ixtle, a cactus fiber, along with Spanish colcha embroidery in their weavings (plate 4). The daily tasks of food preparation bore the unmistakable mark of Pueblo influence, from the use of new types of grinding stones to the inclusion of indigenous foods like purslane and chokecherries in families' diets. Hispanic families sustained themselves with the foods

and skills they learned from Pueblo cooks. Even the very walls of their houses bespoke the convergence of peoples: men built with adobe bricks, as they had in Spain and Mexico, but the plastering and maintenance of adobe homes shifted from Hispanic men to Hispanic and Indian women.

By 1800, Hispanic and Indian families along the upper Rio Grande had come to an accommodation. Their economies, households, and families were interlocked through the exchange of women's bodies and labor, the use of the Spanish language, the adoption and adaptation of Catholicism, and convergent technology and foods. Together, they had crafted new cultural identities reflected in such innovations as new styles of Pueblo pottery that combined European and Pueblo motifs, the distinctive Hispanic Rio Grande blanket, and new santo painting styles.[26] Yet the upper Rio Grande region remained contested terrain, as first Mexico and then the United States claimed the land under new flags.

THE AMERICAN ENCOUNTER

In 1821, residents of Spain's northern colonies became independent without much fanfare or bloodshed. The stirrings of revolution may have at first seemed remote to the people on the isolated northern frontier of New Mexico. More consequential for them, the Mexican government in that year lifted restrictions on trade with Americans. Women, who now made up half of New Mexico's population, initially had much to gain from the opening of commerce, as traders, street vendors, and consumers. They welcomed and valued the metal tools, household goods, and bolts of cloth brought by caravans over the Santa Fe Trail and into the Rio Arriba.

A few intrepid American women, wives of traders, also made the journey into the Hispanic homeland. But more American traders and trappers, eager to take advantage of new markets, married into established Spanish-Mexican families and converted to Catholicism, as they found that the property and connections a Spanish-Mexican wife could bring were as important to success as talent, work, or luck. In the Taos Valley, the most common destination in New Mexico for American foreigners, the rate of intermarriage was particularly high. More than three-fourths of all church-sanctioned marriages between Mexicans and Americans occurred there.[27]

The traders rolling down the Santa Fe Trail brought Mexican women into the expanding sphere of American commerce, just as the market was transforming the way Americans farther east organized their households. To Americans in the 1830s and 1840s, home was becoming many things: the place where family members found food, clothing, and shelter; the domain of women's work and the incarnation of men's success; the locus of an ever-increasing array of consumer goods; the sentimental "haven" from the accelerating economic, social, and physical pressures of modern life; even the sacred space in which salvation-seeking became possible for rightly ordered families. In this heavily laden vision of home, American women were charged with spreading their moral authority at the very moment that the United States expanded its political domi-

nance into newly conquered Mexican and Indian homelands. Every recipe and dress pattern, every homily spoken or embroidered on a framed sampler, was, in a sense, a building block of the new empire.[28]

As American women sought to create an empire of the home, they challenged the rights and potentially usurped the home places of Mexican women at the edge of the empire. When General Stephen Watts Kearny's army moved into New Mexico in 1846, claiming the land for the United States, women who had been citizens of Mexico found themselves now subject to American laws. The Treaty of Guadalupe Hidalgo guaranteed the property rights of former Mexican citizens who chose to remain under the new regime, but Hispanic women of the Rio Arriba endured American conquest as a step backward. When Americans seized control of New Mexico, married women lost their rights under Mexican law to hold property in their own names, make contracts, and testify in court. The American legal system set up by occupying forces followed the English common law doctrine of coverture, most famously explicated by the English jurist William Blackstone: "When a man and a woman marry, the two become one in the eyes of the law, and the one is the man." Under this principle, any property or wages inherited, held, or earned by a woman prior to or during marriage belonged to her husband.

When American officials refused to recognize women's inheritance and the communal property rights embodied in Spanish and Mexican land grants, many Hispanic women sold their land and other property, hoping to recoup at least some portion of the value. Women had a right to their cash, but they could no longer hold title to land. As historian María Montóya found, women sold inherited property to husbands and other male kin, rather than attempt to hold on to it, and some women from wealthy Hispanic families who married Anglo men saw their holdings transferred to the sole control of their husbands. When we read women's wills from this period, we can see the shift in women's inheritance from assets in land, livestock, and homes to portable forms of wealth such as jewelry, furniture, and clothing.[29] Hispanic women understood that the land beneath them had become a legal battleground.

Anglo men, supported by the new territorial government, quickly consolidated their wealth and power in the second half of the nineteenth century. American businessmen and lawyers, maneuvering within the U.S. legal system, allied with local elites, the *ricos*, to take control of land through litigation, fraud, taxes, and government seizure. By the time New Mexico entered the union in 1912, the land had become concentrated in fewer hands. The property system of the Hispanic frontier, based on personal connections, community rights, and patronage, gave way to an American regime founded on private property and individual ownership of land.

The Rio Arriba had sustained generations of Pueblo and Hispanic farmers, but by the opening of the twentieth century, they were having trouble hanging on. Both Hispanics and Anglos had used the land hard. Deforestation, runoff from timber and mining, and overgrazing had stripped the land of its ability to support its inhabitants. The quantity of available rangeland shrank under pressure from commercial ranchers and

a new generation of Anglo homesteaders. And in 1918, a severe drought strained already beleaguered families to the breaking point. Many of the new homesteading families found little profit in farming, sold their land, and moved on. Long-established Hispanic villages were abandoned for lack of water, and the fields of the Pueblos withered.[30] "We used to be celebrated for our vegetable gardens," lamented Santa Clara leader Joseph Tafoya. "Now we can hardly raise anything worthwhile on these lands." Pueblo populations became more dispersed as families moved to more distant fields or sought wage work in the cities and towns, on the railroad, and on migrant crews, returning to the pueblo only for ceremonies.[31]

Homes based in agriculture rhythms were giving way to an economy fueled by railroads and tourism as populations flowed from the rural edges of northern New Mexico into Santa Fe, Taos, and Albuquerque. Civic efforts to increase tourism, supported by the railroad, propelled the growth and prominence of Santa Fe. From 1930 to 1940, Santa Fe's population jumped from 11,176 to 20,325.[32]

Pueblo women were pushed into further dependence on a cash economy fueled by a new industry: tourism. Some found jobs as domestic servants or service workers in the cities of Taos, Santa Fe, and Albuquerque. And some were able to call upon the earth once again, relying on skills that reached back to antiquity, to make a living in the new economy. When the Santa Fe Railroad arrived in New Mexico in 1880, waves of tourists took to the rails to "discover" the Southwest. By the 1890s, millions of dollars had been spent advertising New Mexico to Eastern tourists. What better souvenir of their trip into exotic country than a piece of pottery handmade by a Pueblo woman? Pottery making, which had begun to decline due to the popularity of American tinware and enamelware, revived. Soon potters experimented with smaller shapes and colorful designs that appealed to tourists.

Hispanic villagers also faced the reality of decline and dependency. Writer and home economist Fabiola Cabeza de Baca recalled the fading fortunes of her family in her 1954 memoir, *We Fed Them Cactus*. Born in 1894, Cabeza de Baca grew up on her grandfather's farm on the *llano estacado*, or staked plains, near Las Vegas, New Mexico. As Anglo homesteaders and cattlemen flooded into the high plains, "where once the boundaries over which our cattle grazed had been the earth's horizon, now we were being pushed in and in, until it became necessary to build fences." Cabeza de Baca saw her family reduced from riding the range to catering to travelers: "Through four generations, our family has made a living from this land—from cattle and sheep, and lately by selling curios, soda pop, gasoline and food to tourists traveling over U.S. Highway 66."[33]

And yet, in spite of hardship, women did what they could to hang on to the land. They continued to come together to plaster and maintain the adobe walls of their homes (figure 7). Lorin Brown, a resident of Cordova, remembered how women took over planting when men left the villages seeking wage work: "There was no abandonment of the land. . . . During the long summers, the women tended their gardens and fields with perhaps more care than even their menfolk might have done."[34] With the cash women earned selling produce or crafts, families managed to keep at least a remnant of their

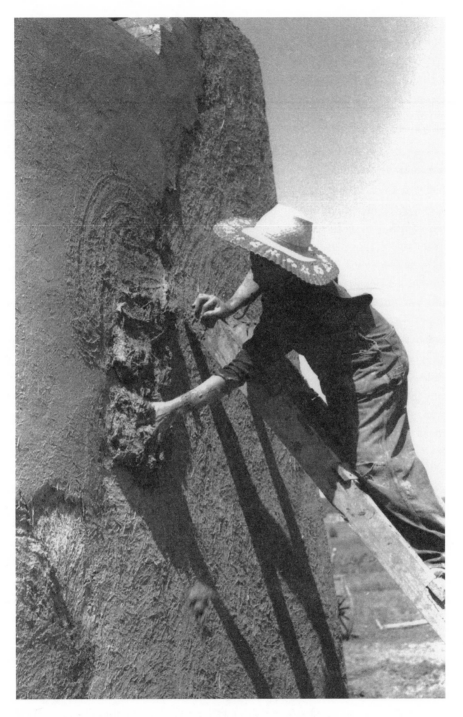

7 | Spanish American woman plastering adobe house, Chamisal, New Mexico, July 1940, by Russell Lee. Library of Congress, Prints and Photographs Division, FSA-OWI Collection (LC-USF33–012823-M5).

land. And as women tended their farms and kept communities together, many of the stubborn villages scattered throughout the Rio Arriba somehow survived.

More women, however, chose to leave their villages and garden plots for jobs in town, cleaning houses or working in stores. As they moved away from their traditional sources of power, they looked for new opportunities in the emerging commercial and tourist economy.

NEW WOMEN IN THE LAND OF ENCHANTMENT

When California writer Charles Lummis traveled to New Mexico for the first time at the end of the nineteenth century, he praised a place he found steeped in the ancient timelessness of "sun, silence and adobe."[35] Lummis's romantic image both missed and masked the turbulent history of the region. But the longing for serenity, timelessness, and beauty brought a new generation of Americans to the Southwest, including a host of adventuresome women seeking refuge from war and the clamor and strife of the machine age. The appeal of ancient earth and an alternative way of living close to the land sparked the creation of a new type of colony, led not by soldiers, or by farmers, homesteaders, and merchants, but by artists, writers, and reformers. To these twentieth-century immigrants, the red earth of New Mexico offered redemption and regeneration.

In the decade following World War I, hundreds of artists, writers, and visionaries, many from the East and most of them Anglos, journeyed to northern New Mexico to claim a home. Anglo women who defied convention in matters of love, family, career, and politics led the migration. In Santa Fe, an artists' colony formed around poet Alice Corbin, her husband William Penhallow Henderson, and writer and feminist Mary Austin. In Taos, the arts community coalesced around Mabel Dodge, the socialite and *salonière* who would scandalize her friends by divorcing her third husband and marrying a fourth, a man from Taos Pueblo, Antonio Lujan.[36]

These women came to Santa Fe and Taos seeking personal and creative freedom. They looked to Pueblo and Hispanic villages for a democratic and transformative vision of home, art, and work. Single women like Elizabeth Shipley Sergeant and Mary Austin invested in the city as property owners, buying adobe homes and proclaiming themselves "mud women." For many women, building in adobe expressed an alternative model of community, one in opposition to the nuclear family household, which allowed them to live integrated with the land. Austin discovered new horizons from her Casa Querida ("Beloved House") at the foot of Cinco Pinatores Hill, where she could see "beyond the town, over and around into sheer desertness." Here, she wrote, "something is drawn from the spaciousness of the country itself, as opportunity, as individual release."[37] Georgia O'Keeffe, a Wisconsin native who had achieved fame in New York, would find in northern New Mexico landscapes around Taos and Abiquiu the repose, light, and scale to create the work that made her the most celebrated painter in American history. O'Keeffe expressed the possessive urge that led her and others to claim the Rio Arriba as a new homeland: "When

claim *modern colonizers*

I got to New Mexico, that was mine. . . . As soon as I saw it, that was my country. I'd never seen anything like it before, but it fitted me exactly" (plate 5).[38]

Anglo expatriates like Sergeant imagined the Rio Arriba as the home of primitive, natural, unselfish people tied to the earth. In her writing, Mary Austin defined land as "all those things common to a given region," including the experiences "passed from generation to generation" that had become, in Austin's thoughts, a racial identity unique to New Mexico.[39] Anglo women glorified what they saw as the preindustrial culture of the Southwest, even as they hired Indian and Hispanic women and men as servants, laborers, and models for their paintings. Professing a vision of harmony, they overlooked their own part as modern colonizers, perpetuating the inequities of the present. These "New Women" of the early twentieth century—progressive, well educated, unconventional—embraced a romantic vision of racial differences, and few formed close ties to the Hispanic and indigenous women whose families had called New Mexico their home for generations. But Anglo women were not alone in grasping new, potentially emancipating ideas about womanhood. As they flooded into New Mexico in search of peace and harmony, Native and Hispanic women also pursued new forms of independence and self-expression. Although women working with and on the earth had for millennia made their mark collectively and anonymously, this generation of diverse women would claim their place in the historical record as individuals.

In the decades spanning the two world wars, diverse women remade the physical, economic, and imaginative landscape of the Rio Arriba. Women once again claimed a home place through the medium of earth, in the form of adobe architecture and real estate. Historian Flannery Burke has noted the important ways in which the "Anglo arts community recast the home as the wider space of New Mexico."[40] They protected the Spanish-Pueblo past they admired not only in their poems and paintings but also through building permits, tax breaks, patronage, and preservation organizations like the Santa Fe Planning Board and the Old Santa Fe Association. Women founded, funded, and erected cultural institutions that directed the city's growth and identity. Working with each other and with male colleagues, they reshaped the cultural and built environment of Santa Fe through the vehicles of real estate, tourism, expositions, and chambers of commerce. They brought the trappings of modernity to New Mexico, guided by a desire to preserve remnants of an allegedly timeless past against the ravages of the modern era.

Amelia Elizabeth White and Martha White made their mark on Santa Fe through patronage and real estate speculation, mingling the language of progressive reform with the possession and pursuit of wealth. Graduates of Bryn Mawr, suffragists, and nursing veterans of World War I, the two sisters first purchased property in Santa Fe in 1923. A year later, with lawyer Francis Wilson, they formed the De Vargas Development Corporation with Amelia as president. Soon they were buying lots south of the city along Pecos Road, Camino Corrales, Garcia Street, Rancheros, and Camino del Monte Sol. For themselves, they purchased extensive property along Garcia Street, where they expanded the original two-room adobe home located on the lot into a complex of buildings, de-

development

signed by William Penhallow Henderson to express an alternative vision of home life based on community and mutual support.[41] They mixed a family home with small apartments and gardens within a walled compound that paid homage to indigenous tradition and their own exquisite taste.

The White sisters continued to invest strategically, both to enrich themselves and to preserve Santa Fe's adobe past. As early as 1936, they were buying up and selling off particular lots in an effort to protect the Santa Fe skyline, prevent overdevelopment, control road building, and sponsor cultural institutions. By 1946, the De Vargas Development Corporation balance sheets showed Amelia White as owner of more than 159,000 acres of prime Santa Fe real estate. Their efforts to preserve a romantic Spanish and indigenous past masked the reality of growing spatial segmentation in Santa Fe. As Anglo Americans claimed new areas north and south of the city's oldest areas, Hispanic residents were forced out into areas to the east and west.[42]

The sisters took advantage of the disarray and confusion surrounding New Mexican land titles, although they were doubtless aware of the cost to previous occupants. In a 1925 deal, Amelia doggedly pursued the purchase of fifty acres of land, which she described as "a hideous piece but we feel that it is *most* important to secure that tract. As for the poor woman who got stung with a bad deed, please buy her out, giving her a proper profit." They justified their willingness to displace people on the grounds of landscape preservation and beautification. Once the deal was done and the original home razed, Martha White wrote that at last she could "rejoice [Santa Fe] is not going to turn into another shanty town." Divided into lots, much of the original tract was sold to Anglo residents or held aside to "protect" the character of the city.[43]

Even as they were ruthlessly cementing their claims to valuable lands in the Rio Arriba, the White sisters and other Anglo women engaged in paradoxical politics. While they disdained the "shanty towns" and "eyesores" of the present, they romanticized the purported timelessness of Indian earthworks, from pottery to adobe to reservation land claims. Amelia White lobbied for state and federal laws to protect Pueblo land and water rights, organizing the Eastern Association of Indian Affairs and serving on the executive council of the American Indian Defense Society. She also supported federal funding for Indian artists because she believed that the arts offered more economic opportunity for indigenous women than wage work could. As patrons, the Whites created new outlets for women's traditional crafts, and they fostered the careers of Native women like the San Ildefonso/Cochiti painter Tonita Peña. Imagining themselves refugees from the grubby world of commerce, they were themselves agents of economic change.[44]

The New Women of New Mexico were not just a flash in the pan, not simply the ragged western periphery of a generation of flappers that spread south from New York, finding personification in Zelda Fitzgerald, or eastward across the ocean with Josephine Baker. They were, instead, a force that would transform the social life, culture, and landscape of the Rio Arriba, embracing tradition even as they embodied modernity.

Consider the three-generation female dynasty of Eva Scott Muse Fényes, her daugh-

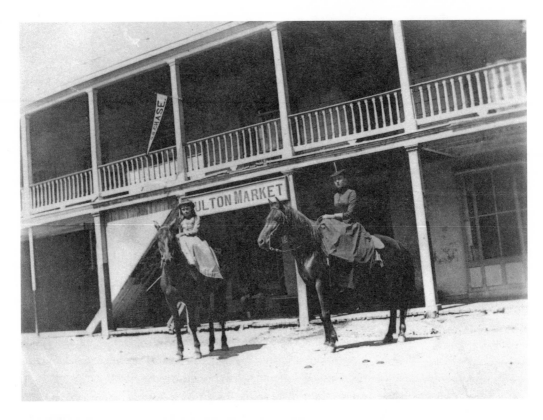

8 | Eva Scott Muse and Leonora Muse in Santa Fe Plaza circa 1891, photographer unknown. Acequia Madre House, Curtin-Paloheimo Collection, Santa Fe, New Mexico.

East ——> West

ter, Leonora Muse Curtin, and Eva's granddaughter, Leonora Frances Curtin. These three women's lives spanned 150 years, an era beginning with the discovery of gold at Sutter's Fort and ending as the election of 2000 approached. Founding mother Eva Scott was born in 1849 in New York, the only child of a wealthy publisher and his pedigreed wife. Like so many elite families of the time, they accommodated the health problems of one member, and presumably the desires of others, by traveling to remote and scenic places. By the time Eva reached her twenties, she had traveled in Europe, the Middle East, and Central America. She had studied painting in Egypt and Europe and, on a trip to St. Augustine, Florida, encouraged imprisoned Indian artists at Fort Marion who had begun to make ledger paintings.

Eva was nearly thirty when she married dashing Marine Lieutenant William Muse in 1878. Her daughter, Leonora, was born the following year, but the marriage was troubled. By 1889, Eva determined on divorce. She took Leonora from Mare Island, California, to the dusty frontier outpost of Santa Fe, New Mexico, where she sketched, rode horses, bought a house, traveled across the territory, and waited for her divorce to become final (figure 8).

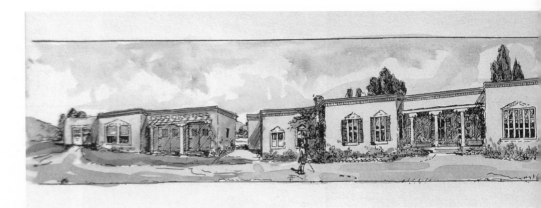

Eva was ever her own woman. In time she would marry Dr. Adalbert Fényes, a Hungarian physician and entomologist of noble lineage practicing—for reasons still unclear—in Cairo, Egypt. By 1896, the family returned to the United States to build an Orientalist mansion in Pasadena, California. Eva found a friend in the writer and ethnologist Charles Lummis, began to paint adobe ranch houses and missions, and developed a passion for historic preservation. Leonora, for her part, attended school and cultivated an interest in plants that would lead to serious study in ethnobotany.

Leonora married railroad attorney Thomas E. Curtin in 1903 and moved to Colorado Springs, Colorado. She became a mother soon after, but by 1911 she was a widow. She and daughter Leonora Frances moved back to Pasadena to live with Eva in yet another magnificent new home, a social center for the artists and intellectuals who were passionately documenting, collecting, and inventing what would become famous as the American Southwest.

The three women traveled all over the world, Eva painting, her daughter Leonora collecting and studying plants, and the granddaughter, young Leonora, coming to share her mother and grandmother's passion for Spanish colonial and folk culture and arts and the vast desert landscape. In 1925, the three women, along with Mary Austin and Frank Applegate, helped found the Spanish Colonial Arts Society. Aesthetes, artists, and patrons of the arts, they were also savvy businesswomen who made shrewd investments in Western real estate. They returned often to New Mexico and, by the 1920s, were ready to settle more permanently in Santa Fe, where they shaped the city's landscape with their forays in the local real estate market and sought the community of other New Women and New Men. In 1926, the three built a house at 614 Acequia Madre, which Charles Lummis called "the House of the Three Wise Women."[45] They had engaged a series of prominent architects (including Wallace Neff and William Penhallow Henderson) on the project, but fired them all, deciding that none understood what they wanted. In the end, they designed the Spanish Territorial Revival house themselves, incorporating not only gracious social areas and comfortable sleeping quarters but also individual

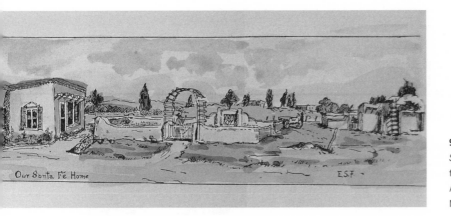

Our Santa Fe Home

E.S.F.

9 | Eva Scott Fényes, *Our Santa Fe Home*, drawing for Christmas card, 1927. Archives of the Pasadena Museum of History.

work spaces for each woman. Their home became the subject of countless sketches, letters, photographs, and even family Christmas cards (figure 9).

Eva Fényes died in 1930, leaving a legacy of thousands of watercolor paintings and countless photographs, a fortune in real estate and other investments, and a wealth of projects to preserve Spanish colonial and Native American crafts. The family's connection to northern New Mexico deepened. Along with their close friends Edgar Lee Hewitt, Gustave Baumann, and others, these women deserve inclusion among those who created what historian Chris Wilson called the myth of Santa Fe. Leonora Curtin studied medicinal plants, interviewing *curanderas* in New Mexico for her 1947 book, *Healing Herbs of the Upper Rio Grande,* and with her daughter investigated the Arabic roots of Spanish words. She was a founder and the first president of the Santa Fe Garden Club and served on the boards of the Museum of New Mexico, the School of American Research, and Lummis's Southwest Museum in Los Angeles. Her daughter worked closely with linguist and ethnologist J. P. Harrington to study the Navajo and Zuni languages.

In 1932, Leonora Curtin and her daughter Leonora purchased El Rancho de las Golondrinas, a historic working ranch south of Santa Fe. Despite the Depression, they had profits from successful investments in the stock market that they wished to convert to land. They raised cattle and sheep and restored the original adobe house, hiring a local woman, Doña Adelaida, and her relatives to hand plaster the walls using red earth brought at considerable expense from several miles away. La Loma, as the house was known, would become a retreat for the two women and their families. Aided by architect John Gaw Meem, they also began to restore and reconstruct historic Mexican buildings on their ranch.[46]

Leonora Frances Curtin would further champion traditional Hispanic craftwork, establishing vocational schools and, in 1934, subsidizing the Native Market as an outlet for Hispanic folk artists. In her store on West Palace Avenue, tourists could meet villagers demonstrating their skills while buying colcha pillows, tablecloths, or *bultos,* carved images of Catholic saints. Leonora wrote promotional brochures obscuring her own role

10 | Gloria López Córdova, *Untitled (Nuestra Señora de los Dolores),* 1990,
cedar and cottonwood *bulto*. Museum of the American West, Autry National
Center; 90.239.1.

as a middleman between the consumer and the indigenous craftsperson, advertising Native Market's products as coming "from village to market to you."[47] By 1937, Native Market was providing income to more than 350 Rio Arriba villagers. At a time when land value was at its lowest, Leonora saw sustainability in the tourist economy. During the Depression years she subsidized the Market's losses with her own funds.[48] Many of the children and grandchildren of artists of the first Native Market continue to create art in the Rio Arriba today. Gloria López Córdova, a fourth-generation *santero* maker, continues to carve *bultos* from unpainted wood in the Córdova style pioneered by her family and the Native Market (figure 10).

In 1946, Leonora Frances married the Finnish diplomat Y. A. Paloheimo. The couple adopted four Finnish war orphans and split their time among California, Finland, and Santa Fe. In 1972, El Rancho de las Golondrinas opened—both as a living history museum and as the ongoing symbol of three generations of New Women who adopted, adapted to, and transformed the landscape of the Southwest.

NEW MEXICO WOMEN: MODERNITY AND TRADITION

For their part, indigenous women artists assuredly did not imagine themselves as remnants of the timeless, static past that so inspired their patrons. Neither did Hispanic women see themselves as quaint relics of a doomed way of life. Instead, they looked for ways to make a good living and to balance respect for the past with modernization. Hispanic villagers purchased kitchen ranges and sewing machines. San Ildefonso potter María Martínez used her income from the sale of her traditional pueblo pottery (plate 6) to buy an iron cooking range and a car. By 1924, Martínez was earning about two thousand dollars a year for her pottery, and pottery making had surpassed farming as the most important source of income in San Ildefonso village. As she devoted more and more time to her lucrative pottery practice, Martínez hired a Mexican American woman to help her with the housework.[49]

Writer and government extension agent Fabiola Cabeza de Baca believed that preserving the Hispanic past offered a means to resist Americanization. She went to work for the United States government in 1929, when Hispanic farmers were rapidly losing land to the United States Forest Service, to the continued legal assault on communal land grants, and to environmental degradation. As much as she understood the ways in which modernity threatened the survival of Hispanics' villages and their independence, Cabeza de Baca was also a firm believer in science and progress. In her view, the job of an extension agent was to bring to distant villages and rural households the benefits of new ideas and goods while respecting the value of old ways of doing things. She was far more sensitive to local traditions and more realistic about rural people's choices than most government agents in New Mexico had ever been (figure 11).

Armed with the latest in kitchen equipment—the canning kettle, the pressure cooker, government bulletins, and her college training in home economics—Cabeza de Baca set

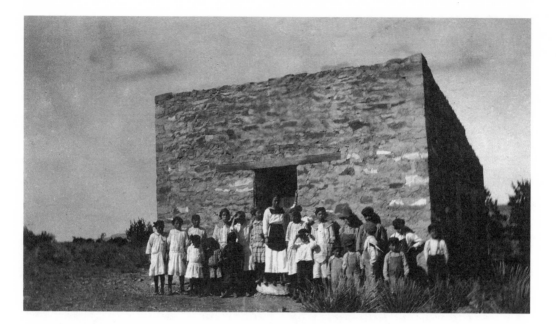

11 | Fabiola Cabeza de Baca in front of New Mexican schoolhouse, date and photographer unknown. Fabiola Cabeza de Baca Gilbert Photograph Collection, no. 000–603–0002, Center for Southwest Research, University Libraries, University of New Mexico.

out for thirty years of life on the road. She helped hard-pressed families get access to canning equipment and sewing machines, and made information available to families not comfortable with English by speaking Spanish (and later Tewa and Towa), translating government bulletins from English into Spanish, and writing her own bilingual materials. Cabeza de Baca in turn heard stories she would treasure; collected folklore about herbal medicine, planting practices, and religious rituals; and learned much of what she would later recount about New Mexican cooking in her 1939 book *Historic Cookery*. She kept voluminous notes about remedies, rituals, and recipes and took palpable pleasure in cataloguing local knowledge, techniques, and skills, observing the mingling of faith and science.[50]

Cabeza de Baca envisioned a future rooted in the soil and the everyday experiences of people. Throughout the 1930s and 1940s, she would join with Nina Otero Warren, Cleofas Jaramillo, and other Hispanic women to create a counternarrative in response to negative stereotypes of Hispanic character, and to combat the disappearance of village life, as dispossessed Hispanics were forced into migrant labor and the service economy or were forced to leave for jobs in burgeoning war industries.[51] In 1935 these prominent Hispanic women founded the Sociedad Folklorico de Santa Fe, an organization dedicated to preserving the Spanish language and Hispanic folk traditions in New Mexico. Cabeza de Baca saw folklore as alive and collective. What had begun as "traditional expressions

12 | Cast iron pressure cooker, 1917–1939, manufactured by National Pressure Cooker, Eau Claire, Wisconsin. Museum of the American West, Autry National Center; 2004.73.1.

13 | Pueblo girls learning to use pressure cooker, 1930s, by Frances E. and Henry Prior Clark. Braun Research Library, Institute for the Study of the American West, Autry National Center; OP.160.

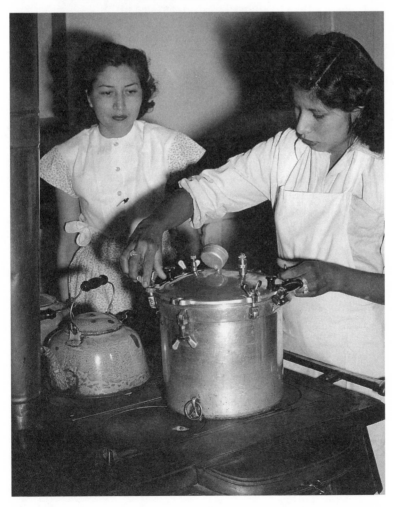

of unsophisticated groups of people . . . of unknown or forgotten origin, that are the personal property of no one," were, nonetheless, "subject to modification while being communicated." In New Mexico, Indian, Spanish, and Anglo traditions overlapped, even as they remained identifiably distinct. The state (and Cabeza de Baca herself) trumpeted its purported "tricultural heritage," but new circumstances and people were creating new lore all the time. "The Beatles have created a modern folklore," Cabeza de Baca pointed out, and "as the Space Age grows, our folklore will experience a new era of heroes, customs, traditions, and a new way of life."[52]

By pursuing a career as a professional artist, Santa Clara Pueblo painter Pablita Velarde rejected tradition, even as she chose to paint pictures of Pueblo daily life and ritual (plate 7). A member of one of the first classes of students at Dorothy Dunn's studio at Santa Fe Indian School, Velarde remembered the boys ridiculing her: "Miss Dunn had to keep me beside her desk for protection. The boys were always teasing me[,] and sometimes they were mean. They didn't want me in the class anyway[,] because they didn't believe women should be artists."[53] She elaborated: "Painting was not considered women's work in my time. A woman was supposed to just be a woman, like a housewife and a mother and chief cook. Those were things I wasn't interested in."[54]

Velarde supported herself through a variety of "clean-up jobs" as nurse, maid, and part-time teacher when she first tried to sell her paintings in the late 1930s. Her big break came in 1939, when Dale Stuart King invited her to paint several large-size murals depicting Pueblo life for the Bandelier National Monument. She would use the money from that job to build a house and studio at Santa Clara, on land given to her by her father. In 1942 she married Herbert Hardin, an Anglo police officer, and moved to a house in Albuquerque, where she painted at her kitchen table and combined her art career with motherhood.[55]

Velarde believed that Pueblo people could preserve their culture only by adapting to Anglo markets and tastes. Yet the earth remained a source of inspiration and an artistic medium. From Dorothy Dunn she learned to grind rocks and raw clay to create pigments for her painting, and Velarde continued to refine her technique. "I dig the dirt in secret places," she wrote, returning to grind it in a hundred-pound metate with a ten-pound mano she salvaged from a Pueblo home in the 1960s.[56] After many years of success as a painter, she affirmed: "I'm at a point where I can pass [on] some of my own expertise and some of my learning and my own feeling. . . . I'm satisfied with the work that I have done so far[,] and this is the way I want to leave my world when I go back to Sandy Lake and become a Cloud Person. I want the earth to remember me through my work." She died in Albuquerque in 2006, having received the Award of Excellence from the Louvre as well as an honorary doctorate from the University of New Mexico; she left a large body of internationally acclaimed work.[57]

In the face of the vast and rapid changes that brought dispossession and cultural loss, women like Cabeza de Baca and Velarde learned new languages, attended American schools, and embraced roles that defied local ideas about what women should do. Each

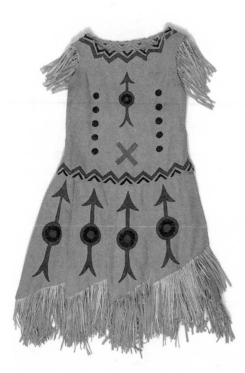

14 | Dress worn by waitress, 1920s, Fred Harvey Restaurant, New Mexico. Purchase made possible by an anonymous donor through the 2005 Gold-Level Members Acquisitions Committee, Museum of the American West, Autry National Center; 2005.31.9.

used imported institutions to create an unconventional life. And both worked tirelessly to preserve and revitalize lifeways rooted deeply in the earth of the Rio Arriba.

Earth remained a potent symbol for New Mexico women throughout the twentieth century. As different from each other as businesswomen Amelia White and Leonora Curtin, artist Pablita Velarde, and writer Fabiola Cabeza de Baca were, all these women traversed geographical, cultural, and social borders in order to imagine new possibilities for themselves as individuals. They did so by critically embracing the necessity of change and by believing in the possibility of common ground. To Anglo expatriates like Amelia White, adobe expressed community, self-expression, and a life integrated with the land. For artist Pablita Velarde, earth was a medium and a legacy. She viewed her paintings as instruments to preserve the memory of traditional Pueblo culture and as devices to educate non-Pueblo people about Pueblo life. For writer, historian, and extension agent Fabiola Cabeza de Baca, adobe was a symbol of a Spanish frontier past. For her, the future of New Mexico's Hispanics remained rooted in the abiding connection of ordinary people with land, and in preserving family and home by using the new tools and products of American conquest.

The New Women of the Rio Arriba hoped to determine for themselves a future in harmony with the past. But their hopes were increasingly at odds with the powers of the global market. Romantic images of New Mexico's preindustrial culture proved perhaps too marketable. By the mid-twentieth century, many New Mexicans had turned from

15 | *Indian-detours*, 1930, Atchison, Topeka and Santa Fe Railway Company
brochure. Museum of the American West, Autry National Center; 95.38.1.

cultivating the earth to courting tourists. In 1922 Erna Fergusson and Ethel Hickey marketed "Koshare Tours" to visitors. Fergusson and Hickey sold out to the Fred Harvey Company, which rechristened the excursions "Indian-detours" and offered tourists automobile trips to the pueblos led by well-groomed, white female couriers. "So," said Alice Corbin, disgusted with the commodification of Pueblo culture, "we've saved the Indians for Fred Harvey."[58]

LOOKING BACK, LOOKING FORWARD

In the Rio Arriba today, the earth is worth a fortune. Pueblo pots created by the descendants of María Martínez, Nampeyo, and other brilliant revitalizers of the ancient women's tradition now sell for thousands of dollars. Sons as well as daughters of celebrated matrilineal clans hang on to their homes in reservation villages by selling clay vessels to people who would never dream of filling those pots with water, let alone putting them on a fire. Adobe houses in Santa Fe and Taos, once derided as the "mud huts" of primitive people, are being snapped up as vacation homes for bicoastal nomads who come to raid and trade, not on horseback, but via jet plane and rental car. Land once planted in corn or left for grazing has sprouted cul-de-sacs and for-sale signs. If you have to ask how much it costs, you can't afford it.

Meanwhile, the long history of village life in New Mexico is, more and more, engulfed in the tidal wave of urban sprawl, suburban growth, and economic development. What were once rural communities clinging to the earth amid hard-hoed, carefully watered fields have become city neighborhoods (Albuquerque's Barelas, Martineztown, Armijo), bedroom suburbs (Santa Fe's Pojoaque and Tesuque), or homes to glitzy casinos complete with spas and championship golf courses (nearly every pueblo has them, or wants them). Those whose ancestors lived and farmed there find their claims to home once again threatened by rising taxes, battles over water, and skyrocketing property values.

Economic inequality falls especially heavily on the backs of New Mexico women. As of 2006, almost 20 percent of women in the state lived below the poverty line, putting New Mexico, among the fifty states, dead last in women's incomes.[59] In 2005, single mothers gave birth to more than half of all the babies born in New Mexico, a fact linked to the state's high number of teen pregnancies. Combined with high divorce rates, this means most children in New Mexico are being raised by single mothers who struggle to care for their children in difficult circumstances. In New Mexico today, motherhood often interrupts women's education, limits their job possibilities, and makes access to health care, child care, and even transportation a daunting challenge.[60]

At the same time, women from many cultural backgrounds have embraced the opportunities that education and professional careers provide, and have begun to make their mark in every public endeavor. Women serve in roles ranging from tribal chair to state Supreme Court justice to congresswoman and governor, demonstrating newfound

power in a public realm long monopolized by men. Fewer women engage in the time-honored craft of house plastering, but many more own their own houses, buy and sell property, and earn their livings in every conceivable way. Women continue to play a notable role in the struggle over who gets to claim a home in the Rio Arriba, and they stand on all sides of every political, social, and economic matter. For every powerful and accomplished woman—every Heather Wilson, the Republican congresswoman, or Diane Denish, the Democratic lieutenant governor; every Sheila Garcia, car dealer and philanthropist; every Verna Williamson, first woman governor of Isleta Pueblo—there are hundreds, thousands, of women simply trying to raise the kids, pay the bills, find a measure of safety and dignity, and claim their piece of the earth in a beautiful but often unforgiving place.

Native American women often shoulder heavy burdens; nearly 75 percent of Indian children born in New Mexico have single mothers.[61] But New Mexico's indigenous peoples have a long history of surviving hardship. Native people today wield a variety of weapons—from the long traditions of their arts and crafts to the vast revenues brought in by casino gambling and the young tribal members with law degrees engaged in the battle to defend land and water rights—in their legal claims to home in the modern West. Daughters of the Pueblos, like Santa Clara sculptor-poet Nora Naranjo-Morse, carry on the fight for self-expression as well as self-determination. Naranjo-Morse's non-traditional figures of mud women use humor and irony to comment on issues facing Pueblo people today. Her poem "Mud Woman's First Encounter with the World of Money and Business" captures the poignancy of the artist's predicament:

She unwrapped her clay figures,
 unfolding the cloth each was nestled in,
 carefully, almost with ceremony.
 Concerning herself with the specific curves, bends and
 idiosyncrasies, that made each piece her own.
Standing these forms upright, displaying them from
 one side to the next, Mud Woman
 could feel her pride surging upward
 from a secret part within her,
 translating into a smile that passed her lips.
 All of this in front of the gallery owner.
After all the creations were unveiled, Mud Woman held her breath.
 The gallery owner, peering
 from behind fashionably designed
 bifocals, examined each piece
 with an awareness Mud Woman
 knew very little of.
 The owner cleared her throat, asking:
 "First of all dear, do you have a résumé? You know,
 something written that would identify you to the public.

Who is your family?
Are any of them well known in the Indian art world?"
Mud Woman hesitated, trying desperately to connect
this business woman's voice with her questions,
like a foreigner trying to comprehend
the innuendos of a new language, unexpected
and somewhat intimidating.
The center of what Mud Woman knew to be real
was shifting with each moment in the gallery.
The format of this exchange was a new dimension
from what was taken for granted at home,
where the clay, moist and smooth,
waited to be rounded and coiled
into sensuous shapes, in a workroom
Mud Woman and her man had built
of earth too.
All this struggled against a blaring radio
with poor reception and noon hour
traffic bustling beyond the frame walls.
Handling each piece, the merchant quickly judged
whether or not Mud Woman's work would be a profitable venture.
"Well," she began, "your work is
strangely different, certainly not traditional
Santa Clara pottery and I'm not
sure there is a market for
your particular style, especially
since no one knows who you are.
However, if for some reason you make it big,
I can be the first to say, 'I discovered you.'
So, I'll buy a few pieces and we'll see how it goes."
Without looking up, she opened a large, black checkbook,
quickly scribbling the needed information to make
the gallery's check valuable.
Hesitantly, Mud Woman exchanged her work for the
unexpectedly smaller sum that wholesale prices dictated.
After a few polite, but obviously strained pleasantries
Mud Woman left, leaving behind her
shaped pieces of earth.
Walking against the honks of a harried
lunch crowd, Nan chu Kweejo spoke:
"Navi ayu, ti gin nau na muu,
nai sa aweh kucha?"
"My daughter, is this the way it goes,
this pottery business?"

Hearing this, Mud Woman lowered her head,
walking against the crowd of workers
returning from lunch.
Nan chu Kweejo's question
clouded Mud Woman's vision with a mist
of lost innocence,
 as she left the city
 and the world of
 money and business behind.[62]

Naranjo-Morse's Mud Woman may have lost her innocence, but the artist herself continues to produce strikingly original, sometimes whimsical work, exhibited in major museums across the nation. She lives in an adobe house she and her husband built in northern New Mexico (plate 8).

But after all, to categorize New Mexico women according to a three-part ethnic division is to accept a tricultural myth that has, for too long, misrepresented the deep history of the Rio Arriba as home. Anglos, Hispanics, and Indians have for too long pretended separation in the face of mix and flow and flux and blending. And today, people from Southeast Asia and West Africa, Ireland and Iran, the Caribbean, the Mediterranean, and the Baltic claim New Mexico as a home they share. New Mexicans continue to work, play, fight, marry, and live with one another. Cultural diversity, still treasured, persists among the people of the Rio Arriba. But the future depends on embracing all the complexity of a convergent past. The earth of the Rio Arriba can be fertile soil or a parched and bloody terrain. If the people of northern New Mexico are to survive on an increasingly crowded, increasingly thirsty, increasingly greedy ground, they will have to learn to thrive together.

MARÍA E. MONTÓYA

WEDDING CHEST

We admire this late-eighteenth-century hardwood wedding chest (figure 16, plate 2), a spectacular piece of furniture, for its craftsmanship. It is not only durable and functional but also ornamental, with beautiful decorations gracing the outside of the box. The chest's origins are unknown; it came to the Autry collection as part of a bulk acquisition with other Spanish colonial pieces from Spain and its New World northern frontier.

Although we do not know who owned the chest or what was kept inside it, we can speculate that it belonged to a woman. In all likelihood, she used it as a wedding or "hope" chest to hold her most personal and valuable belongings as she moved from the house of her father to the house of her husband. Before her marriage she would have filled it with the linens, dresses, and other textiles that she would later use in her role as a wife and mother. When she left the home of her family, she would also carry in that chest whatever jewelry and other portable wealth her father had bestowed on her to take with her into her marriage. If she were a young Hispanic woman of Mexican or Spanish descent—as we suspect, given the objects that were donated with it—she also would have taken into her marriage a piece of landed property that would help her begin a new life with her husband. Like the woman who once owned this chest, Hispanic women of means in early-nineteenth-century borderlands brought considerable assets into a marriage.

The history of the nineteenth-century American Southwest is littered with stories of American and French immigrant men marrying elite Hispanic women in Texas, New Mexico, and California. Young men such as Carlos Beaubien in Taos, New Mexico, and

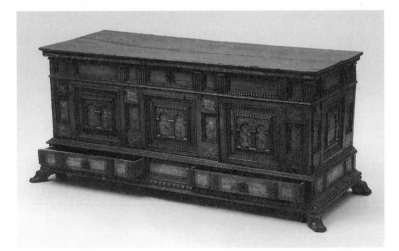

16 | Spanish marriage chest, late eighteenth century. Museum of the American West, Autry National Center; 88.127.99.1. For a color version of this image, see plate 2.

Edward Turner Bale in California realized that one of the most lucrative ways to attain property and social standing in Mexican communities was to marry into the most prominent families. In marrying Maria Paula Lobato in 1827, Beaubien gained access to one of the most prominent and wealthiest families in northern New Mexico. Bale married Maria Antonia Juana Ygnacia Guadalupe Soberanes, niece of the California governor, Mariano Guadalupe Vallejo. Shortly after the marriage, Vallejo awarded Bale a seventeen-thousand-acre land grant, which included present-day St. Helena and Calistoga in the Napa Valley. Because dowry laws in Spanish and Mexican civil law allowed fathers to distribute their property equally among their children regardless of gender, Hispanic women, like their brothers, had the potential to acquire vast tracts of land and wealth. Anglo men with ties to larger markets and trade capitalized on this system and sought alliances that would furnish them with the social standing and property assets of their wives and their wives' families.

The change in regimes after the U.S.-Mexican War and the signing of the Treaty of Guadalupe Hidalgo, however, created a legal situation that made these marital relationships no longer as valuable. Once married, a woman covered by U.S. law now faced uncertainty regarding how much control she retained over her property, both personal and real. Of the many differences that distinguished the experiences of Americans and Mexicans during the first half of the nineteenth century, perhaps none was more profound than the way the two societies organized their legal systems. Their legal structures dictated how property was allocated, how people worked, and, in the case of women, whether they could own property. The law of coverture, which dominated American law throughout the nineteenth century, held that a married woman could not hold property in her own name. Any land she brought into the marriage through her dowry, inheritance, or by contract was also legally owned by her husband. Because of this legal change that swept across what would become known as the American Southwest, women had to rethink their relationships to their husbands with respect to their property, whether cash wealth, precious goods, or land. They even had to worry about their claims to their minor children, who by law belonged to the husband. Consequently, although this wedding chest may be the physical embodiment of what held women's hopes and wealth, it is also metaphorical, especially in terms of what it represented for women as they made their way under the new American legal regime.

A number of wealthy women in New Mexico challenged this new social and legal regime as they attempted to keep control over their property. Eleanor Beaubien Trujillo, who was one of the six children of Carlos Beaubien and Maria Paula Lobato, acted in a deliberate and quick way to preserve her wealth. Upon Beaubien's death in 1864, he bequeathed his interest in the million-plus-acre Beaubien-Miranda land grant to his children in equal parts. Eleanor's marital problems, along with concerns about her status under U.S. law, convinced her to divest herself of her share of real property in the land grant. Eleanor's husband was a notorious scoundrel who had been cheating on her with other women. Because he had come into the marriage with very little, Eleanor accused

him of squandering her property and money. Consequently, she sought a divorce, which the courts granted her without incident. Eleanor, however, wanted no complications in keeping her wealth from her ex-husband. She converted all her real property to cash by selling out to her sister and brother-in-law, Luz and Lucien Maxwell. With cash, Eleanor would be able to convert her property to portable wealth—such as jewelry—that she could then figuratively, if not literally, carry with her in her wedding chest to a new life.

More often than not, however, under coverture the outcome was not so positive for married women. In 1857, Mariana Martinez sued for the return of her dowry because she and her husband, Tomas Lucero, had separated seven years previously and had parted amicably. They had not sought a legal divorce, but both had moved on with their lives and were living with other partners. In fact, Tomas already had created another family by having two children with his new partner. He was, moreover, using Mariana's dotal property (the dowry property she brought to the marriage) to maintain his new family. Mariana wanted the court to stop his spending and return her property and assets to her control. The court, however, ruled against Mariana, reminding her that the two were still legally husband and wife and therefore Mariana could "not during the conjugal association, recover from her husband her separate dotal property." The New Mexico Territorial Court went on to say that "the administration of the dotal property belongs exclusively to the husband during the existence of the marriage." The court then went on to further admonish her for the failed state of her marriage, and stated that her act of leaving her husband voluntarily was "subversive to the true policy of the matrimonial law, and destructive of the best interests of society." She consequently had no legal claim to her property.

Mexican American women, particularly those with personal wealth, had every reason to be suspicious of coverture, as it further devalued their status in the paternalistic society in which they had grown up. The law of coverture severely limited a married woman's ability to control her legal and economic destiny well into the twentieth century. Until the 1950s a married woman in New Mexico seeking a car loan was still required to have her husband cosign the application, and even today, women who buy and sell securities must have the signature of their husbands on legal documents.

In any case, given the recent ups and downs of the American stock market, maybe gathering up all our personal wealth in the form of cash and jewelry, putting it into a wedding chest, and storing it at the foot of the bed is not such a bad idea.

2

WOMEN IN MOTION ALONG THE FRONT RANGE

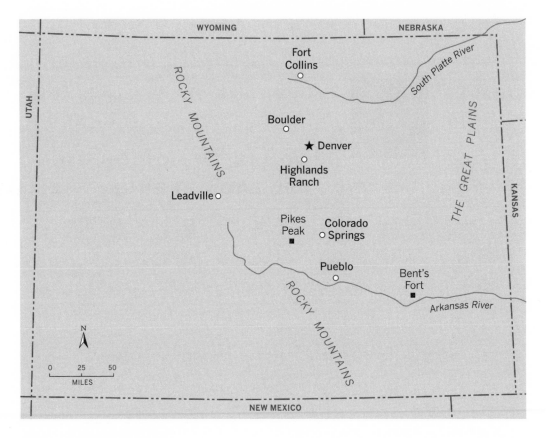

Map 3 | The Colorado Front Range

THE ALLEGORY OF THE AMERICAN WEST HAS BEEN TOLD AS A STORY OF men in motion: the Plains warrior on his horse, the engineer laying railroad tracks across the landscape, Jack Kerouac and Neal Cassady hurtling down the open road in a Ford, a Dodge, a Cadillac convertible. These icons embody power, speed, strength, and control in celebration of man's mastery of the Western environment. But the Western story is also a tale of women's movement. Wherever we look across the landscapes of the West, we find women on the move, traveling in every direction, for myriad reasons, with consequences we have only begun to imagine and appreciate.

In every community across the West, new means of mobility have transformed the physical places where women have lived and worked. At the same time, technological revolutions have themselves been shaped by people's expectations about gender and by women's thoughts and actions. To see this kinetic history clearly, we have to look in new directions and focus on people and activities that we have tended to relegate to the margins—when we have included them in the picture at all. Let us begin by standing at the crest of the Rockies, somewhere on the western flank of what is now the megalopolis of Denver, at the place we have imagined as the "front" of the great Western mountain ranges. Look eastward across the spreading city, to the Great Plains. Imagine that history unfolds before us as a time-lapse panorama, spanning centuries, displaying the comings and goings, staying and building, of peoples on the move. As we witness the migration of Native hunters and gatherers to the plains, the flowering of Plains Indian culture, the coming of the railroad, the building of a great city, and the sprawling of the car culture, we will also see the ways in which women adapted to, and shaped, the impact of the horse, the railroad, and the automobile. New means of movement opened new possibilities for women who navigated the land and claimed its resources. But transportation innovations also imposed new obligations on those women as they went about the business of creating home and community on the great expanse of mountains and plains we came to know as Denver and its hinterland.

CHEYENNE WOMEN AND THE HORSE

The West has been home to women for as long as people have moved into, out of, and through its varied landscape. Some left only a light footprint; others transformed the

ecological and social landscapes of the places they called home. One of those revolutionary movements occurred sometime in the late eighteenth century when Cheyenne men and women, astride their horses, looked to the plains to the west, toward the Rocky Mountains and Arkansas River, and saw a new homeland. Their prophet, Sweet Medicine, had recently emerged from his sojourn in the Sacred Mountains of Noaha-vose, the Black Hills of South Dakota, returning with new codes for the people to live by and sacred arrows to protect them. The Cheyennes assumed a new identity as they headed for a new life out on the Great Plains.[1]

The Cheyennes had been moving toward this momentous decision for a long time. Early French explorers recorded Algonquian-speaking "Chaiena" living in farming villages in what is now southeastern Minnesota and western Wisconsin. They built their villages along riverbanks, settlements that encompassed as many as seventy houses, each dwelling lodging around fifteen to twenty people and organized under the leadership of a woman. Outside each village, fields of corn, beans, tobacco, and squash were farmed by women and guarded by men. They traded surplus farm products, and in the fall, men, women, and children gathered together to hunt bison. As in other Native horticultural societies, women controlled the land and produce that made it possible for the village to survive and to trade.[2]

In the seventeenth century, around the time the northern Rio Grande Pueblos rebelled against Spanish expansion, external forces in the north began to push the Cheyennes westward, out of their farming villages. The Iroquois and the Dakotas, pressured from the east by French and British invaders, moved into the Great Lakes region to stake out new territory. The competition for space and resources, and devastating epidemics of smallpox, measles, and other European maladies, ignited violence throughout the region. Facing the twin scourges of bloodshed and disease, and lacking the power to resist, displaced Cheyenne families began to abandon their villages and homes. Over several generations, these small bands moved first into the Missouri River valley and then into the Black Hills, seeking new alliances and safety. One of the most important would be with the Arapahos, who had moved into the northern plains by the start of the eighteenth century.

As the Cheyennes moved west, horses, introduced to the continent by the Spanish as a tool of conquest, moved northward from the southern Rio Grande pueblos and eastward onto the plains. The spread of the horse, like the spread of corn, led to profound changes. Southwestern border peoples, especially the Comanches, Kiowas, and Apaches, became famous middlemen in the booming trade in horses. Between 1700 and 1850, that trade catalyzed the process that historian Elliott West has called "the great unsettling of the West." Indians and Europeans moved, settled, and moved again, competing for turf and advantage through the exchange of people, ideas, and objects.[3]

The horse was both the symbol and the means of power in this shifting geography. As Elliott West explains, "Once on horseback, whole peoples see entirely new potential both in the land they ride above and within themselves. They recast their meaning and change their story to explain their new social shape."[4] By the 1760s, while some Cheyenne

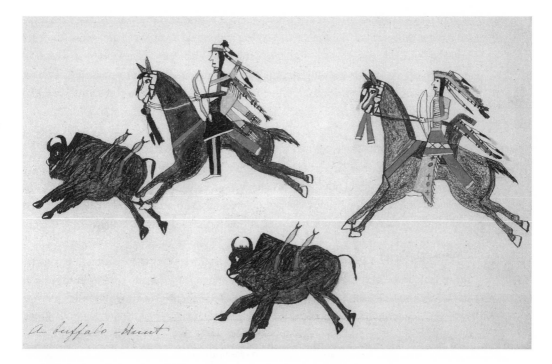

A Buffalo Hunt.

17 | Howling Wolf, Cheyenne, *A Buffalo Hunt*, 1877, ledger book drawing from *Scenes from Indian Life*. Gift of Mrs. Eva Scott Fényes, Braun Research Library, Institute for the Study of the American West, Autry National Center; 4100.G.2.16.

bands continued to farm, others began to embrace a nomadic way of life. Like the horse people around them—their allies, the Arapahos and Arikaras, and their frequent adversaries, the Sioux, Kiowas, and Comanches—they reimagined their way of life and their relationship to the land.

Horses enabled the Cheyennes to take advantage of the plains' seemingly inexhaustible resources: the verdant river bottoms and endless miles of rich grassland that fed vast herds of bison. As they moved to capture that wealth, the Cheyennes upended their entire social structure. Small mobile bands seeking out pasture and game replaced the extended kinship networks of the matrilineal earth lodges. The cycle of planting and harvesting gave way to an unceasing quest for grass and water for the growing herds of horses, which competed with the bison for pasturage. As they killed more and more animals, Cheyenne families made bison their primary source of food, shelter, and clothing. Like all the horse cultures of the plains, the Cheyennes soon developed fast-moving, resilient, interdependent economies of trade and raid.

Cheyenne men and women experienced the shift to the horse and bison economy in profoundly different ways. For women, the transformation from a horticultural to an equestrian way of life meant losing their status as owners of gardens and leaders

of clans. Before the coming of the horse, when bison were hunted on foot or with traps or chutes, women had joined in the collective endeavor of the hunt. Now, men on horseback killed more bison, with greater speed and ease, and women or children moved in afterward for the butchering. Whereas previously the proceeds of Cheyenne women's gardens, trapping, and gathering had been vital to the people's survival and trade, women now turned to processing the skins and meat the men hunted. Women's work—the burden of cutting up immense animals and dressing and preparing heavy hides—burgeoned. Hides, turned into robes, were eagerly sought by white traders. To increase their wealth, Cheyenne men sought to claim multiple wives, obtaining them either from within the tribe or by taking or trading captives. Warfare accelerated, as horses facilitated raiding. New male warrior societies rose to prominence, while women and children faced the rising threat of abduction and captivity. Power shifted from women to men.[5]

Killing a buffalo from horseback with a bow and arrow, or even with a gun, was no mean feat, and Cheyenne men were justly celebrated for their prowess as hunters. But the job did not end with the kill. Hunters worked together to turn the beast onto its belly, cut down the backbone, and remove the hide in two sections. Then, women butchers moved in to slice the meat into long, thin strips to be laid out to dry in the sun.

Dressing a hide took a woman several days. Hides were stretched taut and pegged to the ground so that the hide worker could scrape every bit of flesh off with her flesh-scraper. She then used an L-shaped antler or wooden scraper to shave the hide to a uniform thickness. Some hides were left with the hair on, to be used in trade or as coats or blankets. Others were laced tightly onto vertical frames and scraped clean of hair. The worker then applied a softening paste of bison brains to the shaved skin. Finally, each hide had to be wrung out, pulled, twisted, and rubbed until it was dry, soft, and creamy white. The fine leather could then be sewn and painted for use as shirts, dresses, and other special objects (plate 9).

Given such time-consuming and labor-intensive work, it is no wonder that the fiber and fabric of women's world changed as they moved onto the plains. Their homes, goods, clothing, styles of decoration, and ceremonial art all reflected the new way of life dependent on horse and bison. Even as power and prestige tipped toward men, Cheyenne women found strength and creativity in their own new endeavors.

As the adoption of the horse created a new Cheyenne society along the Front Range and plains, women actively shaped both their surroundings and their people's way of life. They devised new architectural solutions to the demands of their mobile lifestyle. The tipi, an elegant solution to life on the move, replaced the earth lodge. Made from hides stitched together over a frame of poles (plate 10), a tipi could be moved from place to place using a travois hitched to a packhorse. As in the past, women remained responsible for the design, manufacture, and setting up of the home. Often, a family's tipi was understood as belonging to the principal wife. Women trained horses to help transport

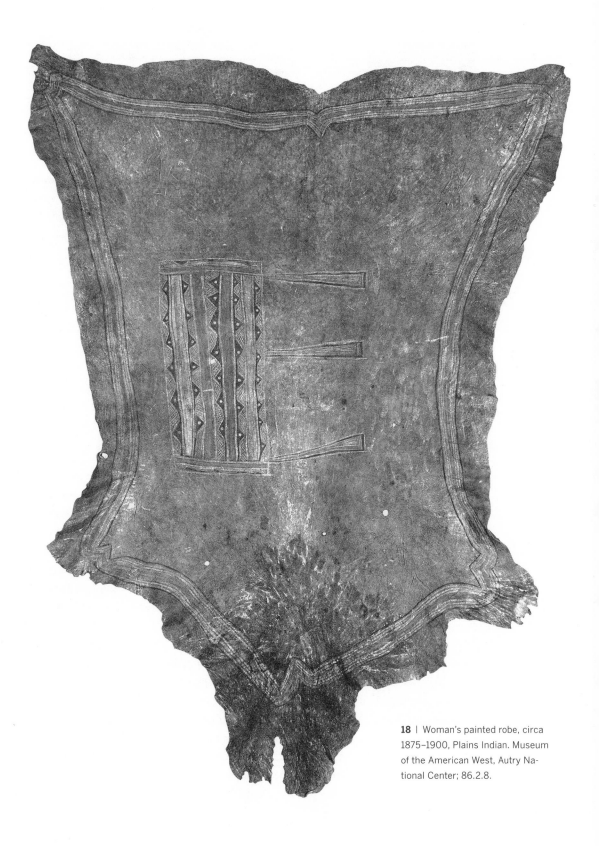

18 | Woman's painted robe, circa 1875–1900, Plains Indian. Museum of the American West, Autry National Center; 86.2.8.

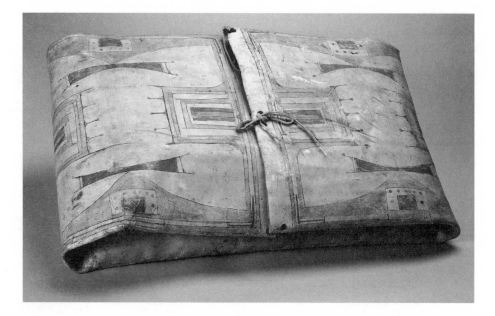

19 | Southern Cheyenne parfleche, circa 1890, painted rawhide. Southwest Museum of the American Indian, Autry National Center; 47.P.143.

their homes and possessions, crafting a new type of wooden saddle with a high, curving cantle and pommel to use with packhorses and travois.[6]

Horses increased families' wealth, and new expressions of women's arts flourished. The parfleche, a folded hide container used to store food, clothing, and personal possessions, appeared among newly nomadic tribes in the eighteenth century and spread westward with them across the plains. Parfleches ranged from small pocketbooks women could use to store personal possessions and small ceremonial objects, to larger containers meant to carry meat and bulky goods, and they were often beautifully etched and painted. Using a sharp and porous bone from a buffalo, a woman incised an outline onto a fresh hide, then worked quickly and deftly before the hide dried, filling in with paint a rhythmic balance of triangles, hourglasses, circles, and squares. We can see the foreshadowing of parfleche pictorial designs in earlier women-made objects such as painted robes and designs used by women in tattooing (figure 18).[7] But of course, parfleches embodied change as well as continuity. When a woman made a parfleche, she kept a link to the past, even as she provided herself and her people with the means to store and transport the necessities of life on the move (figure 19).

Parfleches exemplify the remarkable flowering of women's artistic expression among Plains societies in the first quarter of the nineteenth century. Painting, beadwork, and quillwork adorned everything from moccasins to horse ornaments, shirts to cradleboards. Within the bison economy, skilled women began to specialize in particular crafts. Elected female elders headed religious societies, which taught and enforced strict design rules

20 | Arapaho hide-scraper, circa 1870, elk horn with attached iron blade. Museum of the American West, Autry National Center; 88.241.1.

for women's arts. Even simpler objects, like the tools used to process hides, expressed women's pride and artistry. Each was as individual as its owner. The handles of scrapers and awls varied in size and shape, and women marked their handles to count and publicly display special achievements. When we see the awls and fleshers, saddles and blankets, displayed in today's museum cases, we can imagine them not as monotonously primitive, anonymous objects but instead as expressions of women's individual creativity and as cherished family heirlooms.[8]

The trade that flourished on the plains at the height of the power of the horse cultures offered women both peril and opportunity. Where they had once butchered meat and prepared hides with stone fleshers and scrapers, and cooked meals in baskets or ceramic pots that burned up or broke, Cheyenne and Arapaho women now traded for coveted European metal goods. Knives and kettles made their work far easier. They dickered for muslin to use as lining for their tipis, warm woolen blankets and trade cloth, glass beads and brass buttons. But just as important, indigenous women, like European and mestiza women who lived at the peripheries of the plains, were themselves coveted objects. The trade in captives was central to the thriving plains economy. Women's vulnerability, and the exposure of their children to captivity, was an ever-present reminder that their powers to create home amid the constant demands of horse-driven mobility might at any time be subjected to the most arduous and heartbreaking, even unbearable, ordeal.

OWL WOMAN AND WILLIAM BENT'S WORLD

Assuredly, for most women on and around the plains, new hazards and burdens abounded. But some managed to improve their lives and increase their status in a vola-

tile world marked by the movements and machinations of new players looking to claim resources through raid, trade, and social alliances. Native women often acted as central figures in cultural exchanges, as interpreters, diplomats, and wives. They played particularly crucial roles as intermediaries in the cross-cultural trade in furs and hides, which spread out across western North America in the early nineteenth century, catalyzing a new economic order and creating a new, hybrid social world. White Americans also perceived the frontier as both an economic and a racial borderland. In his image of the trapper's bride, first painted in 1841, the Baltimore artist Alfred Jacob Miller, who traveled west in 1837 as part of the retinue of the Scottish gentleman William Drummond Stewart, captured the potential and threat of the West in creating new types of families (plate 11). The image played on the peril and promise of the West, especially the idea of the frontier as a place of intimate contact between people of different races, and Miller would repaint the tableaux multiple times for Eastern audiences.[9]

The world created by the Cheyenne woman called Mis-stan-sta, or Owl Woman, and the American trader William Bent is perhaps the most famous emblem of that mobile, multicultural borderland society. In a period of competition among Plains tribes for guns, horses, and other trade goods, the Cheyennes sought to establish a reliable market for their hides, as well as strong ties to traders in American and European goods. Owl Woman was the eldest daughter of White Thunder, keeper of the tribe's sacred medicine arrows, and his wife, Tail Woman. Their family was among the leading Cheyenne lineages and at the center of ceremonial life.

The brothers Charles and William Bent, sons of a prominent St. Louis family and among the most successful traders to come out of Missouri, hoped to capitalize on the abundance of fur-bearing animals in the West. In 1824, the Bents began trading with Indians, intending to become the preeminent operators in the Santa Fe–Plains trade in furs and hides. The Bent brothers cultivated a friendship with Cheyenne leader Yellow Wolf. They were quick to see the usefulness of setting up business at long-popular points of trade. While his brother consolidated his power in Taos, William Bent and his partners established a trading post in what is now southeastern Colorado. A larger, fortified post, soon to be known simply as Bent's Fort, was built on the Arkansas River in 1833. Bent's Fort quickly became a hub of the Southwestern fur trade and the center of a far-flung, vibrant social and economic network.[10]

Marriage was the heart of fur trade diplomacy. In 1835, Owl Woman married William Bent, an alliance that formalized the increasingly important commercial and social relationship between the Cheyennes and the Bents. The wedding was both a social celebration and a political event. Bent's wife, Owl Woman, stood at the center of an expanding network of trade. As a woman raised to move fluidly among the worlds of the hybrid borderland, Owl Woman stood to gain advantages for herself and her Cheyenne kin. In turn, marrying Owl Woman provided William Bent with community membership and social power as he moved into the family circle. Their marriage cemented the foundation of peaceful trade among individuals who perpetually crossed cultural borders.

Accustomed as she was to the Cheyenne cycle of movement between winter and summer camps, Owl Woman expanded the compass of her journeys to spend at least part of her time at Bent's Fort. She assisted with the pack trains that came into the fort bearing everything from coffee, tea, wine, sugar, flour, and whiskey to calico and guns. In 1845, when Lieutenant James Abert stopped at Bent's Fort during his travels through Colorado and New Mexico, he sketched Mis-stan-sta in his notebook (figure 21). Abert noted that, although she was the mother of two children, she remained "a remarkably handsome woman." Like any high-ranking woman sitting for a formal portrait, Owl Woman wore what Abert called "her most handsome dress," clearly signaling her status through her gorgeously beaded ornaments, skillfully worked moccasins, and rich necklace. We can see her capacity to shuttle between and knit together seemingly disparate peoples as we envision her serving coffee and tea to guests at the fort in rooms furnished especially for her by her husband, posing for portraits, and sometimes sharing the lodges of her kin camped outside the fort.

Owl Woman and William Bent had four children, Mary, Robert, George, and Julia. Bent had a third son, Charles, with Yellow Woman, Owl Woman's younger sister, whom he brought into the household in the 1840s as a second wife, following Cheyenne custom. After Owl Woman became a mother, she and her children spent summers on the move with her own mother's family. Traveling with Tail Woman, their grandmother, the children learned Cheyenne ways and skills. In autumn and winter they returned periodically to Bent's Fort. When they were old enough, they were sent to white schools in St. Louis. The Bent children were raised to move among worlds even as the world around them was ever in motion.[11]

Envisioning Owl Woman's life in and out of Bent's Fort helps us imagine the high plains of the early nineteenth century not as wilderness but as a dynamic and busy meeting place. Visitors to Bent's Fort included French and German merchants, Missouri frontiersmen, Mexican servants, Indian and Mexican wives, African American slaves, and ultimately, American soldiers and Anglo-American women. Dinner at the fort might be served on Staffordshire china from England, and guests might expect to enjoy imported French wine. Imported peacocks amazed (and annoyed) residents and guests. Owl Woman and William Bent's son George Bent remembered winter balls at the fort where the "travelers present, the trappers, employees, Indian men, Indian women and Mexican women all took part." In this world, American merchants wore moccasins and buckskin, and Indian women wore dresses of calico or muslin, wool or silk, cut according to Eastern fashion. Alexander Barclay referred to the "babel-tongued multitude" of the fort, who spoke a mixture of French, Spanish, English, and Indian languages.[12] We know that William Bent spoke fluent Cheyenne and Arapaho. We might easily imagine Owl Woman conversing in English and Spanish.

Seeking a way to reach across ethnic diversity with respect and optimism, we look back on the fragile cosmopolitan world at Bent's Fort with some longing and a measure of regret. Owl Woman and William Bent came together in the West at a time when

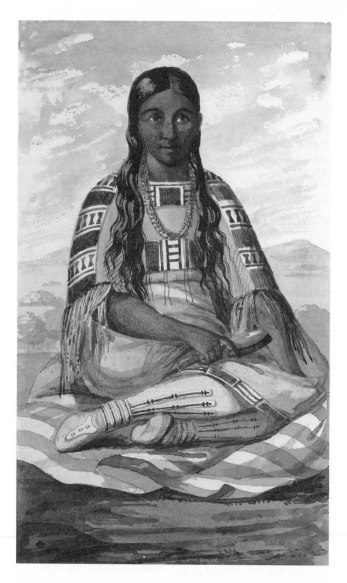

21 | Lieutenant James Abert, drawing of Mis-stan-star [*sic*], 1845. Yale Collection of American Literature, Beinecke Rare Book and Manuscript Library, Yale University.

many contended for power, none compelled obedience, and all were obliged to accommodate one another in the face of the ever-present risk of violent confrontation. The attempt to understand and cooperate with people unlike oneself was often enough a life-and-death matter.

The Bents' place as middlemen would soon be challenged by new forces. By the 1840s, the southern Cheyennes had come to depend on trade with Americans and other tribes for survival. The very success of trappers and traders doomed their livelihood, as beaver and bison populations declined in the face of unremitting slaughter. Time and trade pressed on inexorably; the more they succeeded as market hunters and traders, the less the Cheyennes could sustain their life on the plains.[13]

By the middle of the nineteenth century, a new wave of migrants entered the Indian country of the plains in search of a better life in the Oregon Territory or California. Others traveled the Santa Fe Trail, questing after commerce and, ultimately, conquest. By 1846, the United States Army would arrive at Bent's Fort on its way to war with Mexico and the occupation of what would become the American Southwest. Susan Shelby Magoffin, the pregnant teenage bride of trader Samuel Magoffin, came along with the troops, finding Bent's Fort a comfortable but mighty exotic place for a girl born and bred in Kentucky. Newly married when she made her honeymoon trip, Magoffin claimed fame as the first white American woman to travel down the Santa Fe Trail. Although her claim might be somewhat suspect, it's easy to see why she saw her trip as historic. American newspapers of the day were boasting of the country's "Manifest Destiny" to spread from Atlantic to Pacific, but Manifest Destiny was a projection, not a fact. To make it fact, American families had to claim, travel to, and live in long-inhabited places.[14]

William Bent provided a hospitable welcome to the Magoffins, offering a large room furnished with bed, chairs, and table, accommodations for their own servants (including Susan's enslaved African American maid, Jane), and even good well water with ice—but Susan found the company bizarre. While she waited for her room to be prepared, she sat in the parlor with the Mexican wives of traders Eugene Leitensdorfer and George Bent (William's brother), whom she referred to as "las senoritas." She was appalled at the sight of one of the women combing her hair with "a crock of oil or greese [sic] of some kind."[15] A newcomer to the hybrid world of the plains, Susan Magoffin failed to understand how much she had in common with the other women in the room. All were traders' wives, and each in turn had brought social status of her own to her marriage. Indeed, one of Susan's female companions in that room, Solidad Abreu Leitensdorfer, was the daughter of a governor of New Mexico.

But perhaps we can understand Susan Magoffin's disdain and discomfort in light of the fact that within the week she would both celebrate her eighteenth birthday and suffer a miscarriage, thousands of miles from home. Magoffin endured her ordeal at the very moment the U.S. Army was shipping out of Bent's Fort and a band of Arapahos "thought to be spies" came and went. In the room below her own, a scene was unfolding that testified to the everyday presence of women like Owl Woman in the midst of the

most turbulent and transformative times in Western history. To Magoffin's astonishment, an Indian woman "gave birth to a fine healthy baby, about the same time, and in half an hour after she went to the River and bathed herself and it, and this she has continued each day since. Never could I have believed such a thing, if I had not been here." Susan Magoffin, a fast learner, took a lesson from that unnamed indigenous woman inhabitant of the hybrid borderland: "It is truly astonishing," she wrote, "to see what customs will do. No doubt many ladies in civilized life are ruined by too-careful treatments during child-birth, for this custom of the hethen [sic] is not known to be disadvantageous, but it is a 'hethenish [sic] custom.'"[16]

The Magoffins moved on down the trail to Santa Fe, El Paso, and into Mexico. But their journey foreshadowed wave after wave of European and American migrants moving through, and into, the West. In 1851, seeking to ensure safe passage for overland travelers to California and Oregon, the United States government signed a treaty guaranteeing Indian land claims along the Front Range of the Rockies. But the government, in this instance as in many before and after, failed to honor its treaty obligations. When gold was discovered in 1858, American fortune seekers flooded into Arapaho and Cheyenne territory. In the spring of 1859, more than a hundred thousand people, mostly men, flocked to Colorado, spurred on by the bloated claims of booster writers and by their own get-rich-quick fever. The gold rush carved out a new transportation landscape of spreading Front Range mining camps linked to roads and migrants and investors back East.[17]

The West, it seemed, was becoming a great highway. New routes were ground into the plains with every revolution of the wagon wheels. Women packed up their household goods, climbed into wagons, and left loved ones behind. They had little choice but to follow their husbands and fathers to the next prospect, the next camp, the next boom. Ever industrious, they sewed tents and wagon sheets for their homes on wheels. Hopeful immigrants soon learned to calculate how far they had traveled and how far still to go by counting the number of revolutions of the wagon wheel each day and checking it against guidebooks.

Women's work never ended in transient homes, from the wagon to the boardinghouse, tent, or farmstead. Augusta Tabor's reminiscences offer a litany of daily labors. The lone woman of her party, she cooked and washed for her husband and the other men while caring for her sick baby. At Clear Creek, where her husband first tried his luck at prospecting, she was left alone to care for the cattle "for three long weary weeks" until the men returned and the party set off for Russell's Gulch. There, to bring in some cash, she set up an eating house, selling pies, bread, and milk from the cows she had carefully tended. In other camps, she took in boarders and weighed gold dust for miners. In mining camps where women (and their domestic skills) were scarce, a wife gave her husband a distinct business advantage. By the end of the season, Tabor said with satisfaction, "we had cleared $4000 from the diggings and my work."[18] Women like Augusta Tabor, moving and working from place to place, etched a new infrastructure of people and things, establishing tenuous but recognizable home bases in a landscape of men picking up and moving on.

22 | Wagon wheel odometer, circa 1850. Museum of the American West, Autry National Center; 89.82.1.

In the face of this human onslaught, there was no place for Plains Indian ponies to graze. Gold rushers' oxen and cattle gobbled the last feeble shoots of grass down to dirt, and what the cattle and oxen missed, the wheels of wagon trains crushed. Even the herds of bison that had once blanketed the plains dwindled to shadows of their former magnificence. Now came surveyors with rods and chains to divide the former winter campgrounds of the Arapahos into town sites. Despite the fact that the first child born in the new city of Denver was "the half-breed son of one McGaa and an Arapahoe mother," the uneasy peace between the Cheyenne and Arapaho peoples and the Americans soon shifted to open and often violent conflict.[19] New enterprises like ranching and farming and the trade with the ever-growing influx of emigrants soon replaced the fur trade business as the most important commerce of the plains. Cheyennes and Arapahos were losing control over the resources needed to sustain life along the Front Range. Owl Woman and William Bent's children would be forced to choose between their mother's and their father's worlds, their movements increasingly limited in a society that saw little value in the fluid, multiracial world created by their parents.

Owl Woman died in 1847, shortly after the birth of her daughter Julia. William Bent,

already married to Owl Woman's sister, Yellow Woman, would take yet another Indian bride. Bent worked hard to keep peace between Indians and emigrants, but his efforts would ultimately founder. The world that he and Owl Woman had helped to create was falling apart in the face of American conquerors prepared to advance their regime of white supremacy at all costs. William Bent abandoned Bent's Fort in 1849, although he continued to trade with his kin. In 1860 his oldest daughter, Mary, married rancher Robinson Moore in an extravagant St. Louis wedding ceremony and quietly passed into white society. Her brothers and sister moved between Cheyenne kin and their father's world.

In 1864, a band of Cheyennes, under Black Kettle, a peace chief, were forced by the territorial governor of Colorado to move to a winter camp on Sand Creek and told to await rations and further orders. Meanwhile, a politically ambitious Methodist minister, John Chivington, was elected colonel of the state's militia, the First Colorado Volunteers. Chivington determined to make his name as an Indian fighter by attacking Black Kettle's camp. He posted a guard on William Bent to prevent Bent from warning Black Kettle. He then forced Bent's son, Robert, to guide him to the Cheyenne camp, where Bent's other three children, Charles, Julia, and George, lay sleeping in the hours before dawn. Chivington's men slaughtered more than two hundred men, women, and children that morning, taking scalps that they displayed before elated mobs in Denver.

Miraculously, all of William Bent and Owl Woman's children survived the Sand Creek Massacre. Julia Bent married the mixed-blood army scout and interpreter Ed Guerrier, the son of a Bent's Fort trader and his Cheyenne wife. Like their ancestors, they too were pushed out of their homeland, to settle, finally, on the Cheyenne reservation in Oklahoma territory. Robert Bent risked his career as a U.S. army translator and guide by testifying against Chivington. Charles Bent became a member of the Cheyenne Dog Soldiers, one of the most militant of the warrior societies. George married the niece of Black Kettle, and he too eventually settled on reservation land. He worked with anthropologists to preserve the history of his family and people as the homeland of his parents was erased from the Front Range.

WESTWARD THE COURSE OF EMPIRE

Owl Woman and William Bent represent a hybrid social world in which people made their homes by moving around as much as by staying in place. On May 20, 1862, Congress passed the Homestead Act, enshrining a far different vision of home. In an effort to extend and consolidate American settlement of the continent, the government offered cheap public land to private citizens willing to erect a permanent home and improve the land over a period of five years. While the Homestead Act embodied a dream of equality and economic opportunity, it also represented the intention to settle one particular kind of family and unsettle many others.

If we think of American conquest as a shotgun aimed at the trans-Mississippi West, the weapon was loaded with families. Those families would ideally be sedentary, male-headed, monogamous, and agrarian. Amid the flux and flow of national expansion, middle-class white Americans elaborated a set of ideas about women and men intended to fix the sexes in their rightful places. Women who fulfilled their place in the natural and social worlds were expected to be sexually pure, religiously devout, submissive to male authority, and solidly committed to hearth and home. Men who acted according to nature's and God's plan were expected to provide for and protect the women and children entrusted to their care, to exercise firm but wise authority over their dependents, and insofar as possible, to restrain their carnal urges. Such ideas played out not only in American minds but also in American space.

In the West, this vision powered the federal push for neat, orderly, single-family homes. Only when men's rough-and-tumble taming of the wilderness joined with women's civilizing influence would the West truly be won. The artist and illustrator John Gast offered one of the West's iconic images, putting a blonde American woman at the center of his 1872 painting *American Progress* (plate 12). Dressed in flowing robes and wearing the star of empire, she floats above a prairie landscape with distant mountains, where migrants with wagons and oxen, a stagecoach, and a train push fleeing bison and Indians westward. The golden-haired symbol of conquest carries in one hand a schoolbook and in the other a telegraph wire. The painting succinctly portrayed European American women as symbols of knowledge, communication, progress, and not least, the moral authority of American Manifest Destiny.

The landscape envisioned in the Homestead Act became possible on a new scale when, little more than a month after that act passed, Congress passed the Pacific Railway Act to fund a transcontinental railroad across the Western frontier. John Evans, appointed territorial governor of the newly created Colorado territory, stood on the steps of Denver's Tremont House Hotel that year and declared in his inaugural speech that railroads would lay the cornerstone for a fertile and prosperous Colorado. It's hard to know if his wife, Margaret, initially shared his optimistic vision. Busy overseeing the packing and moving of their Evanston, Illinois, home while caring for an ill daughter, she arrived at the same hotel several months later to take up the job of making a home. Confronted with what was little more than a collection of shacks hastily erected in the wake of the Cherry Creek gold rush of 1859, she confessed to her diary her efforts to "quiet my uneasy mind and be content with circumstances."[20]

The completion of the transcontinental railroad in 1869 connected the West with the East in a technological triumph of male engineers, industrialists, and workers. Equally important, as historian Ann Hyde has explained, the railroad made the Western Plains "a region to be interpreted, developed, and settled, rather than just 'passed through.'" Observers pointed to the annihilation of time and distance that followed in the wake of the railroad, but new technology also produced a new physical, social, and gendered

landscape.[21] Western boosters like John Evans saw the potential of the railroad to transform the plains into a domesticated landscape of homes laid out in neat grids of cities and streets. Throughout the West, the federal government subsidized railroad building by granting hundreds of thousands of acres of public land to railroad companies, which in turn sold the land to farmers and town builders.

The railroad would bring many more women like Margaret Evans and Augusta Tabor, charged with the task of tempering the unstable world of mining men and replacing rowdy boomers with settled families. Railway companies, their profits depending on passenger and freight traffic, created bureaus of immigration and land departments to advertise homes in the West. Men enticed by the promise of railroad jobs, or by railroad advertisements hyping cheap land, uprooted their families and headed west. In the 1880s, railroads fueled a land rush to the plains and cattle range surrounding Denver. To S. S. Worley, a Colorado claim locator, "it seemed as though anybody wanting a home was coming West. Every train from the east to Denver Junction brought would-be homesteaders."[22]

Within twenty years of the completion of the first transcontinental railroad, a network of rail lines spanned the continent. Railroads linked scattered Rocky Mountain settlements and mining camps to Denver and encouraged investment in the region. People and goods traveled farther and faster. An overland journey that had once taken four to six months could now be made in just a few days. Women and men alike were captivated by the speed and thrill of the railroad, and they enthusiastically embraced this new means of travel. Some women used their new mobility in unexpected ways, setting out for Western boom-towns and far-flung communities that were desperately in need of teachers and workers. Some single women claimed land under the Homestead Act and took up farming and ranching on the Great Plains. These women stretched the boundaries of their lives while affirming women's duty to domesticate the Western wilderness.

Women seized the power of the transportation revolution to press for their rights and pursue their own ambitions. The railroad, like the horse before it, inspired women and men to reimagine themselves. Lecturer and women's rights advocate Anna Dickinson crossed the Rocky Mountains by train in 1869, the year the transcontinental railroad was completed. Dickinson reveled in the experience, writing in the language of her Quaker upbringing that, "if thou hast ever breathed the elixir of this air, and felt nerve and blood thrill within thee, thou wilt long for it, many and many a time thereafter."[23] Susan B. Anthony and other women's rights advocates repeatedly barnstormed the West by train, and their efforts contributed to women's winning the right to vote in Western states and territories. Anthony spent three weeks in Colorado in 1877 campaigning for a woman suffrage referendum placed before the territory's male voters. Colorado women exploited the new rail lines to carry the debate on the referendum across the territory. Local activist Mary Shields traveled along small rail spurs to remote mining camps to hold debates on the "woman question," speechifying to Cornish and Spanish miners via translators. During the same campaign, Margaret Campbell traveled more than 1,250 miles, acknowledging that "basically the only way to contact voters in this isolated region

To WESTERN EMIGRANTS.

Having been appointed Ticket Agent of the OHIO & MISSISSIPPI RAILWAY, and all connecting lines North-west, West and South-west, I am fully prepared to make contracts for families and household goods or stock to any railroad point in

Missouri, Kansas, Nebraska, Colorado, California, Arkansas and Texas,

At the Lowest Rates!

Being the agent of all the connecting lines, I can give you choice of routes, and will check your baggage from Cincinnati

THROUGH TO DESTINATION, FREE!

Bear in mind the fact, the Ohio & Mississippi is the Only Line that runs its entire trains through from CINCINNATI to ST. LOUIS with

NO MIDNIGHT CHANGES!

I am on every Steamboat on its arrival at Cincinnati; when you come, do not leave the boat until you see me, and it will be to your interest.

Having been employed on different boats running from Cincinnati to various up river points for fifteen years past, I trust I have the confidence of the Steamboatmen, Wharf Masters and business men generally, and would respectfully refer you them.

Maps, Railroad Time Tables, Land Circulars containing description of Lands, Soil, Climate, Productions, Prices, Etc., on hand and furnished Free.

Office, corner Steamboat Landing and Sycamore Street.

Please call on or address,

Yours Truly,

MAPS, GUIDES, LAND CIRCULARS. Railroad Fare, Time Tables, Freight Rates, and FULL INFORMATION FREE. ENCLOSE STAMP FOR REPLY, CALL ON OR ADDRESS HENRY H. HANNAN, LAND AGENT. SWAN CREEK, OHIO.

GEO. A. KNIGHT,
Ticket Agent, OHIO & MISSISSIPPI RAILWAY,
No. 21 Public Landing, CINCINNATI, O.

Please POST UP, or hand to your Neighbor about to Emigrate.

23 | Letter "To Western Emigrants," circa 1870, printed by George Knight, agent of the Ohio and Mississippi Railway. Museum of the American West, Autry National Center; 90.244.37.

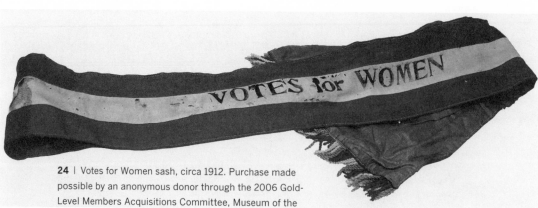

24 | Votes for Women sash, circa 1912. Purchase made possible by an anonymous donor through the 2006 Gold-Level Members Acquisitions Committee, Museum of the American West, Autry National Center; 2006.25.1.

was to get out and find them."[24] Suffragists lost that round, but rapid mobility became an emblem of women's emancipation. In 1889, sensation-seeking reporter Nelly Bly made headlines speeding across the United States in a special train in her attempt to circumnavigate the world in less than eighty days.

WOMEN IN THE QUEEN CITY OF THE PLAINS

By 1890, the city of Denver stood at the heart of a new geography stretching east to Chicago and south to the Rio Grande, fed by an arterial system of rail lines including the Denver Pacific; Kansas Pacific; Atchison, Topeka & Santa Fe; and Denver & Rio Grande railroads. Unlike the horse, which tended to disperse people across the plains and to keep people moving, railroad transportation concentrated settlement and linked the agricultural hinterland with cities in straight, efficient iron lines. New towns, built swiftly and often with little planning, flourished or failed according to their ability to hitch themselves to railroad lines.[25]

Railroads fueled growth and brought thousands of working-class job-seekers to places like Denver, Colorado Springs, Leadville, and Cripple Creek, catalyzing a new, domestic landscape of ethnically diverse industrial towns and cities. After the completion of the transcontinental line in Utah, hundreds of Chinese men headed to Colorado, where they settled in the Cherry Creek district northwest of downtown Denver. In 1881, the Denver & Rio Grande recruited Italian immigrant men to fill jobs in the rail yards, smelters, and factories. The Union Pacific hired African American men to lay track, labor in the company's Denver shops, and serve as porters. In 1900, Denver's population had grown to include twenty-five thousand foreign-born residents, mainly Irish and German immigrants.[26]

Along with the industrial growth and prosperity came new inequalities and problems. Communities learned to live with the noise, the smell, and the danger that ac-

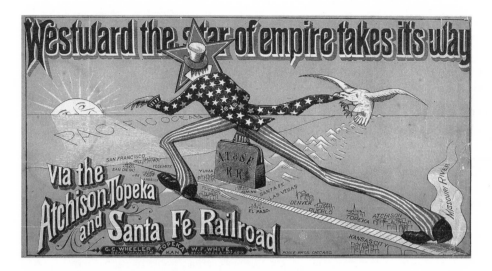

25 | *Westward the Star of Empire Takes Its Way (via the Atchison, Topeka and Santa Fe Railroad),* lithographic poster printed by Poole Bros., Chicago, Illinois, circa 1859–1890. Rosenstock Collection, Autry Library, Institute for the Study of the American West, Autry National Center; 90.253.110.

companied the railroad's intrusion into everyday life. Families now found themselves living on the right or wrong side of the tracks.[27] In Denver, poorer workers were crowded into slums alongside the rail yards and factories strung out along the Platte River, an area known locally as "the Bottoms." Industrial suburbs grew up around the major smelters Argo, Swansea, and Globeville, giving the neighborhoods their names. Resourceful immigrants scavenged secondhand lumber from rail yards to build their houses, opened small businesses, founded social and mutual-benefit societies, and planted gardens, like those of the Italian immigrant families who grew vegetables along the South Platte River, selling produce to Denver consumers to supplement their wages. Local artist Henrietta Bromwell captured this emerging urban landscape of railroad bridges, smokestacks, and factories, the place the newest migrants called home. Living with her father at 117 Eighth Street, near the South Platte River and the Bottoms area, Bromwell applied to Denver's grittier landscapes the same plein air approach she used to paint Rocky Mountain scenes (plate 13).

Even as Denver's boosters promoted the city as a resort for health seekers, Denver's working-class residents paid the price of the industrial boom. The sights, sounds, and odors of the railroad industry permeated the everyday life of Denver's citizens. The smelters sent a steady stream of smoke and pollution into the air. In 1898, a *Denver Times* reporter wrote that, "throughout the day, the chimneys of the big office buildings and the factories pour out tremendous clouds of impenetrable and offensive black

smoke, which rapidly spread their inky filth over the business blocks, sift through the windows of offices and smut the faces of pedestrians." Residents of Front Range mining towns, lacking even minimal city services, faced even grimmer conditions. In Leadville, citizens complained of garbage left along the streets, smelters poisoning the city's water supply, and the high rate of infant mortality.[28]

The city of Denver struggled to cope with the environmental challenges. City health officials saw new immigrant neighborhoods as centers of contagion spread by crowded conditions and ignorance. A report on the housing problem in Denver by the Social Service Department of the University of Denver School of Theology found the land along the Platte River and Cherry Creek "subject to overflow by river water [and problems with] drainage, sewer, garbage disposal and the like. In many instances, the garbage is simply thrown out. . . . One fourth of the privy vaults were full or nearly so, and in 21 instances, the contents leached into the soil."[29] Typhoid, tuberculosis, diphtheria, and scarlet fever ran rampant among Denver's urban poor. In 1907, Denver police destroyed thousands of tent houses lining the Bottoms, following a scathing report published by the *Journal of the American Medical Association*. An anonymous resident of Denver's Bottoms in 1890 simply and starkly stated, "Children be dyin' down 'ere all the time."[30]

Women of every class, race, and ethnic group moved to establish volunteer organizations to tackle health problems and establish community services. As early as 1860, Elizabeth Byers, wife of Denver newspaper editor William Byers, had founded the Ladies Union Aid Society to offer assistance to Denver's ill and homeless. In 1882, the Catholic Sisters of Charity established St. Vincent's Catholic Orphanage, which soon housed more than one thousand children. Clubwomen organized community gardens. Frances Wisebart Jacobs, who had moved to Colorado from Kentucky in 1863, galvanized charitable endeavors in the Jewish community and beyond. By 1887, she headed an interdenominational consortium of charities that became first the Community Chest and eventually the United Way. Denver's Jewish women also spearheaded the campaign that culminated in the 1899 opening of Denver's National Jewish Hospital, an institution with the motto "None may enter who can pay, and none can pay who enter." By the end of the century, Denver women had also established a day nursery in the Bottoms to care for children of working mothers, one more enterprise in a social service infrastructure that ran almost entirely on volunteer woman power.[31]

Women took their fight for reform and relief to the streets in response to tough choices about where to live, shop, and do business, how to get to work, and how to care for children. They shaped an urban geography of distinctive neighborhoods in counterpoint to the rapid urbanization and industrialization of Western "instant cities." While real estate agents, businessmen, and railroad agents hawked the benefits of the Queen City of the Plains, women's clubs and community organizers went about the business of laying the foundation for urban growth, all the while seeking to improve the quality of life in their communities.

FIVE POINTS

Denver entrepreneurs rushed to cash in on Americans' desire for home sweet home by buying up tracts of rural land near cities. They built transit lines—first horsecars, then trolleys, and ultimately roads for motorcars—to connect new developments with the central city. John Evans and William Byers, who had successfully fought to bring a railroad to Denver, invested in the Denver Tramway Company in 1886, and soon Denver could boast of one of the most extensive cable car networks in the country. Trolley lines, like the railroad, stood as a symbol of urban pride and progress. Inexpensive to build, with low fares and frequent passenger service, the trolleys were considered by many to be the "people's railway." In his *History of Denver,* published in 1901, Jerome Smiley wrote that, "with the exception of the steam railways, it would seem that no institution has done so much for the upbuilding of Denver as the street railway system. [It] has enabled men of moderate means to acquire homes for themselves in pleasant places away from the business center, instead of being housed tier upon tier in congested localities as so many have to be in other cities."[32] In 1890 more than two thousand homeowners' built along Denver's newly laid tramway tracks.[33]

In Five Points, one of Denver's first subdivisions, residential and commercial growth followed the tramway tracks first laid in 1871. In the Curtis Park area of Five Points, elaborate homes offered a peaceful and fashionable retreat for those who could afford it. Well-to-do city residents embraced the single-family, detached suburban house, subdividing space according to the ideal of the sheltered woman homemaker and the peripatetic male homeowner and breadwinner. Developers also marketed lots in Five Points to working families, many of whom built their own homes. The neighborhood's middle-class residents favored simple "foursquare" homes laid out in an efficient but roomy two-story box arrangement, with four rooms downstairs and three bedrooms and a bath upstairs. A popular vernacular style, foursquare homes were cheap to build and made the most of small city lots. Plans sold for as little as twelve dollars, and the house could be ordered as a mail-order kit and shipped by rail for as little as one thousand to two thousand dollars.[34]

Although the trolley cars provided workers with quick access to the factories and rail yards near the Platte River, the separation of work and home was never fully achieved in Five Points. Restaurants, music clubs, factories, and small shops stood side by side with detached family homes. Inside their homes, women took in laundry, cultivated kitchen gardens, and set up businesses.

In the years immediately following the Civil War, trolleys and railroads powered Americans' unprecedented ability and desire to move. Between 1870 and 1890, Denver was the fastest-growing city in the nation.[35] The Five Points area attracted a mix of working- and middle-class German, Jewish, African American, and Irish residents. The first Five Points school, which opened in 1879 at Twenty-fourth and Market Streets, at one time attracted students representing thirty-seven different nationalities. By 1905,

Map 4 | *Map of the City of Denver to Accompany the Annual Report of the City Engineer of Denver, Colo., 1890.* Rosenstock Collection, Autry Library, Institute for the Study of the American West, Autry National Center; 90.253.4154.

26 | Students at Gilpin High School, Five Points, 1894, photographer unknown. Denver Public Library, Western History Collection, X-28437.

residents had established within four blocks of each other the First German Methodist Church, Sacred Heart and Trinity Catholic churches, Temple Emanuel and People's Tabernacle, Scandinavian Lutheran Church, and Zion Baptist Church.[36] While some upwardly mobile residents moved on to newly fashionable neighborhoods like Capitol Hill in the 1890s, others stayed and put down roots.

The men and women of Five Points used the opportunities offered by the railroad to transform themselves from migrants to city residents. African Americans leaving the South, and immigrants fleeing poverty and repression in Europe, took advantage of the transportation revolution to seek better lives. Denver's pioneer African American families were part of the larger exodus of Southern blacks escaping rising racial violence, Jim Crow laws, and political disenfranchisement. Railroads offered both the means and the motive for their movement. African American railroad workers, especially Pullman porters, built an extensive information network about jobs, safe routes, and housing that linked rural, Southern black communities with cities in the North and West.[37]

Railroads provided African Americans both new mobility in post-Reconstruction America and new challenges. For black women, traveling by train or even by trolley could prove a test of their respectability and equality. Activist Mary Church Terrell admitted that "there are few ordeals more nerve racking than the one which confronts a colored woman when she tries to secure a Pullman reservation in the South and even some parts in the North."[38] Railways commonly separated passengers by race and class, and a black woman could find herself forced to take a seat in the baggage or smoking car even when she had purchased a first-class ticket. In response to such affronts, black women used mobility to challenge racial segregation on public transportation and denial of access to public places. They courted arrest by refusing to give up their seats to white customers, making a public statement of their right to free and unrestricted movement.[39]

But even as African Americans asserted their right to move, they also claimed the right to settle. The *Denver Republican* described the city's black population as one of the most prosperous in the nation, while the *Denver Times* claimed that "here the colored man and woman have equal rights with their white neighbors. The schools are mixed, the churches liberal, and all the people are progressive."[40] Booster newspapers specialized in hyperbole, but nevertheless, Denver's African American community included a distinctively high number of homeowners. One-third of Denver's African Americans were homeowners, a rate five times higher than for African Americans in New York.[41] Black women founded and staffed churches and established benevolent and social volunteer groups. Women like Ida DePriest and Elizabeth Ensley founded the Colored Women's Republican Club and participated in creating the multiracial Equal Suffrage Association in 1881. A few years later, when a Denver hotel denied African Americans access to public accommodation, the Colored Ladies Legal Rights Association fought and won their civil rights case.[42]

But as the turn of the century approached, American cities began to further segregate by race and ethnicity, first according to custom, and increasingly by legal mandate. By 1890, the year that the United States Supreme Court affirmed the principle of "separate but equal" in *Plessy v. Ferguson*, Euro-American families had begun to leave Five Points, and the neighborhood became more and more the heart of the African American community. Still, Five Points residents made what they could of their narrowing choices. Women owned stores as well as dressmaking, catering, insurance, and loan businesses, and they worked in politics and mining. One local businesswoman, Sarah Breedlove "Madame C. J." Walker, founded a hair products business in Five Points that made her the first African American woman millionaire in American history. Combating racist attitudes, economic and social discrimination, and restricted opportunities, Denver's black women worked as hard to build community as they did to support their families.

Dr. Justina Ford joined Denver's Five Points community in 1902. Born in Illinois in 1871, Justina Warren married the Reverend John Ford in 1892 and moved with him to

Chicago, where she enrolled in Herring Medical School. Although her mother was a nurse, it was still a rarity for women to enter the medical profession. At Herring, Ford trained in gynecology, obstetrics, and pediatrics, among the very few advanced medical specialties open to women. Ford earned her degree in 1899, and sometime after 1900 she and her husband moved from their Chicago boardinghouse to Normal, Alabama, where she accepted a physician's post at a state school. In an interview published in the *Negro Digest* in 1950, Ford hinted at the frustration she must have faced in the South. While proudly claiming her position as the first black woman to practice medicine in Alabama, she admitted the desire to go somewhere "where a Negro might play a fuller part in community life. . . . Denver looked like the place."[43]

After Ford and her husband moved to Denver, she became the first African American woman to be licensed as a medical doctor in the state of Colorado. In the Five Points neighborhood, Dr. Ford established a thriving obstetrics and gynecology practice, eventually delivering more than seven thousand babies. But like other black women in the West, Ford battled the double burden of racism and sexism. Barred from practicing in Denver's city hospitals or joining the Colorado Medical Society, she housed her practice in her Five Points home at 2335 Arapahoe Street.

In her front parlor, Dr. Ford set up her desk, bookcase, instruments, medicine cabinet, patient's chair, and examining table. Traveling by tram, cab, and automobile, she made house calls to hard-pressed patients, mostly African Americans and immigrants who would otherwise have lacked medical care, let alone access to hospitals. During her fifty years of medical practice, Dr. Ford championed the right of African American and immigrant poor people to health care. Many of the immigrants who knocked on Ford's door could not afford hospital care, and others simply didn't trust most doctors. She taught herself the rudiments of eight different languages, including German, Italian, Spanish, and Greek, so that she could prescribe and write instructions in her patients' native languages. Her patients returned her loyalty. Zephra Grant, a Greek immigrant, remembered coming to Ford's home as a child to be treated for asthma. Dr. Ford had helped deliver him in 1911, and she would also help Zephra's wife deliver a healthy daughter decades later.[44]

Justina Ford traversed an urban landscape that held the possibility of multicultural community precisely because women like her created contact and cooperation as they moved from place to place. Because of such women, Five Points remained an economically and racially mixed neighborhood until the 1920s. But Ford's path, toward American community across racial and ethnic boundaries, would prove to be a road not taken in Denver. Native-born Anglos and European immigrants, anxious to cement their claims to the privilege of whiteness, began to insist more and more on segregated cities, in which white neighborhoods guarded by restrictive real estate covenants, and in some instances by walls and gates, guaranteed racial separation. Increasingly, Denver's African Americans were forced into the Five Points neighborhood out of necessity, rather than by choice, while whites fled to the suburbs.

27 | Dr. Justina Ford with baby, date and photographer unknown. Denver Public Library, Western History Collection, Z-8947.

Railways made urban community possible and brought people together in dense neighborhoods along the lines. At the same time, trolleys let people disperse. Soon, another transportation revolution would set Americans in motion again, galvanizing movement in every direction and reshaping American cities once again. From the moment the motorcar hurtled onto the American scene, its potential to transform American life was clear. But the theater in which the drama of the car culture would be played was, at the dawn of the motor age, already gendered space. American ways of automobility and the American construct of gender sometimes meshed and sometimes collided, but the volatile combination of these forces has done much to produce the places where we live, work, and move today, including the metropolis of Denver.

NEW VISTAS

As the new century dawned, American cities boomed. But in the heart of those cities, neighborhoods like Five Points were perceived as places of dirt and danger. More and more, white middle-class Americans identified city life with crowding and pollution, with the hordes of opportunity-seeking immigrants from southern Europe and African American migrants from the South, and with labor unrest, crime, and corruption. They sought a place of refuge, clean and quiet, segregated from "undesirable" persons and impure influences. Now the tramway lines became vectors of separation, sequestering residential space from civic, commercial, and industrial space and relocating the designated domain of women far from men's myriad places of action.

At the behest of Denver mayor Robert Speer, architects and planners (including the celebrated Frederick Law Olmstead) gathered together to guide the city's growth. Advocates of the "City Beautiful" movement spent millions of dollars in Denver to create the monumental Civic Plaza near the state capitol building, which would serve as both home to and the emblem of cultural activities and institutions. They razed homes to build parks, planted trees, buried telegraph and telephone lines, and erected public promenades. The waters of Cherry Creek, which had become an open sewer, were diverted and its banks transformed into a boulevard. City planners mapped out a rational hierarchy of streets and boulevards intended to improve transportation flow through the city. Architectural order, it was hoped, would impose moral order on the city's inhabitants.[45] Penny postcards, newly popular in the wake of the 1893 World Columbian Exposition, promoted Denver's vision of neatly ordered cityscapes to residents and tourists.

Elite women like Anne Evans, the daughter of territorial governor and railroad magnate John Evans, played crucial roles in Denver's City Beautiful Movement. When Anne died in 1941, the *Denver Post* described her as an "empire builder in architecture."[46] Sent as a teenage girl to be educated in New York and Paris, Evans returned to her hometown to make the cultural improvement of Denver her lifelong mission, drawing on a family fortune amassed through investment in railroads and tramways. Working with Mayor Speer, Anne Evans wielded the tools of government power and institution building. She

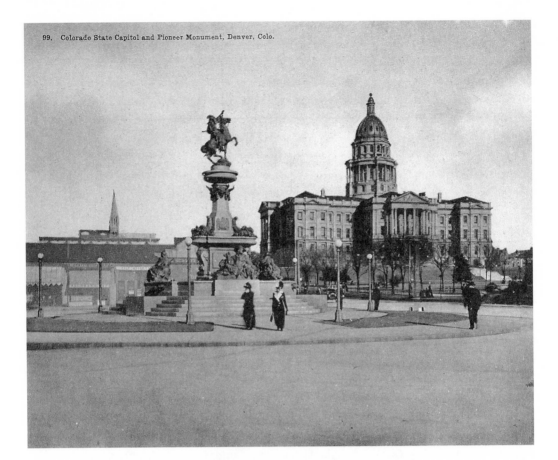

99. Colorado State Capitol and Pioneer Monument, Denver, Colo.

28 | "Colorado State Capitol and Pioneer Monument, Denver, Colo.," circa
1913, postcard. Rosenstock Collection, Autry Library, Institute for the Study
of the American West, Autry National Center; 90.253.1717.1.

headed the mayor's art commission, which promoted a new civic center, and was the
first woman to be appointed to the city's planning board. She was a founding member
and benefactor of the Denver Artists Club, which grew into the Denver Art Museum.
Passionately interested in Denver's past, she promoted regional preservation movements
and the Western History Department of the Denver Public Library. Evans helped bring
the middle-class ideal of home as a moral and peaceful haven into the reform of Den-
ver's urban landscape. Even as she invoked domestic imagery, Evans personified the
growing number of women moving into public life.

As family members, entrepreneurs, laborers, clerks, professionals, and consumers,
women moved through the city in ways that challenged the neat vision of City Beautiful
planners. By 1900, women made up more than 20 percent of Denver's employed work-
force, and Colorado legislators, concerned about inadequate wages and the unsanitary
conditions in which many of these women worked, passed minimum wage laws. Married

women of all ages played an increasing part in Denver's workforce. Poorly trained, many with children under the age of sixteen, they depended on the wages they brought in.[47]

But despite their vulnerable position in the workforce, women workers joined their male counterparts in the public outcry when the Denver Tramway Company sought to raise trolley fares from a nickel to seven cents. The economic challenges of funding public transportation were thorny, to say the least: voters, many of whom depended on the trolleys to get to work, continued to reject any increase in fare, leading to massive layoffs of tramway workers. The politics of work and mobility soon turned ugly; in August 1920, more than a thousand tram employees struck, turning Denver's urban core into an armed camp of men as the corporation brought in strikebreakers and workers blocked intersections and destroyed trolley cars. Riots ended only when the government intervened with troops.[48]

The Denver tramway strike symbolized both the urban disorder that Progressive reformers like Evans sought to alleviate and an urban geography in which transportation and opportunity had become closely linked. The strike failed in no small part because Denverites, like all Americans, were embracing a new and expanding mobility, private and personal, literally off the rails: the automobile. A new "Denver Plan" of 1929, guided by the landscape architect Saco Reink DeBoer, merged the aesthetics of the City Beautiful campaign with the enthusiasm for the motorcar. This plan embraced a gendered and class-divided vision of who would live and move where in the city of the future. The Denver Plan sketched out a new geography that emphasized bypass routes, radial feeder streets, diagonal highways, and wider boulevards. Planners also demonstrated their willingness to demolish the existing infrastructure, as they recommended removing the streetcar system, which they viewed as an obstacle to faster-moving automobile traffic. They expected Denver to grow rapidly, especially at its outer edges, and assumed that the auto would provide Denverites with their main means of mobility between home, work, shopping, and civic life.[49]

The Western urban landscape we have come to take for granted—the sprawling bedroom communities and leisure and business nodes so familiar to city dwellers today— might have come into being without the automobile. But it is hard to imagine how. Families across the nation were buying cars by the millions, and the new cities of the American West would grow up as physical manifestations of the nation's passion for the automobile. No sooner had Americans begun to buy cars in substantial numbers than government planners and private developers moved to design their cities with mobile families in mind. Planners' visions spread far beyond the central city to encompass a future metropolis of suburb-dwelling drivers.

Auto magnate Henry Ford scoffed at the idea of the woman driver ("We're not in the millinery business," Ford famously said), but from the very beginning of the automotive age, women drove, and in ever-increasing numbers. Indeed, the woman driver would become the emblem of American consumer culture, and Western places continued to symbolize freedom of movement. Automobile advertising featured striking images of

A TUNNEL VISTA, CORLEY MOUNTAIN HIGHWAY

THE PIKES PEAK REGION

PHOTOGRAPHS BY LAURA GILPIN

29 | Laura Gilpin, *Pikes Peak Region: Reproductions from a Series of Photographs*, 1926, brochure. Rosenstock Collection, Autry Library, Institute for the Study of the American West, Autry National Center; 90.253.10192.

women driving on behalf of family, in pursuit of fun, and for personal exploration, in cars that offered various combinations of practicality, adventure, and luxury, from the humdrum but sturdy Model T to the sumptuous Cadillac. "Somewhere West of Laramie," said a famous advertisement for the sporty Jordan Playboy, "there's a broncho-busting, steer-roping girl who knows what I'm talking about . . . eleven hundred pounds of steel and action . . . the Jordan Playboy was built for her. . . . She loves the cross of the wild and the tame."[50]

Denver citizens capitalized on the auto-touring craze. Businessmen organized the Colorado Auto Club in 1902 and the Colorado Highway Commission in 1909. Soon Denver had become a leader in cultivating the auto traveler with inexpensive motor courts and trailer parks.[51] Auto tourism offered new vistas for women as well as men, and soon they were discovering the wide-open spaces of the West through the windshield.

In Colorado Springs, photographer Laura Gilpin launched her career in 1917 by promoting Western landscapes to tourists behind the wheel. Born in Colorado, Gilpin had recently returned from studying at the New York School of Photography established by the Photo-Secessionist Clarence White, and she resolved to open her own commercial studio. *The Pikes Peak Region*, a fifteen-page brochure written, designed, and illustrated by Gilpin, would be her first major venture (figure 29). The Pikes Peak Automobile Road opened in 1916, and Gilpin's photographs depicted both the region's history and its scenic vistas for tourists. Selling the brochure for a dollar, Gilpin sought to capitalize on the potential profit, promoting Front Range landscapes to the thousands of new tourists "discovering" the West.[52]

For women living in Front Range cities, the automobile offered both the lure of the open road and the burdens of the chauffeur's job, authority and service, choice and responsibility. In the second half of the twentieth century, as American cities began to spread and sprawl, women motorists became crucial cogs in the ubiquitous yet oddly invisible private transportation system that held American families and communities together. In taking the wheel, "the middle-class housewife roamed farther from home, but home was always within range."[53]

LANDSCAPES OF PRIVACY: THE SUBURB AND THE CUL-DE-SAC

Boulder artist Eve Drewelowe began painting Rocky Mountain landscapes in the 1940s, at the height of World War II. Her 1943 painting *Drifts at the Divide* (plate 14) captured a landscape that trembled with the first road across the Continental Divide and faded into the cul-de-sacs of the American suburb. Unlike Gilpin's photographs from the early years of the motor age, Drewelowe's paintings express unease rather than emancipation. The houses in her paintings appear barely attached to the earth, while the man-made clearings create a note of tension within the pulsating mountain landscape. Late in her life Drewelowe would write, "I cannot but marvel at the wondrous indefinable land of

the Rockies that is Colorado, that is the West! I am dismayed, appalled at the deprivation called 'progress.' Much of the fragile terrain has been layered by acres of asphalt for the convenience of an automobile age."[54]

World War II and the Cold War transformed the face of the West. Wartime restrictions on construction gave way to new federal incentives for home builders, from the G.I. bill to federally insured housing loans. In 1956, the passage of the National Defense Highway Act ushered in an orgy of road building. The federally funded interstate highway system paved the path to suburban sprawl, catalyzing a landscape in which private vehicles provided the link between women's sphere of sequestered spaces and the male world of public endeavor. It may seem ironic that a federal program so devoted to the preservation of the privacy of male-headed, middle-class households was also the largest public works program in American history. But that seeming irony alerts us to the power of separate-spheres ideology as a source of public policy in the twentieth century and beyond.

In Denver, the war had reshaped the economy and landscape and ushered in a new era of mobility. The U.S. government established military installations across the Front Range, including Fort Larson, the Air Force Academy, the Lowry Field training facility and bombing range, the Rocky Mountain Arsenal, and the Rocky Flats Nuclear Weapons Plant. The influx of workers for all these facilities spurred a suburban building boom.[55] The postwar American dream fueled demand for natural resources, from cheap gasoline for cars to free-flowing water for the expanding suburban belt. Cold war jobs drew young families to the Front Range and into new identities. Historian María E. Montóya remembers moving with her family to Arvada, a new suburb on Denver's northwest side, when her father got a job at the Rocky Flats defense plant: "It turned my mother into a suburban car driver," she remembered, "a role which she never intended for herself, but one which she now embraces daily as she heads east from her home in the suburbs to her job in downtown Denver."[56]

The war also transformed Indian country. Congress encouraged thousands of Native Americans to pack up their cars or buy bus tickets and move from rural reservations to urban centers in the West. The defense economy had created opportunities for those willing to travel off the reservation, and nearly half of working-age Indian men and one-fifth of the women left Indian land for war-related work. Starting in 1947, the Bureau of Indian Affairs sponsored the vocational training and relocation of Navajo and Hopi people, mostly men, for jobs in Denver, Salt Lake City, and Los Angeles. Navajo women who took jobs in the expanding postwar service and clerical industries found that the move to the city separated home and work in new ways, disrupting families but also providing for new autonomy and control over their wages and lifestyles. In a reversal of the reservation-era policies that had led to a steady decline in the standard of living and to rural poverty, the bureau attempted assimilation through urbanization. Government officials would continue to push Native people from the Southwest and Plains into Denver throughout the 1950s and 1960s.[57]

The automobile provided the means to navigate the distance between the reservation

and the city, facilitating the creation of intertribal and pan-Indian identities. Historian Philip Deloria has emphasized how, for Native people, automobiles served both tradition and modernity on the plains, where "cars easily served as mobile housing reprising the older functions of both horse and tipi." The car enabled frequent visits and gatherings that maintained family and tribal identities, and it established ties among people who moved between the city and the reservation.[58] But even as government officials urged Indian workers into city centers, Denver planners and boosters propelled people outward.

Developer Edward B. Hawkins and architect Eugene Sternberg joined together in 1949 to offer Denver-area residents a vision of contemporary living in a place that invoked the region's previous inhabitants and majestic setting, even as it paved over the last traces of the wide-open buffalo grasslands: the new suburb of Arapahoe Acres, located at the southern edge of Denver in soon-to-be-booming Arapahoe County. A collaboration between architect and developer, Arapahoe Acres was designed to combine style, efficiency, and affordability. Developments from Arapahoe Acres to Levittown also placed new emphasis on privacy and motherhood.

The floor plans of the original 124 homes in the Arapahoe Acres development emphasized natural views of the mountains, safety, and privacy. Sternberg designed a curving street plan of feeder streets and cul-de-sacs in order to reduce traffic speed and discourage through-traffic. The plan was radical for its time and not without problems. Whereas those who embraced the landscape of separate spheres believed that privacy ensured safety, the Englewood Fire Department, concerned about the difficulties of putting out fires on streets deliberately designed to impede access, resisted giving its approval to the plan. But in contests between privacy and community, privacy generally won. In Arapahoe Acres, houses were situated at an angle to the street, and alleys were eliminated. With deliveries and garbage pickups redirected to the front, families could enjoy nature in the privacy of their backyards. Inside, open floor plans combined multiuse living spaces with views of the outdoors. Kitchen, dining room, and play areas flowed into each other, creating a "virtual command post" for mother.[59] Developers also promoted the burgeoning array of machines—refrigerators, dishwashers, stoves, washers, and dryers—that historian Ruth Schwartz Cowan has identified as an "industrial revolution in the household."[60] With the aid of the latest in devices, promoters and consumers believed, any housewife could get more domestic work done in less time, with ease.

The opening of Arapahoe Acres was announced with splashy publicity in March 1950. Articles featuring the development appeared in *Life* magazine and *House and Home*. *Better Homes and Gardens* offered Arapahoe Acres house plans for sale at a cost of twenty-five dollars. Four thousand people attended the opening, despite a Rocky Mountain snowstorm, and prospective buyers were subjected to sales pitches for everything from furniture to washing machines. Promoters asked visitors to take a survey about preferences as part of "scientific housing research."[61] But at the very moment the promoters were trumpeting the virtues of the landscape of separate spheres and suburban sequestration, it was equally clear that the women who anchored this vision of the good life

would have to move around once families had settled in. Among those hawking their wares to potential homeowners was the Englewood Ford dealer, who offered free test drives to all visitors.

The geography of the bedroom community, far from making driving unnecessary for women, instead compelled them to take the wheel. As historian Dolores Hayden has argued, "If the dream was peaceful family life, the reality was the road." Only the exponentially increasing amount of time spent in the car and the increasing number of driving trips by women made the detached life of the suburb possible.[62]

Dictionaries tell us that a cul-de-sac is a street with only one way in or out, a passage with access only at one end, a blind alley, dead end, or an impasse—perhaps even a trap. In military terms, a cul-de-sac is a position in which an army finds itself with no way out, except to the front. In the suburbs that have sprung up in the wake of places like Arapahoe Acres, the cul-de-sac is a street with only one way out, often curved rather than straight, usually with a circular turnaround at the end. Most cul-de-sacs open onto secondary streets that may be on curvilinear or gridded road plans, connected at intervals to arterial roads that lead out of the neighborhood to the public spaces of commerce, industry, education, and government, and to larger networks of inhabitation and work connected by freeways. These landscapes have become home to millions of Americans living in communities planned and built by developers who operate on a national, even global, scale.

As federal dollars continued to flow during the 1950s and 1960s, Denver expanded rapidly along the I-25 corridor between Colorado Springs to the south, and the Wyoming border to the north. As more and more newcomers came to Colorado and other places in the West, women incorporated movement for work, travel, and leisure into their homemaking. Magazines like *Sunset* and Denver's *Golden West,* targeted to middle-class women readers, sold a postwar good life that emphasized open spaces connected to home via the freeway. The writers of *Golden West* pointed to the exceptional nature of Western places where the "climate, altitude, topography, and western traditions all play an important role in homemaking—indoors and out." In this vision, the New West would be defined not by massive growth but by a way of life where nature was as close as the view from the backyard patio or a family drive to the mountains.[63]

CRACKS IN THE PICTURE WINDOW

Colorado photographer Robert Adams captured a less idyllic New Western landscape of shopping malls and driveways, of countryside bulldozed for housing tracts, of freeways and stifling ranch houses in which women and children lived in an uneasy relationship with the natural world. Adams documented families who had moved to the suburbs to enjoy nature but instead "found that nature was mostly inaccessible except on weekends. Often little of it was even visible out the window."[64] In the isolated female silhouette framed by the window of her new Colorado Springs home, Adams poignantly captured a woman stranded in this new landscape (figure 30).

30 | "Colorado Springs, Colorado," 1968–1970, by Robert Adams, gelatin
silver print, 6 x 5 $^{15}/_{16}$ in., The J. Paul Getty Museum, Los Angeles.

The automobile sped families, like those depicted in Adams's photographs, outward from Denver in search of elbow room and a piece of land to call their own. Investors bought cheap land in Adams, Arapahoe, and Jefferson counties, building malls and gas stations that pulled residential development toward them. Money followed the roads outward, leaving behind a crumbling infrastructure. Freeway construction cut through old neighborhoods and demolished homes. In the name of urban renewal, Denver officials slated now-run-down areas, such as blocks along Larimer Street, for demolition.

A housewife and civic-activist-turned-real-estate-developer named Dana Crawford saw the potential for a different type of renewal. Crawford envisioned a future version of the City Beautiful, in which old buildings reclaimed from Denver's mythic frontier past could be combined with retail development to attract suburban housewives like her back to the downtown area. In 1964, she formed the for-profit corporation Larimer Square, Inc., to purchase and develop property in a "Historic Denver" motif. As Fred Harvey had done for Southwest tourists earlier in the century, Crawford sold a selective past. Her Larimer Square promotional brochures celebrated the exuberant frontier spirit, the "antics of its now legendary city founders, the fur trappers, gold seekers and adventurers." Crawford brought the suburb into the city, running the Larimer Square venture like a shopping mall. She promoted the aggressive spirit of Denver's male founders while quietly replacing the pawnshops, bars, and hotels that catered to working-class men with unique boutiques and restaurants appealing to middle-class female shoppers. Crawford's vision struck a chord with like-minded urbanists seeking to marry preservation and development. By the middle of the 1970s, the Historic Denver Association, founded to protect Denver's architectural heritage, was the second-largest private preservation group in the United States.[65]

Crawford changed the trajectory of urban renewal. She emphasized, in place of demolition, links between preservation and profit by transforming historic centers into distinctive downtown retail spaces. But despite the best efforts of Dana Crawford and her allies, Denver continued to sprawl westward, up onto the steep slopes of the Front Range, and to the east, far out onto the plains in Adams and Arapahoe counties, where industrial as well as residential suburbs continue to proliferate.

The more Denverites drove, the more they fouled their own nest. In 1956, Denver city officials logged 1,250 resident complaints regarding pollution.[66] As air pollution reached deadly levels, the state of Colorado passed the Air Pollution Control Act of 1970. Nonetheless, auto emissions and other smog-causing pollutants have become such an accepted fact of life in metropolitan Denver that the city's air pollution acquired its own name: the Brown Cloud. Denverites nowadays contend with the myriad ill effects of not only smog but also noise, snarled traffic, and the disappearance of rural land in the face of suburban expansion. In response, in 2000, Governor Bill Owens signed smart-growth legislation designed to protect Coloradans' quality of life. The act gave the governor the power to halt traffic and shut down factories when pollution reached dangerous levels.[67]

Denver's suburbs continue to grow at twice the rate of the city. And women drivers, traversing the distances between enclaves of privacy and nodes of public life, are the circulating lifeblood of the metropolis. Colorado in 2000 had the third-highest rate of women working in the nation, with 61.4 percent of women employed in the workforce. Escalating city rents, the rising numbers of households headed by single women, and lower wage earnings for women continue to encourage the move outward to the suburbs, where commute times have gotten longer and more than 80 percent of women get to work by car.[68] Sixty years after Eve Drewelowe painted the intrusion of the automobile through the Rocky Mountain landscape, another Boulder artist, Elizabeth Elting, offered a stark and stunning depiction of Colorado cul-de-sacs (plate 15).

What was, less than two centuries ago, homeland to bison and antelope, horses and mobile Native peoples, has become a sprawling conglomerate of functionally and socially segregated cities strung together by freeways—a twisting system of buildings, roads, and vehicles inhabited by people accustomed to coping with congestion and pollution. The soccer mom in the minivan shuttling between work and home, school and piano lessons, church and Brownie troop, is more than just a target for people selling everything from ready-bake pizza to political candidates. She is an engine of social, economic, political, and geographic change.

From the horse to the railroad and the freeway, the people who have lived where the mountains meet the plains have invested in whatever means of transportation seemed to be the most efficient and profitable way to solve the problems of food, shelter, and defense. Technology propelled men and women first outward and then inward to reinvent themselves. But new possibilities inexorably came up against the limits of what the home place could sustain. From nineteenth-century grass wars to twenty-first-century water wars, the communities now encompassed by a metastasizing metropolis have lived in fragile and contingent relation to the land they move across. And from the buffalo plains of Owl Woman and her sisters, to the teeming railroad town of Dr. Justina Ford, to the suburban cul-de-sacs and feeder roads of Denver, you will still behold a landscape alive with women in motion, a geography of women's movements.

ELLIOTT WEST

FRONT RANGE LANDSCAPES

In the story of Colorado's Front Range, as in history generally, women's voices are muted. And it is even rarer to hear from those living in the scruffier, on-the-edge neighborhoods like the one in Henrietta Bromwell's painting *A Bit in Denver Bottoms* (1890–1910; figure 31, plate 13).

The Denver bottoms ran beside the Platte River and Cherry Creek, where the discovery of gold in the summer of 1858 sparked a rush of wealth seekers the next year. That in turn led to the dispossession of the area's Indian peoples and the rise of towns and cities, Denver chief among them, along the base of the Rockies. By the end of the century, Denver had matured into the region's leading governmental and mercantile center. As Bromwell's lovely cityscape suggests, it had some modest industry as well.

The bottoms were home to working-class families, the poorer ones in shacks, those a bit better off in the hotels and frame houses crowded onto some of the city's cheaper lots. There you would have heard a mix of languages and accents. Any page of the Denver census around the turn of the century will likely show that at least half the adults were born outside the United States, most of them in Germany, Ireland, or England, but some in places as unlikely as Argentina and Iceland. The men here were laborers, carpenters, miners, and workers on railroads and in brickyards, tanneries, and other enterprises. Most women by far, although not all, appear in the census as engaged in "keeping house."

This was not Henrietta Bromwell's world. Born in Illinois the year of the gold rush, she came with her widowed father to Denver around 1870. He became a prominent legislator and jurist. She studied art at the University of Denver and later taught out of her downtown studio. She was a founder of the Artists' Club of Denver, which evolved into the

31 | Henrietta Bromwell, *A Bit in Denver Bottoms*, 1890–1910, oil on canvas. Copyright, Colorado Historical Society, DFA Collection, H.1493.43. For a color version of this image, see plate 13.

Denver Art Museum, one of the finest in the West. Most of her works, like this one, are impressionist views of the city in the plein air style.

Her paintings are mostly unpeopled, so we are left to wonder about those living in the shadow of those smokestacks, women who passed their years well below Bromwell's station. What would "home" mean to them? The one sure thing is that it involved hard work. The labors simply of "keeping house" were considerably heavier than in the plugged-in, plumbed, relatively appliance-rich households common among even lower-income families today. The load was enough to support a vigorous trade for decades in stimulants pitched to worn-out wives and mothers. "Can anything be more wearing for women than the ceaseless round of household duties?" asked an advertisement for the most famous tonic, Lydia Pinkham's Vegetable Compound. "Oh! the monotony of it all—work and drudge." The load mounted with the number of children, and in Denver's working-class households having four or five under the age of twelve was not unusual. Housewives, besides, often shored up the always chancy family income by cooking, cleaning, and laundering for unattached men.

Work, however, only began to define homemaking, and a household as workplace did not make for a home. *Home* is one of those words rooted deep in our language—this one for more than a millennium—that seem simple and yet are given to subtleties and many meanings. More than a fixed dwelling, it evokes relations among people and between people and place. It implies embeddedness and an emotional harbor.

Among women on Denver's lower economic rungs, making a home had plenty of frustrations. Men's shifting, unsteady employment kept families moving, often within the city and around the region. The same uncertainty pushed some women into the workforce—about one married woman in sixteen held outside employment in Colorado in 1880—where they found the choice of job far narrower and the wages much lower than for men. Most had come to Denver from elsewhere. That, plus frequent moves after arrival, fractured the sustaining networks of family and friends that most, then and now, consider essential to home. All this applied to married women. The difficulties were far greater for single women, those widowed, divorced, or never married. For single mothers they were daunting indeed.

Unsurprisingly, those women are also the ones whose voices are scarcest in the historical record. In Denver, however, we have one remarkable exception. The single mother Emily Rood French kept a diary from the first to last days of 1890. It is a rare window into the lives of women for whom home was ever desired and always elusive.

Born in Michigan in 1843, Emily Rood eloped at fifteen with Marsena French, her elder by eight years. Over the next thirty years, her life showed three traits common to the lives of Western women of that time. She moved around a lot, found little economic stability, and had lots of children. Between 1860 and 1881 she bore five daughters and four sons. The family moved from Michigan to Iowa, living in three different towns there before heading to Golden, Colorado, then back to Iowa, back to Denver, and finally to Elbert

on the Colorado plains. Marsena operated a clothing store, studied and practiced medicine, and took up a homestead in Elbert, none with much success.

In 1889 Emily and Marsena divorced. He was an "old rascal," she told her diary, "an awful mean old fellow." By then her family had mostly spun apart. Her own parents had divorced before she married, and although she lived near her father during his last years, she apparently never contacted him. She had lost one son to accidental poisoning, had lost track of a daughter, and was largely estranged from her other older children. She lived with the two youngest, Olive and Daniel ("Ollie" and "Dannie"), ages fifteen and twelve. As the diary opens, she is keeping them apart from the others by hiding them in a Denver boardinghouse. So much for nostalgic views of ideal families of the past.

She began her diary: "Let me only in the fear of God put on these pages what shall transpire in my poor life." She was then in Elbert helping her semi-invalid sister on her homestead next to Emily's ex-husband's. She supported her sister, her children in Denver, and herself by domestic work in that small, drought-stricken town about fifty miles south of the capital. She wrote of relentless labor—washing, cooking, ironing, mopping, making and mending clothes, and tending animals—but often could eat only when a friendly employer gave her food. A modern study found that in rural Colorado a domestic worker's average wage was thirty-three cents a day. In the spring she returned to Denver and her children.

Home was a recurring note throughout the year. In Elbert she confessed to having "hard thoughts—why is this life for me, a *home lover?* I do so crave a *home,* will I ever have a *home?*" And shortly after her return to Denver: "We [are] still talking about a home, the one thing to bee [sic]." She meant more than a settled house. Reading the entries, it is hard not to see her as reaching toward secure, loving connections long missing in her own story. When Ollie wrote of being elected editor of her school paper, Emily was proud: "How I pray as well as work for their advancement." Four days later her hope rose during sleep: "I dreamed a pleasant life for myself and *children,* only to wake and find the same starring [sic] me in the face."

Still, a home, as a physical place of grounding, did hold great importance for Emily ("I have all these years tried for one"), and in Denver she made her bid: "Will I get my home, god help me. . . . I *must* venture or lose all." She looked for a cheap lot, avoiding any owned by a loan association ("a dangerous organization for a helpless woman"). On Willow Street she found one she thought she could afford and gave her gold watch as security. And now, she wrote, "I must work as I never did before." She bought some materials and scavenged others: "I got a few boards," and "I got some broken pieces of brick." She paid a carpenter and painter by providing him dinner. By winter the house was framed out but far from complete.

Meanwhile she struggled under the double burden of basic needs and new obligations. She worked briefly in a sweatshop and at housekeeping when she could. In summer she again left the children in Denver to work erratically as a domestic in the mountain town of Dake. Firmly religious, she attended church nearly every Sunday, and she

began many entries with biblical passages, some with a poignant resonance: "Thou wilt show me the path of life," and, on the day she committed to a house, "This is not our resting place." She worried about her reputation; an employer called her "an adventuress." Divorcees were always suspect, and in fact single mothers turned often to prostitution—no big surprise in light of the life shown in her diary. By one estimate, a prostitute could bring in ten dollars a night (twenty tricks at fifty cents each), ten times the average wage of a schoolteacher and fourteen times what a domestic could expect in Denver.

The strain of giving home a physical place must have stressed terribly the family's home as emotional bond. She worried about the children and complained of their behavior, and one of her older, estranged sons contacted Dannie about leaving. After Christmas he ran away. Emily despaired. His return, when he walked into the drafty, unfinished house during the last hours of 1890, lifted the diary's final words to a rare hopeful note: "*Old year goodbye.* Oh here is Dannie."

That final uptick was symbolic, in that things were changing for Colorado's women. Opportunities were opening, especially for those with some education. "The American woman is going ahead," an editor wrote approvingly, noting women's employment in sales and clerical work and even in executive positions and medicine, where not long before a woman physician had been seen as "next to a freak." On the Colorado plains, single women were more likely to meet the requirements of the Homestead Act and gain title to their land than single men were—Emily's sister did in 1891—and in 1914 the International Congress of Farm Women, convening in Belgium, chose as its president a farm wife living near Denver.

As for the French family, there is not much more to say. Emily apparently lost the house to creditors, then remarried and moved away. Dannie is listed in the 1900 census in Elbert, then he vanishes from the record. Ollie married in 1891, at age fifteen, as had her mother, but divorced a few years later and took a place on Willow Street, across from where Emily had chosen to "venture or lose all." Then she too disappears. We are left to judge Emily French on her own terms. "I seek not the applause of the people," she wrote in her diary's first entry, "only that I deserve the epitaph—She hath done what she could."

3

WATERSCAPES OF
PUGET SOUND

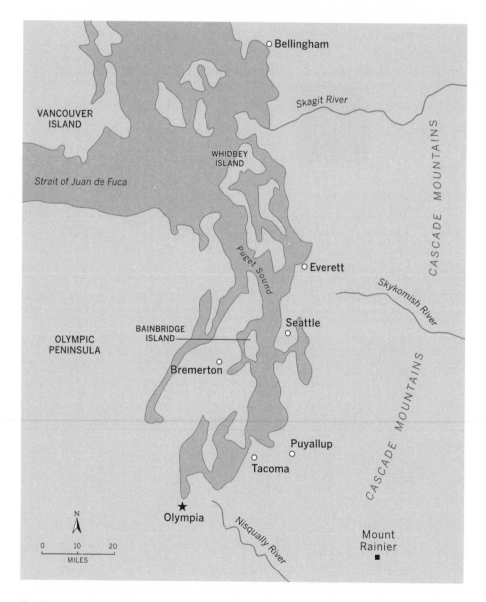

Map 5 | Puget Sound

HUMAN BEINGS ARE MADE, WE ARE TOLD, ALMOST ENTIRELY OF WATER.
Whatever else holds our bodies together is liberally infused with and animated by water. We have more than an affinity for water; we are water, we need water, water is in us, and wherever the possibility exists, we are, at least some of the time, in water.

Any place humans claim as home requires water. And wherever those homes are claimed, women follow, collect, carry, use, and manage water. Where water is scarce, they spend hours every day gathering and storing and conserving precious drops. Where water is plentiful, they seek to channel the power of that abundance, to protect themselves and their communities from the ravages of aqueous excess, to move with the currents and tides and to make water work for them. The relationship between women and water has been much more than mythic. From the Pueblo woman filling an olla at the river and carrying it home on her head, to the farmworker picking strawberries in an irrigated field, to the suburban housewife turning off the faucet and drying her hands in her spic-and-span house, Western women have claimed the power of water to make home places.

The search for scarce water drives some of the best stories of the American West, from Walter Prescott Webb's *The Great Plains* to Donald Worster's *Rivers of Empire*, from Mary Austin's *Land of Little Rain* to Roman Polanski's *Chinatown*. But the West is not only a dry place. Some parts of the West are, and have been, so overflowing that we may want to think of them not as landscapes but as *waterscapes*. People have sustained themselves and claimed those places as home by looking to, taking advantage of, and taking what the water offers. Look at the ebbs and flows, the mainstreams and side channels of history in those Western waterscapes, and you will find water and women at work.

Consider the fluid province of Puget Sound, a region encompassing more than two thousand miles of shoreline, which lies between the Strait of Juan de Fuca to the west, Vancouver Island to the north, the Cascade Range to the east, and the Olympic Range to the west. The glorious panorama of mountains and shoreline, of rivers and streams, was made by water in its frozen state. Glacier ice carved channels into rock, broke rock into soil, contoured microclimates, and scraped against, scoured, and piled up massive landforms. Over thousands of years, frequent rain and temperate weather have nourished a diversity of plant and animal growth. Salmon and cedar slowly moved in, followed by the first human migrants, as habitats—ranging from marine bays and freshwater rivers to

prairies and forests—evolved. These well-watered places have offered people abundant prospects, and women and men have been living in Puget Sound, where the forest meets the sea, for centuries. Inhabitants arrived from all directions, people eager to exploit water and forests in remarkably varied ways. Indigenous fishing people, Hawaiian and Russian sailors, British and European traders, farmers and missionaries, and immigrant workers from Europe and Asia and other parts of the United States have moved in and out of the region, on and off ships, between shore and sea.

Women have flowed through the waterscape, joining the stream of trade and exchange. Amid fluidity, they have also anchored families and communities. Women transformed resources gathered from the water into commodities, and they harnessed water into useful forms to sustain themselves. They organized work around the paths and opportunities water offered, even as they channeled the waterscape with their work. They built new homes and communities, started businesses, and served as the backbone for an industrial workforce. Sometimes they were flooded out or washed away by the tide of history. But like the ebbing and flowing tide, even some who were forcibly swept out returned, and they claimed a home place on the Sound.

PEOPLE OF SALMON AND CEDAR

The bands of people who shared Lushootseed and Whulshootseed languages, and who are collectively now known as the Coastal Salish, had Puget Sound pretty much to themselves well into the eighteenth century. Their ancestors arrived some eleven to twelve thousand years ago, having traversed the Siberian land bridge after the last great Ice Age. They created a dense landscape of villages stretched along shores and watersheds and connected through kinship, trade, ceremonial gatherings, and the villagers' ability to travel with the tides and currents. Prior to European contact, as many as ten thousand men and women may have been living within the Sound, where waterscapes defined and distinguished them as a people.[1]

The Suquamish called themselves the "people of the clear salt water," while the Duwamish referred to themselves as the "river people." Water provided the salmon, the source of their livelihood, the subject of their lore, and the means of their commerce with one another. According to one Salish elder, "The salmon is to us on the coast what the buffalo is to the people of the plains. We survive on the salmon."[2] Salish families learned the ways of the salmon, and some grew wealthy exploiting the seas and rivers. Men captured fish of the deep waters with spears, whereas women crafted small fishhooks that allowed them to supplement their diet with fish as they moved through the landscape foraging.[3] Artists and artisans, in turn, created a rich material tradition expressing their understanding of life in the Puget Sound waterscape.

Where the land was densely covered with forest, water offered a much easier and quicker way to get around than traveling by foot. Salish women and men crisscrossed the waterways in canoes they designed and built to navigate both the swells of the open

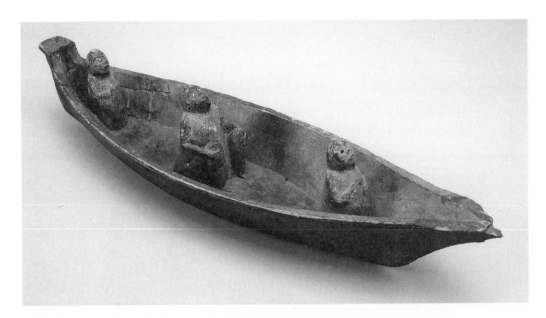

32 | Coastal Salish canoe model, date unknown. Southwest Museum of the American Indian, Autry National Center; 871.G.9.

ocean and the sometimes raucous rivers. Families built small, efficient cedar canoes to use in their hunting and gathering. Skilled artisans constructed the larger saltwater canoes that could hold a hundred people. And boat builders also made canoes designed especially for women, who were charged with the task of moving their entire households in the spring and summer. Both men and women painted their paddles with designs acknowledging their spiritual helpers (plate 16), and both knew how to read the times and tides and currents that made life possible. As they moved about, they navigated and created a waterscape overlaid with a dense network of seasonal travel and family ties.

The rhythms of life followed the seasons and the tides. In the winter, families joined together in permanent, autonomous villages built along rivers and shorelines. Here they lived in multifamily cedar longhouses, two hundred to six hundred feet in length, built facing the water. In late spring and summer, villagers abandoned their longhouses and moved in small family groups between the river, the shore, and the interior, collecting and trading. Women and men together welcomed the first salmon runs in the spring. Using open-weave baskets fashioned from cedar root, women moved on to gather clams, mussels, and shellfish on beaches, both to feed their families and to barter with interior tribes. Along the Duwamish River, deep shell middens, centuries-old layers of refuse, attest to women's gathering activities and long-standing presence in the heart of what is now Seattle. Throughout the summer, women traveled the waterways in search of re-sources, seeking out the best berry fields and looking for places where they could gather cattails by the hundreds. They bound the plants into bundles, and around November,

33 | Clam gathering basket, late nineteenth century, Coastal Salish or Klallam.
Gift of Elizabeth Bugbee, Southwest Museum of the American Indian, Autry
National Center; 646.G.31.

the time of year referred to as "putting paddles away," families returned to their long-houses. They made use of their time indoors during the cold gray winter by weaving cat-tails and cedar bark into mats and baskets and participating in religious ceremonies.[4]

Across Puget Sound, Salish groups claimed prime fishing and gathering territory as their own. In contrast to life in the longhouse, where male lineage shaped power and meaning, female kinship determined access to summer gathering places and to impor-tant fishing sites. Families made sure that both men and women married to the greatest possible advantage, so higher status women married outside the village as a way to gain access to campgrounds, strengthen political alliances, or increase the family's wealth.

The Salish marriage system stimulated travel along the Sound's waterways. People moved around, attending celebrations, funerals, and ceremonials at villages across Puget Sound, visiting kin, and finding partners. When women married outside their villages, they were acting on their own behalf and in their own defense. They forged links in a social network that provided defense against aggressive northern neighbors, from bands along the Strait of Juan de Fuca to southern Alaskan tribes, who raided Puget Sound villages looking for women and children prisoners to increase their own wealth and sta-tus. Intervillage loyalties, forged in marriage and trade, helped create a regional identity among the heterogeneous bands that populated Puget Sound. Where families shared waterways, more and more they also shared time and kinship bonds.

COHABITED LANDSCAPES

As men and women navigated the Sound, they reckoned their courses by mental maps that were both extensive and expressive of their spatial reality. They worked with the concepts of east and west, north and south, but also located themselves landward, sea-ward, downriver, and upriver. Place-names recorded where rivers ran dangerously deep, or where the best rushes might be gathered. But in 1792, this cartography began to change. In that year, George Vancouver became the first European commander to sail his ship through the Strait of Juan de Fuca. He promptly began renaming what he saw around him in honor of the men behind his venture to the Pacific Northwest, emplo-ying a new, deeply gendered Enlightenment language of science and diplomacy. Van-couver named the Sound itself—originally known as "Whulge," or "big saltwater," in the Lushootseed language—after his own lieutenant, Peter Puget, who was entrusted with the survey of the western channels. Vancouver decreed the names Port Townsend and Hood's Canal after two patrons from the Board of Admiralty authorizing his mis-sion. Those male names often erased the presence and power of women in the water-scape. For example, the mountain originally known as Talol, Tahoma, or Tacoma, from the Puyallup word meaning "mother of waters," became Mount Rainier, after Vancouver's friend Rear Admiral Peter Rainier. On this fluid, contested terrain, Europeans and in-digenous people met, sometimes uneasily and sometimes to mutual profit.[5]

Native waterscapes as well as Native forms of diplomacy persisted, notwithstanding

the new names, as Puget Sound furs and lumber streamed into American and European maritime trade systems. For one thing, the economic and political centers of trade networks were so far from the region that new traders and settlers flowed into the region at a mere trickle. And, despite the ravages of disease and slave raids, which reduced populations even before Vancouver's journey to the Sound, Native residents still significantly outnumbered newcomers.

The Puget Sound Salish expanded long-established trade networks and patterns to incorporate the newcomers, cementing new ties much as they had previously, by visiting and trading and marrying. In the 1820s the Hudson's Bay Company expanded its operations into the far Northwest, setting up Fort Nisqually and Fort Langley to capitalize on the Sound's profitable waters. Encounters with Russian, British, and American whalers and fur traders sailing the Pacific Coast provided new material wealth and inspired new artistic expression, such as the figurines carved by Haida artists and often traded to the newcomers. Some women weavers, inspired by new materials and objects, began twining narrow strips of cloth acquired in trade into the designs of their cedar baskets (plate 17). Hudson's Bay traders would help create a new social order, founded on the trade in furs, perpetually under negotiation by the Native, European, and mixed-blood peoples who now shared a home place. Native women played a pivotal role in the fur trade, butchering animals, preparing sea otter hides and other skins for sale, and bargaining with and getting to know the Europeans. In some cases, as on Nootka Sound, Native women managed the traffic in furs.[6]

With so much competition for a resource at first abundant but growing less so, the potential for conflict, for sudden violence, was all too present. Women from Native families employed their traditional strategy for negotiating volatile contact, increasing their influence, gaining access to goods they wanted, and preventing war: they married. In turn, the Hudson's Bay Company encouraged its male employees to form liaisons and to marry Native women as a means to further the firm's interests. Soon, everyday contact and marriage alliances blurred lines between natives and foreigners, creating interdependent communities and setting the pattern for more than two centuries of intimate relations. As Puget Sound was "discovered" by Europeans and Americans, women's marriages wove together nets of familial and economic obligations.

Native people played an active role in shaping nineteenth-century settlement of Puget Sound. Newcomers, whether traders, merchants, or settlers, inserted themselves into what, for the most part, remained an indigenous waterscape. As fur traders sought to expand in the 1840s, the Duwamish, Snoqualmie, and Snohomish confined Euro-American settlement to the southern end of the Sound, near the trading posts at Olympia, Fort Nisqually, and along the Cowlitz River. As more white immigrants looked to the Northwest, trickling in from the Willamette Valley, California's northern coast, and the American Midwest, they discovered a still-fluid landscape. Salish men hired as guides and porters for families seeking homesteads used their intricate knowledge of the waterscape like real estate agents showing houses to prospective homeowners, both aiding

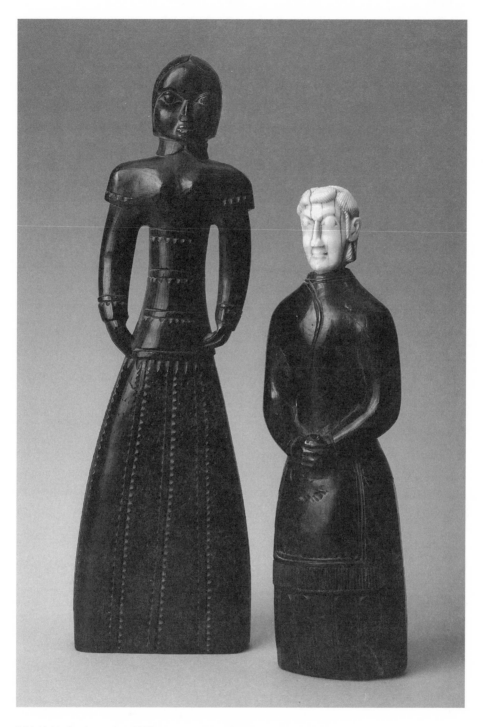

34 | Haida figurines, circa 1845, carved argillite. Gift of Mrs. Rhoda Rindge Adamson in memory of Frederick Hastings Rindge, Frederick Hastings Rindge Memorial Collection, Southwest Museum of the American Indian, Autry National Center; 980.G.143B, 980.G.142.

and steering them in the location of white settlements. Salish families, in turn, pitched camps alongside the newly established homesteads and towns, in effect locating the newcomers within their own established territories and social relations.

The story of Arthur Denny, the self-proclaimed pioneer founder of Seattle, is less a story of a heroic frontiersman than a tale of two extended family groups confronting and accommodating each other. The Denny party included Arthur and his wife, Mary Ann, their two daughters, his parents, his four unmarried brothers, and Mary Ann Denny's brother and sister. Mary Ann's arrival in Puget Sound was the stuff of legend: having survived the rigors of the journey west, recent illness, and childbirth, it is said that upon seeing the partially built cabin intended for her new home, she broke down weeping.

Mary Ann's party arrived at Prairie Point on November 13, 1851, although her brother and husband had gone ahead to negotiate with the Suquamish chief Seatthl (known to most Americans as "Seattle"), who had put out word that Americans were welcome. Se-atthl and his family did more than offer a ritual greeting to the Denny party. The Suquamish leader had a history of working with Fort Nisqually traders, was a convert to Christianity, and had recently entered into a business arrangement with Captain Robert Fay, who accompanied the Denny party, to provide Indian workers to catch and preserve salmon to ship to San Francisco markets.

Not long after the Denny party landed and renamed Prairie Point, calling it "New York Alki," local residents began to congregate around the newcomers "until," wrote Arthur Denny, "we had over a thousand in our midst." Who was in whose midst is an open question, but throughout that first winter, Denny reported, the Salish "built their houses very near to ours, even on the ground we had cleared." Salish and Americans lived together uneasily, according to Denny, as the emigrants "did not feel safe in object-ing to their building thus near to us for fear of offending them, and it was very notice-able that they regarded their proximity to us as a protection against other Indians." A year later, the American families moved from Prairie Point to the site of the present-day city of Seattle.[7]

For three decades, Native and white people cohabited in the Puget Sound waterscape. Native people traveled back and forth for work, trade, religion, and social gatherings, and white settlers depended on Native peoples' established networks of food, labor, trade, and even kinship. Native women sold fish, clams, baskets, and berries to their white neighbors. Louisa Boren Denny recalled how Native women traded for tin cups and silk quilting strips, hoop skirts and parasols.[8] Some women chose to work in the homes of new settlers as domestic servants or washerwomen, or in the fields. Many continued to marry and raise families with white men.

White women, too, adapted to this hybrid world. During her first summer in her new home near Olympia, claimed under the 1850 Oregon Donation Land Act, Phoebe Goodell Judson found herself surrounded by Native women, noting their industriousness as they gathered and dried plants, wove mats, picked berries, dug camas roots, dressed

and dried salmon, and tended their children. In a territory still contested, both on the ground and between far-off empires, Judson acknowledged it was "no more than justice that they should be allowed to build their homes wherever they pleased, and we would not interfere with them, at least before the government had treated for their lands."[9] Others experimented with new forms of social relations. Henry Yesler married Susan, the daughter of a Duwamish chief, despite being legally married, with a wife and son in Ohio. When, after seven years apart, Sarah Yesler arrived in Seattle in 1858 to be reunited with her husband, she joined not just Henry but also his second wife and their young daughter, Julia. Although Susan faded from the historical record, eventually taking another husband, Julia continued to be recognized as Henry's oldest daughter. Sarah and Henry became a prominent, wealthy pioneer family who remained connected to their Duwamish kin.[10]

But the mixed and fluid world they had known began to stretch, strain, and shred apart, despite their best efforts, in the face of conflicts over land and resource use. The federal government added fuel to the fire in 1854, pushing for Natives to cede their land and give up their established ways. As the government and new white settlers tried to establish clear, legal boundaries between whites and Indians in Puget Sound, American officials also mounted an effort to halt the flow of intimacy between Native women and white men. In 1855, the territorial legislature passed a law voiding all existing marriages between whites and persons with half or more Indian blood. Like most political efforts to control intimate matters, the law was impossible to enforce. The legislature responded by revising the law to prohibit future intermarriages. But whites and Indians ignored regulations that made them outlaws in their own homes.

Indians also resisted government efforts to isolate them on reservations. Few chose to claim allotted reservation land in the 1850s and 1860s, and those who did continued to move around to fish and forage and to hire themselves out as workers, demanding and receiving wages equal to those of white workers. An 1887 Indian agent reported Indian families homesteading, squatting across from sawmills, selling fish in Port Townsend, wintering in Whatcom, and farming in the village of Jamestown.[11] In Seattle, Indian families continued to live along the waterfront in the city center, in interracial, working-class enclaves, and in tidelands to the south. A constant stream of canoes brought Makah, British Columbian, and Alaskan Indians to take advantage of seasonal work opportunities in the hop fields and the fishing, lumbering, and tourist trades.

One of the more famous of these urban Indians was Kikisebloo, Seatthl's daughter, often known by her English name, Princess Angeline. Kikisebloo grew up with the city of Seattle. As a young girl she witnessed her father's rise through success in war and in trade with new European arrivals at Fort Nisqually. As a young widow, she stood with her father to welcome the Denny and Bell families to Prairie Point in 1852. And, unlike her father, she refused to leave her home along Seattle's waterfront following the signing of the Port Elliott treaty that ceded Duwamish and Suquamish rights to the land in exchange for cash and reservation lands.[12]

Like her father, Kikisebloo moved back and forth between Seattle's white and Indian populations. She retained close ties to Seattle's white pioneer families, and both of her daughters married white men. Along an urbanizing waterfront, Kikisebloo combined age-old gathering practices with new opportunities in Seattle's marketplace, digging clams, selling her baskets to Seattle's new residents and tourists, and hiring herself out as a washerwoman for prominent families. Memoirs of Seattle's white settlers capture a mixed legacy, in which leading white women throughout the city received Kikisebloo in their kitchens for the exchange of gifts and news.[13]

Digging clams along Seattle's waterfront, Kikisebloo caught the attention of Edward Curtis, a young photographer who had just opened a studio in Seattle. Although he had established his reputation as a photographer of high-society women, Curtis became fascinated with Seattle's "Indian princess." The caption accompanying his portrait of Angeline described her as a familiar figure on Seattle streets, and his photograph meticulously detailed the aged, careworn face of his subject. Curtis continued to pay Kikisebloo a dollar per photograph, and she would become the unnamed archetypal figure in Curtis's celebrated photographs "The Clam Digger" (plate 18) and "The Mussel Gatherer." "I paid the princess a dollar for each picture made," wrote Curtis. "This seemed to please her greatly and with hands and jargon she indicated that she preferred to spend her time having pictures made than in digging clams."[14] Yet his images presented Kikisebloo as an anonymous symbol in the twilight of a disappearing wilderness, rather than as an individual in the urban milieu that was her home. Seattle citizens likewise embraced Princess Angeline as an icon, reproducing her now famous visage on everything from postcards to china plates and paperweights. These souvenirs turned Kikisebloo into an emblem of a vanishing race, erasing the more complex history of Seattle as a city inhabited and shaped by both Native and white people and undergirding a counter identity for Seattle as a modern city.

WOMEN IN THE BOOMING WEST

By the end of the nineteenth century, people from around the world were streaming into Puget Sound. The United States and other nations throughout the Pacific—China, Japan, Australia—were in the midst of a building boom, and nowhere were forestlands richer than in the Pacific Northwest. As new migrants arrived in Seattle and Tacoma, they began to shape a waterscape of international commerce, clearing rivers of debris, opening upper valleys to farmers and loggers, building sawmills, diverting rivers, experimenting with oyster culture and fish packing, and opening and expanding city ports to a global trade. In Seattle, tide flats to the south were filled in, and Seattle's landmark hills were leveled to make room for new businesses and homes. In Tacoma, builders dredged and filled in the estuary of Commencement Bay to create additional shipping space. As one 1888 guidebook boasted, "Between the harbor of Tacoma as it was in 1883 and as it is

35 | Women carrying water, Bellevue Avenue, Seattle, 1911, by Asahel Curtis.
University of Washington Libraries, Special Collections, A. Curtis 22556.

to-day there is as strong contrast as between a wilderness and a walled city."[15] Washington's new entrepreneurs recruited workers from the American Midwest and West, Canada, Europe, and Asia, and thousands of newcomers arrived, skilled and unskilled, earnest and on the make. Bolstered by the Alaska-Yukon gold rush of 1897 and booming trade with Asia, Seattle became an urban engine transforming the waterscape.[16]

Industry needed cheap labor, and workers themselves needed support services. In Seattle and Tacoma and throughout the Puget Sound region, women worked in canneries and served as seasonal agricultural workers, hotel and boardinghouse keepers, seamstresses, cooks, waitresses, laundresses, and domestic servants. In nearly every one of those occupations, they worked with water, from cleaning and processing salmon to picking strawberries in irrigated fields, washing floors or windows or dishes or clothes, bathing babies, hauling and sloshing and sluicing and soaking in water. Their scrub brushes, scaling knives, boiling kettles, and washboards replaced the painted paddles, baskets, and canoes of their Salish predecessors, but women's tools were adapted to work with water, all the same.

SCANDINAVIAN WOMEN IN PUGET SOUND

In 1882, nine hundred agents of the Northern Pacific Railway fanned out across Europe to extol the benefits of life in the American Northwest. Northern Pacific broadsides like "The Western Hemisphere's Scandinavia, Western Washington" boasted of agricultural land, orchards, and forests superior to those found in Norway, Finland, and Sweden together. Ernst Skarstedt, a Seattle newspaperman and tireless promoter of immigration, believed that Scandinavians were made for life in the region. Writing to readers in his native country of Sweden, Skarstedt described how Washington and Norrland shared the same "mountains, dark evergreen forests, and running rivers." When cartographer and promoter G. E. Kastengen gave public lectures, he used maps of Scandinavia and Seattle to point to the similarities between Seattle's Lake Washington and the Baltic Sea, between Swedish and Norwegian fjords and islands and the contours of Puget Sound.[17]

English and European steamship companies likewise launched publicity campaigns throughout Scandinavia, blanketing cities and towns with brochures. Price wars kept fares for passage low. The companies developed a prepaid ticket system that encouraged families, friends, and employers in the United States to purchase open-ended tickets that could be used at the point of departure from Scandinavia. Steamship companies headquartered in Scandinavia, and ships built jointly by Swedes and Americans carried masses of migrants from Scandinavia to the United States faster and in greater numbers than ever before.[18]

The typical Scandinavian immigrant arriving in Seattle and Tacoma in the 1890s was young and unmarried, but contrary to the pattern in other international migrations to the United States in the nineteenth century, many of those travelers were female. Single women came in great numbers from Norway and Sweden to Seattle, and they knew how to get along on their own. In their home countries, they were accustomed to managing without husbands for long periods of time, as Scandinavian daughters commonly left home to work for pay before marrying. Like the Native inhabitants who had integrated newcomers into their waterscape and social life early in the century, young Scandinavian women incorporated migration to the American West within their own cultural patterns. Over half of these new female immigrants were between the ages of sixteen and twenty-five.[19]

For single women, setting sail for, or getting on a train to, the Northwest was risky but also ripe with the possibility of reward. Migrating might mean deferring marriage (a potential plus or minus, depending on the girl), but coming to America was likely to mean gaining more independence in choosing a husband (or, for that matter, not choosing). Working girls who brought home a paycheck stood a good chance of having more influence in family decisions. And unlike many immigrants, Scandinavian women did not have to negotiate the barriers of race. In Puget Sound they lived in nonsegregated communities, learned English quickly, and adjusted rapidly to American life. Affluent households in the West as much as the East sought out white immigrant women to

DET VESTRA HALFKLOTETS

SKANDINAVIEN

VESTRA WASHINGTON.

Vestra Washington omfattar bättre åkerbruksjord än det bästa
i Sverige, bättre fruktland än hvad de bästa frukttrakter i något af de
tre skandinaviska landen erbjuder, betydligare skogsareal än som finnes
i Norge och Finland, större jernvägsfält än Sveriges och Norges tillsam-
mantagna; dessutom outtömliga kolgrufvor samt rika guld- och silfver-
grufvor.

Städerna i Vestra Washington ha nått en jemförelsevis större
utveckling under de senaste 10 åren än hvilkensomhelst skandinavisk
stad under de senaste 200 åren.

Klimatet i Vestra Washington är hela året om likt de behagliga-
ste årstider i de nordiska landen och passar bättre för oss nordbor än
någon annan verldsdel, vår egen födelseort ej undantagen.

Vi sälja endast jernvägsland.

Vi lemna kontrakter, underskrifna af Northern Pacific jernvägs-
bolaget, som näst efter New York Central är det starkaste bolag i För-
enta Staterna.

Åtkomsten (Title) till detta land är för längesedan afgjord af
Förenta Staternas högsta domstol.

Ett "Homestead", en "Pre-emption" eller ett "Timber Claim"
kan blifva föremål för tvist i landkontoret, men ej rätten till ett stycke
jernvägsland.

Vi lemna icke våra, utan kompaniets egna kontrakter till alla,
som köpa af oss.

Vi begära ej en cent öfver kompaniets pris.

Vi sälja ej land kladdvis. Vi sälja ej för smärre hustomter ute
i vilda skogen, utan ordentliga farmar på 40, 80, 120 eller 160 acres el-
ler mer, derest köparen så önskar.

Vi erbjuda rimligaste försäljningsvilkor, nemligen 5 eller 10 år
på köpesumman.

Vi ha anställt de erfarnaste och mest beresta skandinaver såsom
"Locators." De hafva fast aflöning och ha ingen fördel af att vilseleda
någon köpare. Vi visa hvarje köpare landet gratis. Om du önskar
köpa land så kom in till oss och vi skola sända en af våra 'locators' att
visa det land, vi ha till salu i den trakt, der du önskar köpa.

Vi utbjuda för tillfället land i Pierce, King, Mason, Thurston,
Lewis and Cowlitz counties, från $3 till $10 pr acre. Några få uppgå
till $12. ☞ Kom ihåg, vi sälja på 5 till 10 års tid.

Åkerbruksland i Vestra Washington är den bästa "Investment"
i verlden för mindre bemedlade. Arealen är inskränkt. Handelns,
sjöfartens, grufdriftens och skogsafverkningens raska utveckling gör att
städer växa upp med exempellös hastighet och farmaren har i alla tider
en marknad just vid dörren, der han får högre priser för sina produkter
än på hvilken som helst marknad i Amerika. Försu. ma icke tillfället
utan kom innan det blir för sent!

☞ Kontoret är öppet till kl. 8 hvarje afton.

A. E. Johnson & Co.
Land & Emigrations-Agenter
1201 Pacific Ave.
TACOMA　-　-　WASH.

36 | "Det Vestra Halfklotets
Skandinavien, Vestra Washington"
(The Western Hemisphere's
Scandinavia, Western
Washington), 1895, broadside.
Washington State Historical
Society.

clean their homes, haul their water, wash their clothes as chamber- and parlor maids, and serve meals as waitresses. In 1900, more than half of all Seattle's female servants were foreign born or children of foreign-born parents, chiefly German or Scandinavian.[20] Many who worked as domestic servants lived with their employers, where they not only learned the language but also picked up the habits of middle-class Anglo-Americans. Married women also used hard work and racial privilege to get ahead.

No one better embodied the spirit of adventure and enterprise than Thea Foss, the Norwegian immigrant woman who inspired the fictional Tugboat Annie. Born June 8, 1857, in Eidsberg, Norway, Thea Christiansen met Andrew Olesen during a visit to her sister in Christiania (Oslo), Norway. At the time, Andrew was working as a sailor and ship's carpenter for vessels traveling to Canada and Minnesota. They continued their courtship across an ocean when Andrew moved to join the Norwegian community in St. Paul, Minnesota, and Thea stayed behind, working as an indentured servant to earn the price of her passage. In 1882 she joined Andrew in Minnesota, where they married and changed their names to become Mr. and Mrs. Olesen-Fossen (later Americanized to Foss). After eight years and three children, the family determined to move to the Pacific Northwest, where, Andrew hoped, he could take advantage of construction jobs in the booming timber and fishing industries. Once again, Andrew moved in advance of his family, a separation that lasted for eight months, until the family joined him along Tacoma's bustling Commencement Bay waterfront in a houseboat Andrew built from scavenged timber.[21]

The family continued to struggle, with Andrew taking odd jobs in construction as they came along. But Thea's years of managing on her own had given her the knack for making something out of nothing. They fished or bought supplies from Native American fishermen. With no running water, Thea and the children carried water from a stream a quarter of a mile away. When Tacoma city officials determined to divert the Puyallup River to foster industrial growth, the Fosses moved their houseboat to Hallelujah Harbor. As the family story goes, one day when Thea was sitting on the porch of her houseboat, a frustrated Norwegian fisherman offered to sell her his rowboat for five dollars. Thea took him up on his offer, then turned around and sold the boat for fifteen dollars. She bought two more rowboats and began renting them out, and by the time Andrew returned from a construction job days later, she had put aside a tidy sum and begun to think about a bigger boat business. She persuaded Andrew to lend his carpentry skills to the enterprise, and in time they had a fleet of two hundred small vessels, which they rented to fishermen and duck hunters and sawmill workers along the Tacoma waterfront. Soon, they moved on to steam-powered vessels, inaugurating Foss Launch and Tugboat (now known as Foss Maritime Company, one of the largest maritime firms in the West).[22]

Thea and Andrew Foss took expert advantage of their position on Puget Sound's "marine highway." By the 1890s, commerce and industry moved and thrived along the waterway from Olympia at the southern end of the Sound, through the inland passages,

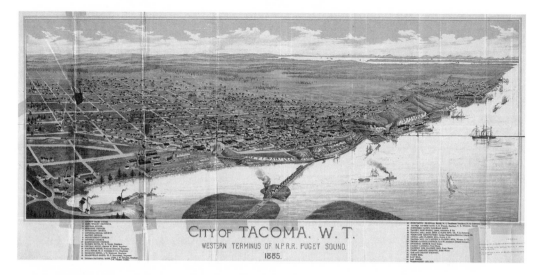

Map 6 | *City of Tacoma, W.T.: Western Terminus of the N.P.R.R. Puget Sound, 1885.* Washington State Historical Society.

to the British Columbian and Alaskan coasts. Seattle's new settlers, like the Salish peoples before them, linked travel and communication to waterways. Thousands of steamships moved between small ports and piers, hauling everything that needed to be moved: settlers, goods, produce, livestock, mail, timber. The Fosses capitalized on ship-to-shore traffic, renting rowboats, investing in powerboats to launch a ship-to-shore delivery service, and eventually servicing all ships anchored on the Sound. As business grew, they hired additional Scandinavian workers, who lived in the dormitories and traded at the Foss general store managed by Thea.

A woman who admitted to a fear of water, Thea Foss made a fortune from it. Working within the structure of family networks, she reinvented herself as an entrepreneur. And while most Scandinavian women in Seattle chose not to work after marriage, Thea reconciled her genius for business with cultural expectations about woman's place.

FROM MOUNT FUJI TO MOUNT RAINIER

Scandinavian women sailed across the Atlantic, then made their way across a continent to claim a home in the Northwest. But women came from all directions with similar purposes. Japanese women, moving eastward across the Pacific, were similarly motivated by both a sense of adventure and the lure of a better life in the American West. Yet while Anglo-American Washingtonians welcomed and encouraged Scandinavian family migration, Japanese women's immigration was the unintended result of federal efforts to reduce Asian immigration to the West Coast.

From the early nineteenth century forward, Puget Sound entrepreneurs had actively

pursued business ties with Hawaii, China, and Japan. Yet despite growing commercial connections, there was little movement of populations. In 1853, Japan ended a two-hundred-year policy of isolation from Europe and America, but immigration remained tightly controlled. Japanese migrants began traveling in significant numbers to the United States after 1885, when Japan officially lifted its ban on emigration. Japanese men, mostly younger sons, flocked to seek jobs in Puget Sound's fishing, logging, and maritime industries, following in the footsteps of other immigrant men who had headed west without expecting to settle permanently. Seattle, the first American city to establish regular trade routes with Japan, soon became a major point of entry to the continental United States for Japanese migrants.

While merchants pursued trade with Pacific nations and did what they could to attract Asian workers, Asian immigrants themselves faced mounting racism in the West. The Chinese Exclusion Act of 1882 prohibited the immigration of Chinese into the United States. A wave of violence spread throughout the West during the economic downturn of 1885 and 1886. In Tacoma, mobs forced Chinese workers and their families from their homes and onto outbound trains. A few months later, Seattle citizens expelled all Chinese remaining in the city. To the south, the California Asian Exclusion League campaigned to segregate Japanese and Korean children from white children, and in 1906 the San Francisco school board voted to remove the children to "oriental schools." The Japanese government, fearing a Japanese Exclusion Act, pressured President Theodore Roosevelt to rescind the California legislation. Roosevelt and the Japanese officials resolved the conflict through the act of diplomacy known as the "Gentlemen's Agreement." In exchange for rescinding the school board's decision, Japan agreed to issue passports only to nonlaborers and to limit immigration to parents, wives, and children of men already in the United States.[23]

Thus ironically, popular agitation to prohibit Asian men from coming to America had the unintended consequence of spurring the immigration of women and children, who came as family members of men already in the United States. Wives of men who had already made the journey crossed the water to reunite with their husbands. Special sightseeing tours, known as *kankodan*, also assisted young unmarried men in Seattle and Tacoma in finding wives.[24] For those unable or unwilling to make such a journey, family members acted as legal go-betweens in arranging marriages. These women, often known to their prospective husbands only through letters and photographs, were soon labeled "photograph brides" or "picture brides" by U.S. Immigration officials. Shige Owaki, like many of these women, packed a single *yanagi-gori*, or willow container, to hold all her possessions as she made the monthlong journey from Nara, Japan, to Seattle to meet her new husband, Yoshinosuke (figure 37). As Japanese women moved into the region, Japanese communities sprang up all along the West Coast, rooted in family and work. Shige and Yoshinosuke together would start up the successful Deerborne Bakery in Seattle's Asian district.

Japanese women who journeyed to Puget Sound extended their cultural waterscape

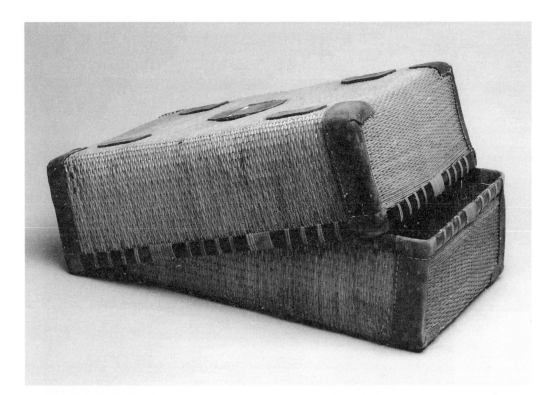

37 | *Yanagi-gori* (willow container), 1921, used by Shige Owaki. Gift of Frances Owaki, Japanese American National Museum; 2000.283.1.

across the ocean. From Mount Fuji to Mount Rainier, the starting points and endpoints of their journey, water and mountainscapes framed both the familiar and the strange. Far from home but connected to Japan by the lively transpacific trade, these women both adopted new ways and maintained tradition. Although most exchanged their kimono from Japan for American-style outfits upon arrival, they fed their families the foods they knew from home. The Araki family, for example, used traditional rice steamer boxes, as they had in Japan, to make *mochi* (sticky rice cake) for New Year celebrations in Seattle. Writer Monica Sone described the pantry of her Nisei home, where "the sack of rice and gallon jug of *shoyu* stood lined up next to the ivory-painted canisters of flour, sugar, tea, and coffee."[25] As avid purchasers and consumers of soy sauce, polished rice, and tea, Japanese women helped power the growth of wholesale companies especially set up to cater to newly arrived brides. One Seattle-based Japanese grocer thrived on furnishing "the whole kitchen requirements for the women, from the pots and pans down to the smallest cooking utensils."[26] *domestic economy*

Puget Sound's shores also offered a bounty of familiar foods. As a young girl growing up on Bainbridge Island, Carole Ann Hatsuko (Koura) Kubota recalled wading in the surf at Point White with her grandmother, aunts, and uncles from Seattle in order to

38 | Rice steamer baskets, 1920–1940, used by Araki family, Seattle. Gift of Toru and Peggy Araki, Wing Luke Asian Museum; 2002.028.003.

gather strands of nori (seaweed), which they would later "take home, rinse in icy water, and hang to dry on thin cedar poles. After drying, the nori is stripped from the poles and stuffed into pillowcases to be stored for use during the year." In addition to the nori, the beach offered immediate rewards: "tsubo (sea snails) that we will boil, pull from their shells with a needle, peel off the leathery, protective opercula and pop the curled, sea-tasting bodies into our mouths."[27] Women harvested fish, seaweed, clams, and other produce of the sea, both to contribute to their family's subsistence and to renew ties to the Japanese homeland.

Until 1915, the Gentlemen's Agreement limited Japanese immigration to wives and children of farmers and businessmen. Japanese immigrants responded by streaming into agriculture and opening small businesses. Puget Sound's Japanese community spread outward from Seattle and Tacoma into the valley between the Puyallup and White rivers. In a signal demonstration of bravery and enterprise, emigrant families moved onto logged-over lands on the islands of Bainbridge and Vashon, where they took up the hard work of farming for the market.

Alien land laws shaped Japanese families' decisions about where to invest time, labor, and money. State legislatures first banned the sale of land to foreigners declared ineligible for citizenship in 1889, and the Washington Alien Land Law (1912) further prohibited the leasing or renting of land to noncitizen residents. Despite the laws, white land-owners wanted a way to turn deforested land, blanketed with stumps and littered with debris, into productive farmland. So they circumvented laws preventing Japanese land-ownership by leasing land in exchange for the backbreaking work of clearing tree stumps, draining marshes, and digging ditches. Japanese farmers managed to get the best out of the logged-off holdings by planting berries and other crops that required less land and allowed them to work around the stumps. Some Japanese farmers bought land that they then managed through another, white farmer. Other families purchased land in the names of their American-born children, legal citizens by birth, and soon were raising strawberries and other produce on land that had been laid waste by the timber companies.

A 1911 government study of the Seattle-Tacoma area described the average Japanese farm home as a simple frame building of four small rooms quickly built on first arrival and with the expectation of a short lease. Japanese wives expected to spend more time in the fields than the house, and as tenant farmers they had little to invest in home fur-nishings or comfort. Indoor plumbing was nonexistent and furnishings Spartan, al-though most Japanese families added a wooden bathhouse, or *ofuroba*.[28]

Like logging, railroad construction, and fishing, berry and vegetable farming entailed a tremendous amount of manual labor. But whereas the lumber and railroad camps were overwhelmingly the domain of single men, on the farmsteads organizing work was a family matter, and family embodied a direct link between producers and consumers. By the 1920s, Japanese farm families produced 75 percent of Seattle and King County vegetables, and networks of Japanese vendors, peddlers, stallholders, grocers,

retail merchants, hotels, and restaurants linked these small family farms to both local and global enterprises.

Women joined their husbands and fathers as small business owners and as workers both in and outside the home. By the 1930s, more than 60 percent of Japanese women engaged in some form of paid labor, a number that did not include women's unpaid work in the home.[29] Sen Natsuhara recalled the challenges accompanying her first home in Auburn, where "I had to carry water every day, in buckets or oil cans, as the well was about 200 feet from the house, on the landlord's property." Kimiko Ono described a day begun before dawn picking tomatoes in the family's greenhouse, followed by preparing breakfast and getting her children ready for school. While her husband left to take the tomatoes to market, she watered the plants. When her husband returned, she prepared dinner and put the children to bed, then returned to sorting tomatoes for the next day's market. Whether hauling water for the family, watering tomatoes, working in laundries and bathhouses, or harvesting strawberries in the field, women combined work for the market with taking care of their families.[30]

Kimiko Ono's story also reveals her family's connection to a place along the waterscape that would become a Seattle icon: Pike Place Market. At the beginning of the twentieth century, Seattle, like other growing cities, was fast becoming home to a population that no longer grew its own food but relied on middlemen to distribute the produce from farm and ranch, field and dairy. Consumers in the city were outraged at what they regarded as price gouging on the part of food brokers and demanded that the city step in to regulate shady practices in the food trade. In 1907, the city established a public market along the waterfront at Elliott Bay. The Pike Place Market was a smash hit from the first; on the day the market opened for business, farmers sold out before they had even parked their wagons. Shoppers, mostly women, arrived by wagon and boat, on foot, or by carriage, streetcar, or bicycle, from all parts of the city and all classes, representing every ethnic group in the city's diverse mix. The market was alive not only with the sound of vendors crying their wares but also with the sound of Swedish, Norwegian, Chinese, Japanese, Finnish, Serbo-Croatian, Italian, Chinook, and Tagalog.[31]

Japanese women were crucial contributors to their families' success in creating homes and stable communities in the West. But that very success provoked a racist reaction. Exclusionists pointed to high birthrates among Japanese immigrants, a result of the large numbers of marriages following the Gentlemen's Agreement. An article published in the *Seattle Star* under the banner "Shall the Pacific Coast be Japanized?" argued for the need to stand against an invasion of mothers, observing, "It is because Japanese women are so prolific that they present a menace to the Pacific Coast. We do not deny their right to give birth to children. But we view with alarm the ever-growing population of Japanese in the Pacific Coast."[32]

Nativist fears shaped immigration policy between 1890 and 1924, as Western states passed a series of exclusion laws attempting to contain the peril of thriving communities full of women and children. Ultimately, the 1924 Immigration Act halted all Japa-

nese immigration to the United States. But Japanese American communities, strengthened by hard work and family and economic success, embodied the very ideals whites claimed for the American dream. Despite the worst efforts of nativist neighbors and the American government at all levels, Japanese emigrants and their children were putting down tough roots in Western soil.

INDUSTRIAL WATERS

By the dawn of the twentieth century, water was on its way to becoming a commercial, rationalized, and mechanized resource, and both the means and the object of burgeoning cities full of consumers. Elizabeth Warhanik, one of Seattle's early-twentieth-century artists, captured the changing waterscape of Puget Sound (plate 19). Warhanik represented a broader regionalist movement in American art, in which painters presented local themes in modern, realistic styles. Women painters figured prominently in regionalist movements, and like other women artists in California, New Mexico, and other Western locales, Warhanik sought to depict a spirit and landscape unique to her homeland, the Pacific Northwest. In the 1920s she turned away from still lifes and other subjects considered "ladylike" to paint the ships, harbors, and locks at the heart of Seattle's industrial waterways. Warhanik's paintings of Ballard's Fisherman's Wharf and Seattle's harbors and docks featured lush painterly strokes mimicking the movement of waves while also capturing the smokestacks and industrial warehouses of the working waterscape.[33]

Warhanik found beauty in Seattle's gritty, bustling harbors. But Ella Higginson, a Washington poet and naturalist, wrote passionately about threats to Puget Sound's natural glory. Higginson worried that an "eastern" mentality that valued profit over beauty was spreading across Puget Sound, "blind to all these things, [coming to] tear down our forests, rip open our mountain sides, blow out our stumps with giant powder, dam up our water ways, and see in our wide, sea-weeded tidelands only 'magnificent places for slaughter houses, b'God,' and in our blue, shining sea only so much water that at ebb tide would 'carry off the filth, y'know.'"[34] An early advocate for conservation, Higginson was horrified at the rapid destruction and pollution of the region's natural resources under the banner of progress.

Nothing more clearly embodied the possibilities and costs of progress than the fate of the salmon in Puget Sound. Nineteenth-century settlers had overlooked salmon as a resource, although it remained an economic mainstay and cultural symbol for Native people. In treaties following the Indian-American conflicts of the 1850s, salmon had been so little valued by whites that they readily granted Puget Sound's tribes the right to continue to fish in common. But those rights would be contested soon enough, as American fishing interests to the south overfished the Sacramento and Columbia rivers. In 1877, the first salmon cannery appeared on the shores of Puget Sound. By the end of the nineteenth century, more than a half million cases of canned fish were being

packed every year in canneries across Bellingham Bay, Lummi Island, Semiahmoo, and Chuckanut Bay. Puget Sound salmon had become a commodity with enormous economic potential, and by 1919 Washington ranked second in the United States in fish processing.[35]

The Smith butchering machine perhaps best epitomized the industrial transformation that so horrified Higginson. Introduced in 1903 in Bellingham, the Smith machine cut off the head and fins of a fish, split and gutted it, and then cleaned it with water jets. Named the "Iron Chink," after the derogatory term for the Chinese workers it displaced, advertisements for the device proclaimed that it would solve the "oriental labor problem" by cleaning salmon better, faster, and more economically.[36]

Cannery operators also solved their labor problem by employing women. As salmon canning became more mechanized after 1890, employers increasingly preferred European American women, many the wives and daughters of local fishermen, who extended their domestic work—processing food, cooking, cleaning—to work alongside male family members. Katherine (Tink) Mosness, the daughter of a lumberman, explained that, "when you marry a man who is in fishing, you eat, sleep and breathe fishing. It changes the whole family."[37]

Puget Sound's canneries employed a diverse workforce: European immigrants, Chinese and Japanese men, Native women, and European American women. A 1926 government study of Washington's canning industry, sponsored by the Woman's Bureau, reported that in one cannery, the women workers, mostly Native American, were hired through a Chinese firm, and the payroll information was in Chinese. During peak season, when canneries relied on "extra hires," almost equal numbers of men and women were employed.[38]

As Puget Sound's canneries expanded, women were mostly hired for the tasks of gutting, packing, and canning, or trimming and mending cans. They worked in barnlike structures running along the shoreline, often built over the water. Women stood in the small, cramped spaces of the canning and trimming lines, where floors were constantly wet and slick, even if the floors were constructed with gaps between the floorboards to allow water to drain off. One woman, interviewed at the end of the season, declared "she had enough of the cold and wet work and at that moment preferred starvation without work to freezing." "Good pay," another woman admitted, "is the only compensation for this job."[39]

As historian John Findlay noted, "Salmon became something of a symbol of the American Northwest not so much in its 'natural form,' but as a canned good that permitted consumers across the globe to sample a taste of the region."[40] The tins of canned salmon with their colorful labels depicting Puget Sound scenery (plate 20) were marketed around the world. Salmon in cans symbolized both the rapid industrialization of Puget Sound and a modern consumer culture in which women served as chief purchasing agents for their families. Canned fish seemed, at first, like a tough sell, associated as it was with military rations. So the companies used multiple strategies to appeal to

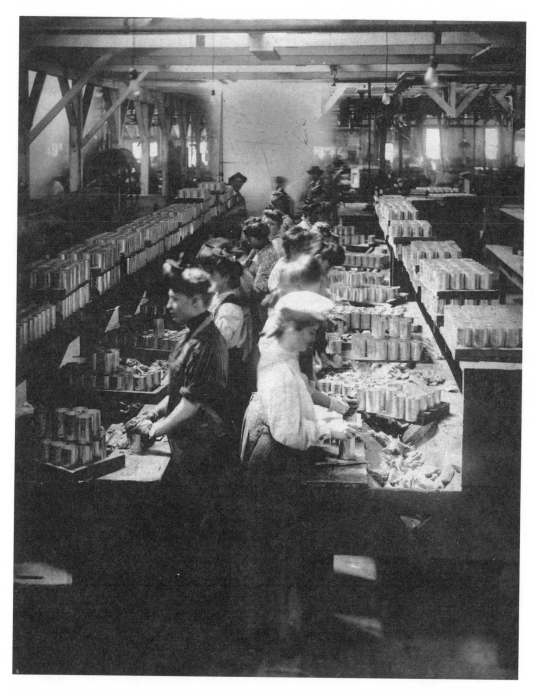

39 | Cannery workers in Bellingham, Washington, 1915, by Galen Biery. Galen Biery papers and photographs no. 1298, Center for Pacific Northwest Studies, Western Washington University, Bellingham, WA, 98225–9123.

40 | *Salmon on Your Table,* advertising brochure, circa 1930–1950 (right), Canned Salmon Institute, Seattle, and *Thousand Dollar Prize-winning Recipes: Canned Salmon,* booklet, Associated Salmon Packers, 1931. Museum of the American West, Autry National Center; 2007.53.1, 2007.53.3.

consumers, advertising canned salmon as affordable and nutritious, sponsoring recipe contests, and publishing fact and recipe booklets. *chicken of the sea*

As we have already seen, not everyone applauded every facet of the industrialization of Puget Sound. Women who labored in industries like salmon canning endured dangerous and exploitative working conditions, and Progressive reformers had begun to pay attention. They pioneered a new kind of politics, linking the problems of female workers with the power of female consumers. Alice Lord, who arrived in Seattle looking for work during the Alaskan gold rush boom, found conditions so appalling that she organized the Waitress Union Local 240. Labor activists like Lord joined forces with clubwomen, suffragists, and the National Consumers League to campaign for equal wages, job protection, and increased professional opportunities for women. They won significant victories. After two defeats in the state legislature, Washington women won the right to vote in 1910. In 1911 Washington became one of the first states to enact workmen's compensation laws, including eight-hour laws for women in a range of occupations, although significantly, cannery workers were exempted from the law.[41]

Even as they fought the worst aspects of industrialization, women also sought to use their power as consumers. After 1919, when a general strike in Seattle failed, union leaders appealed to the wives of workingmen to reshape their shopping and spending habits, to buy union-made goods in order to support improvement of working conditions. There was some irony in this strategy. As historian Dana Frank explained, "Such campaigns involved an intensification of housewives' labor as consumers"—even as unions were marginalizing and even excluding women as workers.[42]

As activists pushed to mobilize women by connecting workers to consumers, by linking the cannery worker—wielding her scaling knife in a sodden canning shed—with the housewife opening a can of salmon, cooking, and washing the dishes, a new kind of gender politics began to emerge in Puget Sound. "Municipal housekeeping," a slogan that had launched Progressive women's efforts throughout the nation, combined efforts to clean up political corruption, make business efficient, protect workers and consumers alike, and promote a vision of metropolitan life founded on spotless, efficient middle-class households. At the crest of this wave of reform, Seattle became the first big city to elect a woman mayor. Bertha Knight Landes rose to power in the city by making the connection between the realm of the household and the domain of commerce and industry (figure 41).

Born in Ware, Massachusetts, in 1868, Bertha Knight met her future husband, the geologist Henry Landes, when both were students at Indiana University. They moved to Seattle in 1895, where Bertha Landes settled into life as a mother and University of Washington faculty wife. Like other members of the first great generation of college-educated women, she sought out women's organizations. She would be a founding member of the Women's City Club and go on to win the presidency of the Seattle Federation of Women's Clubs. While Seattle's working women formed unions and cooperative guilds, Landes organized Seattle's middle-class women to promote the Women's

41 | Bertha Knight Landes, date and photographer unknown. University of Washington Libraries, Special Collections, Portraits Collection, UW7333.

Educational Exhibit for Washington Manufacturers in 1921. The exhibit, an attempt to boost Seattle's image as a modern city, showcased more than one hundred Washington industries, with a staff of female demonstrators assigned to educate visitors about each manufacturing process.[43]

Landes's success in club work and civic boosterism led to an appointment on the mayor's unemployment council. From her base in women's organizations and the business community, she would be one of two women elected to the Seattle City Council in 1922. "The City of Seattle represents a great big family," she said, "consisting of men, women and children, each with their own peculiar needs and desires which must be attended to in addition to the general welfare of the city."[44] She was reelected to the city council in 1924, and in 1926 determined to run for mayor.

At the time, women held less than 2 percent of the seats in the nation's state and federal legislatures. But in the West, women began to crack the political glass ceiling. Two women, Wyoming's Nellie Tayloe Ross and Oklahoma's Miriam Ferguson, won election as state governors in the mid-1920s, both succeeding their husbands. Montana suffragist Jeannette Rankin had broken a path for women's independent entry into politics, winning a seat in the United States House of Representatives in 1916. Bertha Knight Landes was the first woman to vie to run an American city entirely on her own.

Landes skillfully balanced an appeal to women's special concerns with a common-sense approach that emphasized progress and growth for all citizens. Her campaign

asked, "Not WHO but WHAT does SEATTLE NEED?" Her list of answers linked the public world associated with men with the private realm identified with women: "business prosperity, business activity and stability, employment, Homes Built, Homes Paid For, Homes Safeguarded."[45] In nightly radio talks, she championed utility development, conservation issues, and civic decency. Supported by a coalition of male and female voters, Landes beat her opponent by 5,898 votes in a record turnout.[46]

As a politician, Landes placed herself squarely at the intersection of the family and industry. Newly elected and the object of national curiosity, she staked out her political turf: "City governments exist largely because of the family and the home, and their first duty is to serve these two institutions. . . . There is nothing sentimental or womanish in this philosophy, I insist. It is hard common sense. No city is greater than its homes."[47]

Hitching her star to the idea of a modern metropolis built on domestic comfort for happy, healthy families, Landes brandished waterpower as the mightiest means of fulfilling her vision. As a councilwoman, she had worked to continue development of the Skagit River dams to provide cheap power to fuel the city's growth. The harnessing of the power of the Skagit, which flowed from British Columbia through the Cascade Range and down to Puget Sound, had begun as early as 1905. The Gorge Dam, first of three dams to be built on the Skagit, was completed in 1921, and construction of a second, Diablo Dam, began during Landes's tenure as mayor.

At every phase of her career, Landes worked to expand public services and supported public ownership of utilities. As she invoked the rhetoric of municipal housekeeping, she put her faith and her most sustained efforts in promoting hydropower. Like many other Progressive Era reformers, Landes believed cheap power would provide more democratic control of land and resources, mitigate crowding and pollution, transform the desert into a garden, and improve women's lives by reducing labor in the home.

Western cities like Seattle invested in water as a civic good. In the 1890s, fearing outbreaks of cholera and other diseases, city officials financed a large-scale project to lay miles of sewer lines to flush away the grime and disease of city streets. Proponents of hydroelectric development in the 1920s and 1930s saw waterpower as both a catalyst of industrial growth and a positive force for improving domestic life. The Pacific Northwest's dams became the engines of a consumer and household revolution. Corporations, builders, home economists, and women's magazines promoted electricity as integral to the modern and efficient single-family home. Advertisements encouraged women to buy electrical appliances, from washing machines to clean their ready-made clothes, to refrigerators to store produce from irrigated farms and fish from the Sound, to dishwashers made to sluice away the remnants of meals made from canned, refrigerated, and ultimately, frozen foods. Seattle's City Light, the municipal utility company, actively promoted the use of electricity in the home in the 1920s and 1930s. The company sold electrical appliances, hired home economists to advise customers, and sponsored women's club tours of Gorge Dam in the hope that women would connect their cozy homes to the behemoth power plants that had reconfigured the ways people lived and worked.[48]

42 | Woman standing in mouth of Penstock Tunnel, Gorge Dam Powerhouse,
April 1, 1924, photographer unknown. University of Washington Libraries,
Special Collections, Seattle City Light Albums, UW28279z.

Electrical appliances, however, did not eliminate women's work in the home. Instead, the new devices led women to wash clothes more often, put more energy into shopping and cooking fancier meals, and spend more time keeping the house cleaner, even as the marketing of "labor saving" technology encouraged the public to imagine that housewives had become ladies of leisure.[49] The demand for power for home consumption—everything from electrified houses and appliances to street lighting—preceded and laid the foundations for Puget Sound's wartime industrial and economic growth.

Boosters like Bertha Knight Landes saw waterpower as a social panacea. Other Puget Sound women were concerned that the industrialization of water carried high social and environmental costs. In 1936, Tacoma artist Virna Haffer captured with her camera the drama of a Native American family net fishing, poised on a platform among the crashing waters of Celilo Falls (plate 21). A place where generations of Indian families had sustained themselves by fishing, Celilo Falls was one of the few Indian fisheries that had survived the encroachment of industrial fishing into the 1930s. Some two thousand men and women continued to gather to catch migrating salmon using tall wooden platforms and large dip nets. Haffer captured a vibrant cultural waterscape soon to disappear. In 1957, with the construction of the Dalles Dam, the falls were flooded and submerged, and a way of life that had lasted more than ten thousand years was destroyed.

PUGET SOUND WOMEN AND WORLD WAR II

As workers, consumers, and politicians, women took part in the radical transformation of Puget Sound's waterscape and possibilities. Bertha Knight Landes had declared as early as 1927 that Seattle stood at the center of "richness in water power resources of the entire nation." She predicted that "water power would secure for Seattle a great industrial future."[50] Landes's prediction came true in a remarkably short time. Dam construction provided jobs even in the depths of the Depression, and cheap electricity produced by the state's new dams attracted further federal investment to Puget Sound. With the outbreak of World War II, the region was perfectly positioned to become an epicenter of wartime production. In 1943, Belle Reeves, Washington's first female secretary of state, boasted that Seattle ranked among the top three cities in the nation in war contracts per capita. "No state has been more profoundly affected economically by the expansion of war industries than Washington," Reeves declared.[51]

The war uprooted thousands of families and brought droves of expectant workers into the region. Husbands and sons left to fight overseas. The boom in shipyard and industrial jobs set off new waves of migration. More than a quarter million new people moved to the area within two years. Historian Karen Anderson has argued that such social upheaval fell hardest on the household: "The housing shortage, child care problems, the tensions of geographic and social mobility, and other adversities of wartime living contributed to the stresses on family life." Marriages, births, and divorces skyrocketed.[52]

For some American women, the war truly came home. After Japan's attack on Pearl

Harbor on December 7, 1941, decades of anti-Asian racism intensified into a panic over an imagined threat of subversives in the homeland. Throughout the West, Japanese Americans faced economic boycotts, curfews, and ultimately arrest. On February 19, 1942, President Roosevelt issued Executive Order 9066, authorizing the forced relocation of Japanese families from so-called "sensitive areas" to internment camps in the interior of the West. By March 2, Lieutenant General John Dewitt claimed the entire West Coast as such a key military zone.

Suddenly, the Puget Sound waterscape looked and felt different, as neighbors eyed one another uneasily, wondering who was loyal and who looked suspicious. Monica Sone, who would write about this time in her memoir, *Nisei Daughter,* recalled feeling "acutely uncomfortable . . . living on Beacon Hill." Suddenly, she saw how "the Marine Hospital rose tall and handsome on our hill, and if I stood on the west shoulder of the Hill, I could not help but get an easily photographed view of the Puget Sound Harbor with its ships snuggled against the docks. And Boeing airfield, a few miles south of us, which had never bothered me before, suddenly seemed to have moved right up into my back yard, daring me to take just one spying glance at it."[53]

Executive Order 9066, a product of rising war fear, was also the consequence of altered cultural landscapes or, in the case of Puget Sound, waterscapes. When well-established patterns of racism met the war crisis, girls like Monica Sone suddenly looked like threats to nearby navy shipyards, including Bremerton, where five of the surviving battleships from the attack on Pearl Harbor had been brought for repair.

In March 1942, the Japanese American families of Bainbridge Island became the first in the nation to be relocated. Over 250 Japanese Americans, mostly farmers and fishermen, lived on Bainbridge Island. Ikuko Amatatsu, a teenager just about to graduate from high school, was given six days to register, pack the limited amount of clothing, bedding, and necessities allowed under the order into two suitcases, and dispose of remaining home and household goods. On March 26, army trucks transported Ikuko, her mother, and three sisters to the dock, where they boarded a ferry heading to Seattle. From there, they traveled by train to the Manzanar War Relocation Center in central California. A silent crowd of two thousand people, including many sympathetic friends and neighbors, watched them leave. As the local newspaper reported, "For many days previously, the Japanese made 'good-bye' calls on their Caucasian friends. Especially tearful were the parting scenes at Bainbridge High School where friends of many years were forced to part."[54]

The larger number of Japanese American citizens in Seattle and Tacoma posed a different challenge. The Civilian Conservation Corps, a New Deal agency established to do conservation work in the nation's wilderness and rural areas and provide jobs for unemployed young men, was charged with the task of running relocation camps for Japanese Americans. The agency's workers hastily erected an assembly center twenty-five miles south of Seattle, on the grounds of the Western Washington Fairgrounds in Puyallup. The buildings were little more than two-by-four planks laid over scraped ground, with

boards nailed onto them, and tar-paper roofs. Some white Americans were appalled. Joseph Conard, documenting the Seattle relocation for the American Friends Service Committee, described the buildings as "approximately 40 rows of these rabbit hutches. 4 hutches to a row, 6 rooms to a hutch. Each room is about 20 feet square and separated from the next room by a partition that runs up part way to the roof." Conard concluded: "If you were to take the members of the Board of the Service Committee and their families and herd them all into huts on the Sesquicentennial Grounds in South Philadelphia, the disgrace would be no worse than it is to take these charming, cultured, college-bred young men and women and their mothers and fathers and brothers and sisters and herd them together in these boxes in Puyallup."[55] Dubbed "Camp Harmony," these hastily erected barracks and converted stables soon housed more than seven thousand Japanese and Japanese American men, women, and children. For these families, Camp Harmony would be home for several months, until final relocation to the Minidoka Relocation Center or one of the other internment camps in the Western interior.

In assembly centers and camps, women sought to make a home even under horrible conditions. Uprooted from the waterscape of Puget Sound, they found themselves in places where water, or the lack of it, was a perpetual problem. Simple tasks like laundry, cooking, and bathing the family became newly difficult. Long lines, overcrowding, the ever-present mud, disgusting communal latrines, and the absence of plumbing complicated their tasks. But families determinedly salvaged dignity, privacy, and comfort against heavy odds. They scavenged scrap wood and nails to make rudimentary furniture. Geta, the traditional Japanese platform sandals, became popular with every generation as the shoes helped people navigate muddy lanes. Women strung curtains across partitions and windows to provide privacy and comfort. An American Red Cross report described the appearance of living quarters at Puyallup, where "most of the walls are decorated with calendars, pictures from magazines, or sketches done by the evacuees."[56]

Executive Order 9066 forced more than twelve thousand Japanese and Japanese Americans from their homes. Many chose not to return to Puget Sound at the war's end. For those who had not lost their former homes, vandalism to their property and continuing harassment from anti-Japanese groups opposed to resettlement persuaded many to move to the Midwest and East, as they set about reestablishing their homes and families.

WOMEN IN WAR PRODUCTION

As Puget Sound's Japanese American families were dispossessed, men and women from across the nation flocked to the Northwest looking for war work. Servicemen flooded military bases in Tacoma, Olympia, Bremerton, and Seattle. Workers from across the country came to Seattle and Tacoma to fill jobs in the busy shipyards and aircraft factories. With the influx of millions of dollars in federal contracts, Puget Sound would be transformed once again. Commercial trade and agriculture would give way to a more intensive

focus on industry. Although women had always played an important role in the Puget Sound workforce, they would soon take on occupations previously reserved for men. As men temporarily left their families for military service or for jobs in war production in other cities, women tackled new family responsibilities and new opportunities.

The heavy demand for war workers led the federal government to launch a campaign to bring women into wartime industries. Cities like Seattle launched door-to-door solicitation drives to persuade women to enter the workforce. Business supported the effort, as indicated by the advertisement sponsored by I. Magnin and Company, a posh department store, confidently asserting that "an American homemaker with the strength and ability to run a house and family . . . has the strength and ability to take her place in a vital war industry."[57]

Pulled by both patriotic duty and the opportunity for higher-paying jobs, women—young and old, single and married—streamed into Puget Sound's aircraft plants, lumber mills, foundries, and shipyards. For the first time, married women entered the workforce in significant numbers. Seattle and Tacoma shipyards hired more than ten thousand women workers in 1943, and working mothers provided new role models for their daughters. Eugenie Thrapp, eighteen years old and bored with high school, dropped out and followed her mother into an aircraft production plant, where she was trained as a riveter. Sewing seams on the nose section of the aircraft, she worked nine hours a day, six days a week. Freda Philbrick, who applied for a job at the Puget Sound Navy Yard, admitted that "somehow the kitchen lacks the glamour of a bustling shipyard." By 1944, women over forty made up 35 percent of female workers.[58]

Higher-paying jobs and the excitement of war work attracted women like Eugenie Thrapp and Freda Philbrick. Male workers' reactions to their new colleagues, however, ranged from support to wariness to outright resistance. Union leaders in Seattle and Tacoma protested that women were physically incapable of doing the job, that they would distract male workers, and that giving women money of their own would sow marital discord within the home. African American women faced additional challenges from their coworkers, including white women. In Vancouver, Washington shipyard managers fired six African American women after they complained about the insults constantly hurled at them by their white supervisors.[59] When all was said and done, women in Puget Sound shipyards seldom advanced beyond unskilled jobs, and the messages directed at them were at best mixed. As late as 1944, government propaganda posters simultaneously declared, "America's women have met the test" and "We never figured you could do a man-sized job."

The figure of Rosie the Riveter has become the emblem of women's wartime contributions, and there were Rosies aplenty in Puget Sound, the sound of their riveting guns ringing across the shipyards and airplane factories. But even at the height of war production, most Puget Sound women worked first as wives and mothers. Rosie returned from her shift at the factory to face the job of feeding, cleaning for, and caring for her family. Scarcity and rationing during the war made the task of shopping and food prepa-

43 | "Shop 06 Tool Sharpeners, Navy Yard Women Employees," Bremerton Navy Yard, Washington State, World War II. Navy Museum Northwest, Bremerton, Washington.

ration a complex and time-consuming task for women on the home front. Women juggled ration cards and point systems, stood in long lines, adjusted work and child-care schedules, and dealt with shortages of meat, sugar, and vegetables as best they could. The U.S. government initiated an extensive propaganda campaign in radio, ads, posters, and pamphlets to encourage families to comply with rationing. The Office of Price Administration rallied women around the motto "Use it up, wear it out, make it do, or do without." The government also sponsored training sessions for women on how to shop, conserve food, plan meals, and grow and can food.

A small number of adventuresome women took another approach to the changing waterscape and seized the chance to serve in the women's auxiliary of the U.S. Navy. Prior to the war, the navy had prohibited women from serving, but in the summer of 1942 Congress authorized legislation that allowed unmarried women to enlist. Elizabeth Dean, a white schoolteacher from Nebraska, enlisted in the WAVES (Women Appointed for Voluntary Emergency Service), hoping "to see a lot more of the world." Her training took her from Nebraska to Iowa and then on to New York, before she was finally stationed in Seattle.[60] By March 1943, more than three hundred WAVES were stationed

44 | World War II ration book, U.S. Government Office of
Price Administration, issued to Clarence and Queenie Holt,
Washington, 1943. Museum of the American West, Autry
National Center; 2006.1.1.

at Sand Point Naval Station in Puget Sound, where they worked as metalsmiths, aviation machinists, parachute riggers, storekeepers, and radio and switchboard operators. In Tacoma, the WAVES set up a recruiting office where they staged contests, ship christenings, and other publicity events to promote navy service.

The movement of women into Puget Sound during the Second World War opened the door to new possibilities. The desperate need for women's war work focused national attention on problems, including child care and equal pay for women. Wartime exigencies gave rise to the Lanham Act, the first federally funded child-care program, and in 1942 the National War Labor Board endorsed the principle of equal pay for equal work. When wartime priorities deprived many tribal reservations of federal funding and services, larger numbers of young men and women migrated to Seattle for wartime service and jobs. Adeline Skultka Garcia, along with her sister and cousin, left her Haida village in Alaska to look for war work. She found a job on the Boeing assembly line in Seattle. Native women also migrated from the Midwest. Lily Laveau, an Ojibwa, left her job in a wood-processing plant in Westlund, Minnesota, when Boeing recruiters enticed her and her sister to more lucrative jobs in a Seattle plant.[61] Wartime plants such as Boeing, Solar, Douglas, and Thompson aggressively recruited Indian workers, and as much as one-fourth of the tribal population left reservation lands for urban centers during the war. For women from a variety of backgrounds, wartime work accelerated earnings and mobility; it also placed women's work at the center of the postwar material expansion of the American dream.

TOXIC WATERS AND RECLAMATIONS

Seattle's iconic space needle and monorail were landmarks of the city's 1962 "Century 21" World's Fair and symbols of the city's bright future. Yet the waters would soon circle back in unexpected ways. Although the fair proclaimed "better living through modern science," some women had begun to challenge such visions of the good life. They organized around their own visions of both past and present. In 1958 a handful of Native American women who had come across the West to make Seattle home during World War II, including Adeline Skultka Garcia, founded the American Indian Women's Service League. They meant to confront issues of urban poverty, health, and cultural preservation, and to gain recognition of their right to shape the city's future.[62] In the following decade, Seattle's Japanese American artists and activists would organize the nation's first Day of Remembrance, held as a family potluck on November 25, 1978, at the Puyallup Fairgrounds, former site of Camp Harmony. Author Monica Sone, activist Cherry Kinoshito, and Councilwoman Dolores Sibong fought to reclaim a legacy of home places, seeking redress for businesses, jobs, and homes lost to Executive Order 9066 and winning important victories at the city, state, and federal levels.[63] And when progress in the form of modern development threatened to raze the old Pike Place Market, women and men joined to preserve it. Revitalized in the 1970s as a community farmer's market with

a mission of allowing consumers to meet the producers, Pike Place fit neatly into the emerging image of Seattle as ecotopia.

The dream of Seattle as the city of the future seemed to come true in the 1990s, as Seattle became a center of high-tech industry. With its manufacturers of aircraft and computer, Internet, and wireless technologies, Seattle embodied the integration of the West into a global marketplace. Seattle's earlier ambition to be the West's eminent port in transpacific commerce had been replaced by the much larger vision of the global information highway. Pacific Northwest entrepreneurs would make Microsoft, Starbucks, and Amazon.com household names.

As Seattle boomed, women across the world once again became the invisible workers in the new economy. Despite the stereotype of information technology workers as young, male, and highly educated, by the year 2000 women made up 47.2 percent of Seattle's information technology workers. Women have also become the fastest-growing segment of the world's poor. The liberalization of free trade and the rise of global markets shifted labor to poor women working assembly lines in countries like the Philippines, Mexico, Malaysia, and Sri Lanka, in a process known as offshoring.[64]

The dark undertow of the new economy became international news one week in 1999. Thousands of protesters took to city streets from November 30 to December 3 to oppose a meeting of the World Trade Organization in Seattle. That fall, as the University of Washington hosted a conference on empowering women to take leadership in the new economy, a coalition of community, environmental, and labor leaders encouraged residents to send a message to the World Trade Organization by joining teach-ins and street protests. Organizations like the Direct Action Network, Workers' Voices Coalition, and Diverse Women for Diversity protested that, rather than empowering women, the organization's policies had increased poverty, unemployment, ecological destruction, and violence against women. In their December 1 manifesto, titled "Seattle Declaration," Diverse Women for Diversity stated its intent to stand for women's "self-sufficiency, self-reliance and solidarity" against corporate globalization.[65] One year later, a slump resulting from the dot-com bust would empty many of the new downtown offices as effectively as the protests.

Puget Sound residents of the twenty-first century face the challenges posed by some of the most polluted waterways found anywhere in the United States. The Environmental Protection Agency identified forty-nine sites throughout Washington as among the nation's worst "Superfund" sites requiring mandatory cleanup, including hot spots along the Duwamish River, Tacoma's Commencement Bay, and Seattle's Harbor Island. In 1999, the Chinook salmon was designated as an endangered species, and by 2006 the Washington Department of Health was warning families to limit meals of Puget Sound salmon due to the high levels of mercury, PCBs, and other contaminants. The problem of pollution in people was further brought home in the 2005–2006 body-burden studies, where ten Washingtonians had their hair, blood, and urine tested for toxins. Every person tested was contaminated with phthalates, PCB, and PBDE (believed

to be tied to infertility and learning deficiencies), as well as twenty-six to thirty-nine other toxic chemicals.[66] Residents of Puget Sound could no longer ignore the fact that the same chemicals in their waterways were coming out of their faucets and even lodging in their bodies.

Women politicians, activists, and consumers, like the municipal housekeepers before them, are once again linking women's private and public spheres through their activities. Washington's Governor Christine Gregoire created the Puget Sound Partnership in 2006, to bring together state, federal, local, and tribal governments, businesses, and activists to return the Sound to health by 2010. So-called eco-moms are rethinking the food they eat, the homes they live in, the cars they drive, and the products they buy. Women across Puget Sound have placed the home at the center of debates over environmental sustainability.[67]

As a new century dawns, Native American women participate in fish-ins, women organize to clean up the damage of a century of industrial water pollution, women wash microchips in booming new factories, and women wash dishes in the sinks of their kitchens in houses in the burgeoning urban landscape. From the woman stopping to gather organic produce on her way home from work at a dot-com start-up, to the tourist snapping a picture of vendors tossing fish at Pike Place Market, the presence of women as both producers and consumers continues to shape the Puget Sound waterscape. Water flows wherever they go. And they may make their way, of course, wherever there is water to channel their designs for life.

GAIL DUBROW

JAPANESE AMERICAN WOMEN IN THE PACIFIC NORTHWEST

On the way from Kobe to Yokohama I looked at Mt. Fuji standing loftily against the cloudless blue sky and in that moment resolved: A woman going to America, depending on a husband she has never seen, should have the noble spirit of this majestic mountain. Such high-mindedness and eternally firm strength, indifferent to any weather, should be the spirit of Japanese women like me. —**Tsuruyo Takami**

Tsuruyo Takami, who penned her memories of immigration some fifty years later to assist journalist Kazuo Ito in writing a history of the Issei, was dressed in her finest kimono and sandals when she departed Kobe for Seattle in July 1918. Decorated with light blue waves and a short-beaked plover, her kimono was tied with a sash of white and striped with black, blue, and orange. Yet another bride, whose garment has been preserved in the Autry Museum's collection, wore a kimono decorated with a less abstract and more representational example of the waterscapes that frequently adorned early-twentieth-century Japanese women's wear (figure 45, plate 22).

Views of Mount Fuji, the "majestic mountain" that symbolized "high-mindedness and eternally firm strength," were more likely to appear on men's kimono of the period.

45 | Married woman's kimono, circa 1922, Japan. Museum of the American West, Autry National Center; 2008.16.1. For a color version of this image, see plate 22.

Tsuruyo Takami played with this gendered iconography when she depicted Mount Fuji as emblematic of the inner strength and resolve picture brides needed to establish new lives in America. In appropriating an image with masculine associations—the snow-enrobed mountain—to describe the mind-set of kimono-clad picture brides, Takami effectively captured the changes in women's sense of self that began with preparations for the overseas journey and which were fully realized on the Western frontier.

Regardless of how carefully they prepared to greet new husbands waiting for them in American ports such as Seattle, few picture brides were ready for the sheer rapidity with which they would be corseted into Western attire upon landing. Prior correspondence from Issei men, who impatiently awaited the arrival of steamers that carried their new brides to American ports, provided few clues as to the actual living conditions that awaited Issei women on farmsteads and in lumber mill towns where their married life soon would begin.

The backbreaking labor required of immigrants to convert straw bedding, crude shacks, and the uncultivated land that surrounded them into farmsteads fit for human habitation would confound picture brides' sense of their own identity as modern women of the Meiji era. As Kimiko Ono recalled of her 1924 arrival in the sawmill town of Mukilteo, Washington, "Though there were some houses which had electricity, in our house we had to use lamps. Since I had not known anyone using lamps in the place [where] I was raised in Japan, I felt very inconvenienced, as if we had gone back to primitive times. Neither was there any running water. For a couple of months we carried water for washing from the neighbor's house," a step above those who had to draw water from brooks and streams. "Also, we went to our neighbor, Mr. Shimada's, for a bath."[1]

In the most severe cases, the circumstances women encountered seemed to cross the line between nature and civilization that divided the conditions of animals from those suitable for human beings. Women's narratives of immigration make it clear that their journey east across the Pacific was accompanied by a steep decline in the standard of living. Their domestic labor, work beside their husbands in the fields, and efforts to establish community institutions substantially raised the bar and essentially brought civilization to the Western frontier.

Not only did the Pacific Ocean divide female immigrants in the American West from their island homeland, but also water itself in its many manifestations proved to be the key signifier of primitive as opposed to civilized living conditions. The most common complaint expressed by Issei women had to do with the lack of running water in their homes and on their farms, since its absence complicated virtually every aspect of female domestic labor, from cooking, cleaning, and doing the laundry, to their new responsibilities for fieldwork, and finally to their efforts to reestablish traditional cultural practices such as preparing the family *ofuroba*, or bath.

But to speak only of work is to miss the high standard of living Issei women carried with them on the journey from Japan to Pacific Northwest destinations. First-person narratives, captured by Kazuo Ito in his 1960s history of Issei settlement in North America,

captured the shock and dismay of picture brides whose husbands proudly introduced them to the rough-hewn shacks they were expected to inhabit. A gap of four thousand miles separated women's expectations from deeply disappointing realities. As one female immigrant put it, the house presented by her husband was just a "slant-roofed shanty such as swine live in,"[2] and the bedding, made of straw, likewise was fit for animals rather than citizens of one of the world's great powers. "Even backward Japan was not so bad as this," Sakiko Suyama observed. "It was really living in some God-forsaken place."[3] Many Issei women shared her dark perspective.

Any sense of family comfort on the frontier came at the expense of female norms of beauty, as hard work resulted in rough hands, sunburned faces, and in some cases starvation. The typical combination of housework, fieldwork, and repeated pregnancies tested women's physical endurance in a life that lacked a moment of rest.[4] Those who added livestock to their chores as a strategy for supplementing the family budget noted with dismay that the additional work further drained them. As Yo Yamashita ironically observed, "As the pigs grew fat, I got thin."

Similarly, the dowry carried in Issei women's *kori* (luggage) was sacrificed for the family, as only the fanciest kimono were spared being ripped apart for other urgent uses. Indeed, as the winter cold and damp seeped through gaps in the cedar sheathing of their dwellings, and the comforters on which the women slept each night turned threadbare, kimono of common silk or serge were deconstructed at the seams and reused as bedding covers, as Gin Okasaki recounted.[5] In their place, women on farmsteads wore dresses made of dime-store fabric, sewn by hand or on newly acquired treadled sewing machines. Men's white shirts and simple skirts replaced traditional garb for immigrant women who worked in urban shops and factories.

Women's expectations of an easier life were folded away with their most beautiful unworn kimono, to be examined only infrequently against a background of hardship. Sueko Nakagawa shared the sad recollection of "finally folding my Japanese kimono on the bed and putting it away."[6] And Shoko wrote:

Lovely kimono,
I've never worn you, and yet
Still air you every summer.[7]

In the end, those who remained in the Pacific Northwest for a lifetime never gave up traditional Japanese icons such as Mount Fuji and cherry blossoms bursting forth in spring as their geographic, temporal, moral, or aesthetic points of reference, as Tomiko Niguma's poem illustrates:

Every day I watch,
Looking westward to Japan.
What attracts me there?
Fuji stands against the sky
In eternal gown of snow.[8]

The force of nostalgia, however, fused emblems of the Nikkei (overseas Japanese people's) homeland with their counterparts located in the Pacific Northwest. Before too long, Seattle's gardens were planted with mums, pomegranate flowers, cherry trees, and other Japanese botanicals that reminded Issei of their island homeland, as poetically conveyed by Sumako Egashira:

Wan moon of morning,
Calling many things to mind.
Watching, remembering . . .
In a Seattle garden
Thinking of my home country.[9]

Mount Rainier became the paramount object of interest for Japanese American camera club expeditions. A tonic for what Sueko Nakagawa called "lifelong loneliness/for cherry blossoms in spring" could be secured at Japanese American nurseries, whose stock remade the Pacific Northwest landscape in pink and white blossoms each year just in time to celebrate the end of cheerless winter rains.[10] The fact that the Pacific Ocean connected American and Japanese shores, even as it divided them from one another, was not lost on women who endured a lifetime of loneliness for their home place. As Kimiko Ono wrote:

Warm to the sad heart
The thought of Pacific Sea
Touching Japan shores
I found some solace
Listening to the sound of waves.[11]

If there was scant room in *kori* for Issei women's hopes and dreams, much less for their "comforters," in the broadest sense, female immigrants nevertheless carried with them images of home, family, and community life that over time remade the Western landscape, in ways ranging from improved housing and cultivated farmsteads to recreational facilities for youth in church and temple annexes. Stereotypical images of female passivity and stoicism in the face of hardship fail to capture the force Japanese women exerted not only in enduring hardship with a sense of dignity but also—operating as agents of change—in remaking the environment in their own interests.

Each improvement made to hovels that Issei women perceived as suitable only for beggars, or to shacks deemed fit for swine not human beings, brought the Nikkei closer to a standard of civilized living they had known in Japan, which they had to reconstruct in both a literal and a figurative sense on the American frontier. By these means Japanese immigrants brought the primitive West into line with the norms of Meiji Japan. Although the story of American immigration often is presented as if it entails less advanced cultures coming to a new world that elevated both their expectations and their living conditions, the raw voices of Japanese women tell a far different story about who

brought civilization and culture to whom in the two-way traffic between Japan and America.

Almost everything female immigrants first encountered in the Western landscape represented a sharp departure from the ways and standard of living they had come to expect in Japan. When they converted kimono to bedding, it was less a capitulation to the demands of Americanization campaigns or an embrace of modern attire than a way to recivilize living conditions that had been undermined by two decades of bachelor culture in Western cities and in remote railroad and lumber camps. Sakiko Suyama captured the sentiment of her sister picture brides when she speculated, "If I had known more in detail beforehand, I would probably never have come."[12] But once having made the four-thousand-mile journey on a one-way ticket with little hope of return, they set out to remake the Western landscape to conform to their images of home.

Each earthen floor replaced by floorboards meant relief from the standpoint of housecleaning. Steady improvements in the conditions of domestic labor—as water first carried from brooks was then hauled from wells and finally piped into the house—directly improved the conditions of women's lives and their sense of themselves as human beings rather than beasts of burden. And when, despite the corrosive force of Alien Land Laws, a family could move out from under the debt associated with farm tenancy and achieve a modicum of stability and prosperity through property ownership, either directly through an American-born son with rights of citizenship or indirectly through arrangements with white allies, the ultimate symbol of success was a home of their own with running water, electricity, indoor plumbing, and an *ofuroba*, with its pleasures of soaking in a steaming hot bath.

Although immigrant women ate modestly after the men in the household had consumed their fill, and soaked in the *ofuroba* only after every male family member had taken his turn, their endless labors and high expectations for what constituted home raised Japanese immigrants' collective standard of living far beyond what male sojourners had been able to achieve on their own. Haruko captured this sense of how Issei women converted an unfamiliar landscape into some semblance of home when she wrote:

Pomegranate flowers!
Seattle has now become
A friendly town.[13]

PLATES

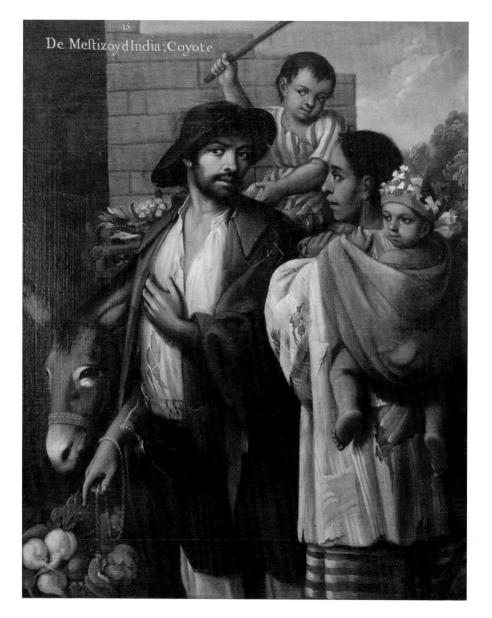

In the painting, the text reads:

13.

De Meſtizoyd India; Coyote

Plate 1 | Miguel Cabrera, *From Mestizo and Indian, Coyote*, 1763, Mexico City, New Spain, oil on canvas. Elisabeth Waldo-Dentzel Studios, Northridge, California, USA.

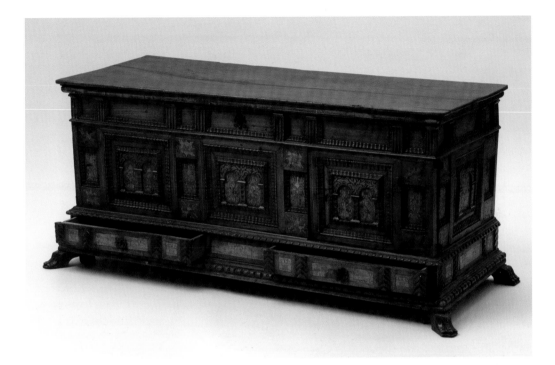

Plate 2 | Spanish marriage chest, late eighteenth century. Museum of the
American West, Autry National Center; 88.127.99.1.

Plate 3 | Banded Navajo blanket, 1875–1885. Gift of Mrs. Alice C.D. Riley,
Southwest Museum of the American Indian, Autry National Center; 672.G.10.

Plate 4 | Colcha blanket with ixtle (cactus fiber) backing, 1750–1850, New Mexico. Purchase made possible by an anonymous donor through the 2005 Gold-Level Members Acquisitions Committee, Museum of the American West, Autry National Center; 2005.31.3.

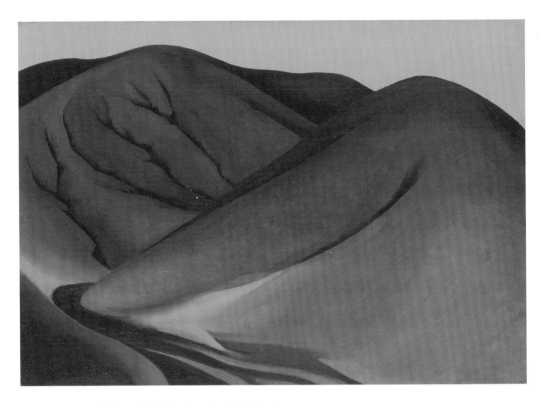

Plate 5 | Georgia O'Keeffe, *Red Hills, Grey Sky*, 1937. Courtesy
of The Anschultz Collection.

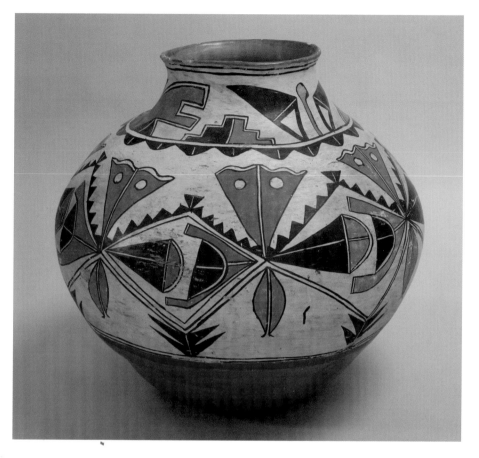

Plate 6 | María Martínez, San Ildefonso Pueblo, olla, 1900–1930. Gen. Charles
McReeve Collection, Southwest Museum of the American Indian, Autry
National Center; 491.G.955.

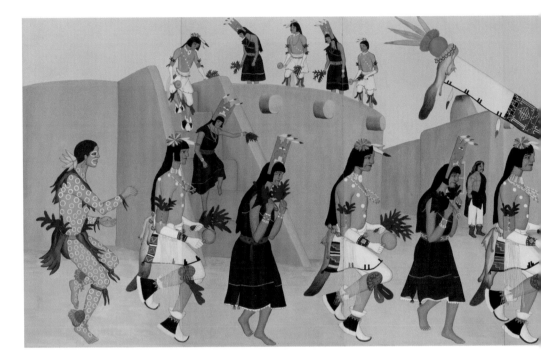

Plate 7 | Pablita Velarde, Santa Clara Pueblo, *The Green Corn Dance,* 1956, oil on Masonite, seven-panel mural commissioned by the Western Skies Motel, Houston, Texas. Museum of the American West, Autry National Center; 2007.2.1.

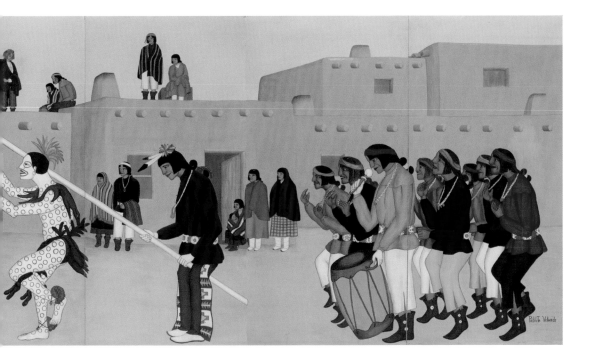

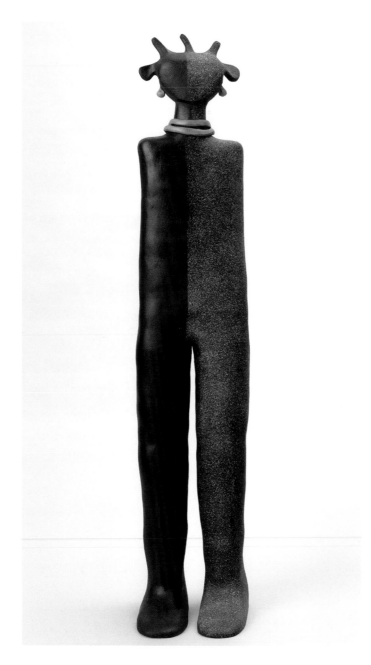

Plate 8 | Nora Naranjo-Morse, Santa Clara Pueblo, *His Brother,* circa 2006.
Purchase made possible by an anonymous donor through the 2006 Gold-Level
Members Acquisitions Committee, Museum of the American West, Autry
National Center; 2006.26.1.

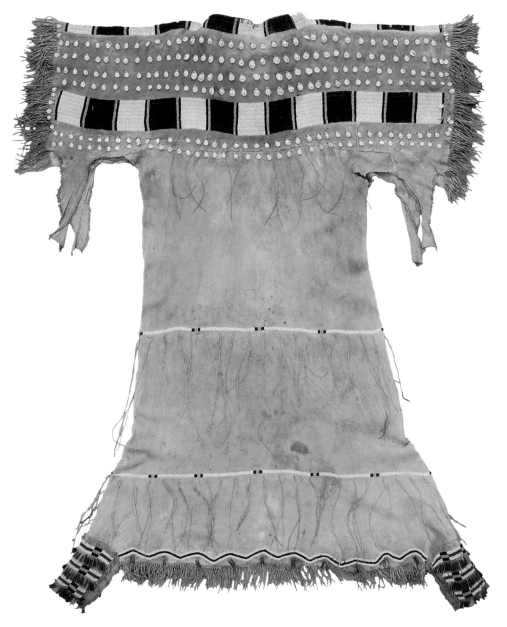

Plate 9 | Cheyenne woman's dress, circa 1860. Gift of Mr. Fred K. Hinchman, Southwest Museum of the American Indian, Autry National Center; 535.G.1001.

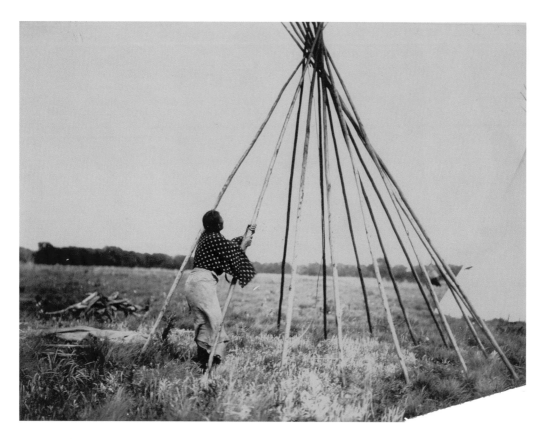

Plate 10 | Cheyenne woman raising tipi poles, date unknown, by Elizabeth C. Grinnell. Braun Research Library, Institute for the Study of the American West, Autry National Center; P.10711.

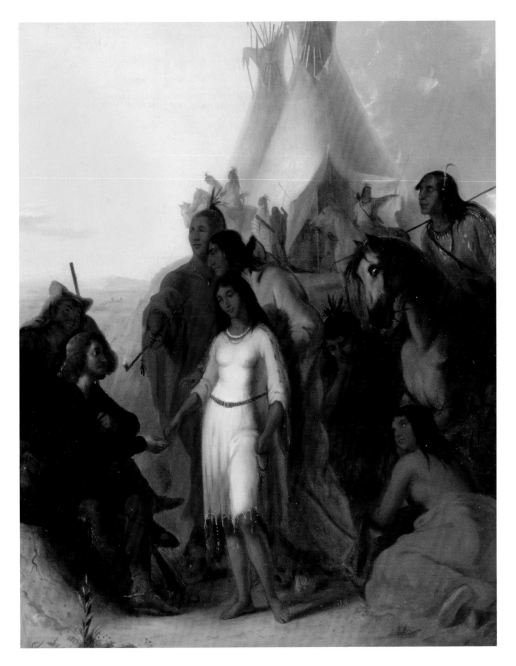

Plate 11 | Alfred Jacob Miller, *The Trapper's Bride,* oil on canvas, 1846.
Courtesy of The Alan Mason Chesney Medical Archives of The Johns Hopkins
Medical Institutions.

Plate 12 | John Gast, *American Progress*, 1872. Museum of the American
West, Autry National Center; 92.126.1.

Plate 13 | Henrietta Bromwell, *A Bit in Denver Bottoms*, 1890–1910, oil on canvas. Copyright, Colorado Historical Society, DFA Collection, H.1493.43.

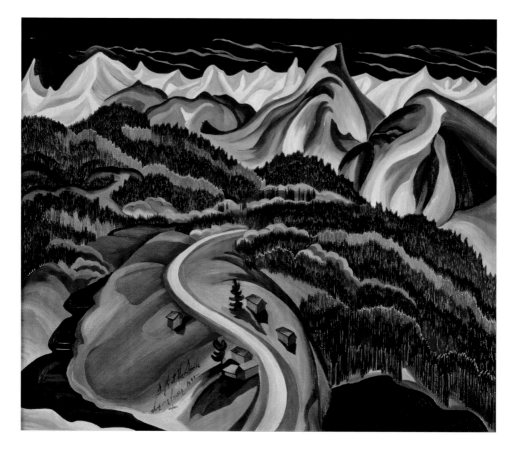

Plate 14 | Eve Drewelowe, *Drifts at the Divide*, 1943, oil on canvas. Museum of the American West, Autry National Center; 95.155.1.

Plate 15 | Elizabeth "Buff" Elting, *Where the Sea Used to Be*, 2004, oil on
canvas. Museum of the American West, Autry National Center; 2006.4.1.

Plate 16 | Susan Point, Coastal Salish, painted paddle, 2004. Purchase made possible by Simon and June Li through the 2005 Gold-Level Members Acquisitions Committee, Museum of the American West, Autry National Center; 2005.16.1.

Plate 17 | Hudson's Bay Company trade basket, Salish, circa 1835. Gift of
Mrs. Wahtawaso Tethrault Gillespie, Southwest Museum of the American
Indian, Autry National Center; 611.G.172.

Plate 18 | "The Clam Digger," circa 1910, by Edward S. Curtis. Braun Research Library, Institute for the Study of the American West, Autry National Center; P.37817.

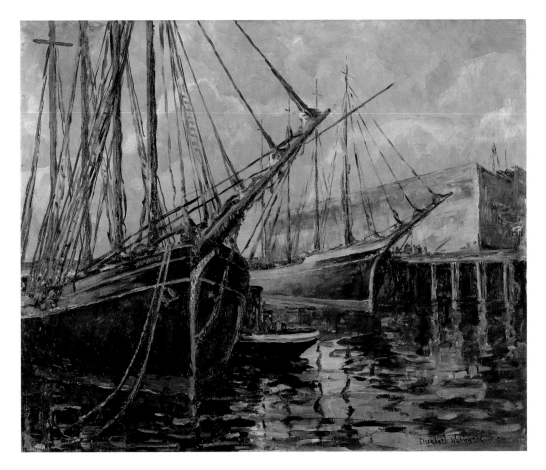

Plate 19 | Elizabeth Warhanik, *Seattle Harbor Ships,* circa 1929, oil on canvas.
Purchase made possible by an anonymous donor through the 2006 Gold-Level
Members Acquisitions Committee, Museum of the American West, Autry
National Center; 2006.39.4.

Plate 20 | Salmon can labels, 1900 and 1917, Fidalgo Island Canning Company, Anacortes, Washington. Museum of the American West, Autry National Center; 2006.20.1, 2006.20.2.

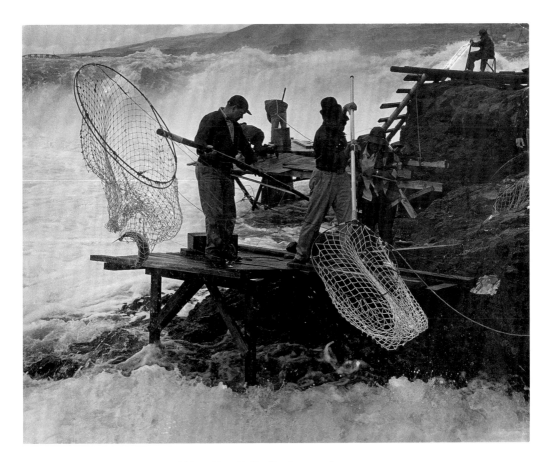

Plate 21 | "Untitled (Celilo Falls)," 1936, by Virna Haffer. Purchase made possible by an anonymous donor through the 2006 Gold-Level Members Acquisitions Committee, Museum of the American West, Autry National Center; 2006.39.1.

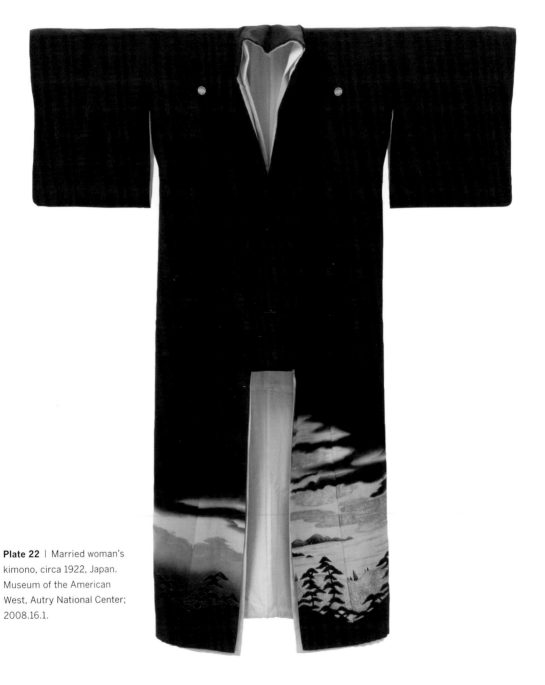

Plate 22 | Married woman's kimono, circa 1922, Japan. Museum of the American West, Autry National Center; 2008.16.1.

POSTSCRIPT: HOW WILL WE MAKE THE WEST?

AS THIS BOOK GOES TO PRESS, THINGS DON'T LOOK SO GOOD FOR THE
region, the nation, the planet. The country is in the midst of an economic crisis, mired
in two wars in the Middle East, struggling to recover from a too-long period of neglect
and incompetence and corruption among our leaders and no small measure of mind-
less, wasteful consumption among ordinary people. The planet itself is warming
quickly, because those of us in rich countries have gobbled up fossil fuels as fast and as
furiously as we could, heedless of the consequences to the environment, ourselves, and
people and other living things around the world. A *New Yorker* cartoonist captures the
shaky, grim spirit of the moment with a drawing of a storefront window advertising an
"End of Days" sale.

It is, in short, the perfect moment to reflect on the stories we have told in this book,
stories that demonstrate the profuse and diverse ways in which the peoples of the West
have claimed homes in places that set limits to what humans can consume and demand.
From the ancestral Puebloans to the soccer moms of Arapahoe County to the cannery
workers of Seattle, we have seen how women's efforts to sustain themselves and their
families shape larger realities. The Cheyenne woman grazing a pony, like the housewife
watering her lawn, may not think very hard about the consequences of doing what she's
done, every day, for as long as she can remember. But routines matter. When we ignore
the signals that we are using up the things we need to sustain home—grass or water,
gasoline or farmland, or that perhaps most fragile thing, human community—we are
likely to lose what we hold most dear.

And yet, in the pages of this book, we have seen how ordinary women found the
means to carry on in seemingly empty places. The captive who taught her mistress or
adopted sister a new way to glaze a pot, the teenage girl who painted a picture or wrote
a poem in the grimy barracks at Manzanar, the doctor who, denied privileges at the
local hospital, made house calls on people who looked different and spoke different
languages—each of these women called on her own deepest well of dignity and creativity
and made something important out of what little she had. At their best, the patron of
the arts, the philanthropist who promoted health care, the photographer of dams, and
the politician looking to clean up a city or a state or a nation all had the potential to be
forceful advocates for those who struggled. But when those who have much forget their
obligations and neglect their connections to other people and the living planet, they be-

come (as they used to say in the sixties) part of the problem, not the solution. When we live in fear of our neighbors, hoarding what we possess, shunning those who seem strange, or using violence without reason, we run the risk of losing everything.

Big changes are often nothing more than the accumulation of small adjustments. In a Plains Indian woman's parfleche, we can see an adaptation to a new way of life, crafted with skill and an eye to beauty. The canvas grocery bags in the trunk of a compact hybrid car represent a similar small decision with potentially larger consequences. Such individual acts of deliberation cannot, by themselves, ensure that a people will be able to continue to claim a home on earth. But we cannot go forward without them.

In this book, we have encountered the peoples of the Rio Arriba, the Front Range and Great Plains, and Puget Sound. We have linked the peoples of each place to one another over hundreds, even thousands, of years. We have tried to know the places as homelands, and we have focused our attention on women as historical actors. But we have set these places apart from, in isolation from, one another. In the end, they are connected, just as women and men are connected: to one another, by the earth upon which we all stand, the waters that flow around and between us, the lines of transportation and communication that link us, our own movements across time and space, and our relations with each other. We have seen here how women in many times and places forged the connections to place and to others that made home sustainable. If the West is to be a home in an anything-but-certain future, we will have to realize and embrace, criticize and adapt, sort through and discard, and treasure those connections.

INTRODUCTION

1. Judith Stacey, *Brave New Families: Stories of Domestic Upheaval in Late-Twentieth-Century America* (New York: Basic Books, 1990); Judith Stacey, *In the Name of the Family: Rethinking Family Values in the Postmodern Age* (Boston: Beacon Press, 1996).

1 | HOME ON EARTH: WOMEN AND LAND IN THE RIO ARRIBA

1. For debates over women's roles in the ancient world, see J. M. Adovasio, Olga Soffer, and Jake Page, *The Invisible Sex: Uncovering the True Roles of Women in Prehistory* (New York: HarperCollins, 2007); Karen Olsen Bruhns, *Women in Ancient America* (Norman: University of Oklahoma Press, 1991); Cheryl Claasen and Rosemary A. Joyce, eds., *Women in Prehistory: North America and Mesoamerica* (University Park: University of Pennsylvania Press, 1997); Patricia C. Crown, ed., *Women and Men in the Prehistoric Southwest: Labor, Power, and Prestige* (Santa Fe: School of American Research, 2000); Joan Gero and Margaret Conkey, *Engendering Archaeology: Women and Prehistory* (Oxford: Wiley-Blackwell, 1991).

2. Leslie Marmon Silko, "Interior and Exterior Landscapes," in *Yellow Woman and a Beauty of Spirit: Essays in Native American Life Today* (New York: Touchstone Books, Simon and Schuster, 1996), 38.

3. Hamilton Tyler, *Pueblo Gods and Myths* (Norman: University of Oklahoma Press, 1964), 122.

4. Cheryl Claasen, "Changing Venue: Women's Lives in Prehistoric North America," in Claasen and Joyce, *Women in Prehistory,* 77–78.

5. Patricia Crown and W. H. Wills, "The Origins of Southwestern Ceramic Containers: Women's Economic Allocation and Economic Intensification," *Journal of Anthropological Research* 51, no. 22 (Summer 1995): 173–186; J. J. Brody, *Anasazi and Pueblo Painting* (Albuquerque: School of American Research, University of New Mexico Press, 1991).

6. Pedro de Castañeda de Najera's narrative transcribed in Richard Flint and Shirley Flint, *Documents of the Coronado Expedition, 1539–1542* (Dallas: Southern Methodist University Press, 2005), 418–419.

7. For more on this early landscape, see Colin Calloway, *One Vast Winter Count: The Native American West before Lewis and Clark* (Lincoln: University of Nebraska Press, 2003); Crown, *Women and Men in the Prehistoric Southwest*; Joan Jensen and Darlis Miller, eds., *New Mexico Women: Intercultural Perspectives* (Albuquerque: University of New Mexico Press, 1986); William Morgan, *Ancient Architecture of the Southwest* (Austin:

University of Texas Press, 1994); Carroll L. Riley, *Rio del Norte: People of the Upper Rio Grande from Earliest Times to the Pueblo Revolt* (Salt Lake City: University of Utah Press, 1995).

8. Riley, *Rio del Norte,* 91; Jared Diamond, *Collapse: How Societies Choose to Fail or Succeed* (New York: Viking, 2005), 145–147.

9. Stephen Lekson, "Landscape and Polity," in *The Road to Aztlan: Art from a Mythic Homeland,* ed. Virginia Fields and Victor Zamudio-Taylor (Los Angeles: Los Angeles County Museum of Art, 2000), 216.

10. John Brinkerhoff Jackson, *A Sense of Place, a Sense of Time* (New Haven: Yale University Press, 1994), 43.

11. Ross Frank, "Demographic, Social, and Economic Change in New Mexico," in *New Views of Borderlands History,* ed. Robert Jackson (Albuquerque: University of New Mexico Press, 1998).

12. For transformations of the built environment, see Crown, *Women and Men in the Prehistoric Southwest;* John Kessell, *Kiva, Cross, and Crown: The Pecos Indians and New Mexico, 1540–1840* (Washington, DC: National Park Service, 1979); Robert Powers, *The Peopling of Bandelier: New Insights from the Archaeology of the Pajarito Plateau* (Santa Fe: School of American Research Press, 2005); Katherine A. Spielmann, ed., *Farmers, Hunters, and Colonists: Interaction between the Southwest and the Southern Plains* (Tucson: University of Arizona Press, 1991).

13. J. J. Brody, "In Space and Out of Context: Picture Making in the Ancient American Southwest," in Fields and Zamudio-Taylor, *The Road to Aztlan,* 160.

14. Spielmann, *Farmers, Hunters, and Colonists;* Martha A. Works, "Creating Trading Places in the New Mexican Frontier," *Geographical Review* 82, no. 3 (July 1992): 268–281.

15. Ned Blackhawk, *Violence over the Land: Indians and Empire in the Early American West* (Cambridge, MA: Harvard University Press, 2006).

16. Ramon A. Gutierrez, *When Jesus Came, the Corn Mothers Went Away: Marriage, Sexuality, and Power in New Mexico, 1500–1846* (Stanford, CA: Stanford University Press, 1991), 50–51. On slavery, see James F. Brooks, *Captives and Cousins: Slavery, Kinship, and Community in the Southwest Borderlands* (Chapel Hill: University of North Carolina Press, 2002), 48–55.

17. Hilary L. Scothorn, "Pueblo Women, Colonial Settlement, and Creative Endeavors: Power and Appropriation in Native American Ceramics," in *Dimensions of Native America: The Contact Zone* (Tallahassee: Museum of Fine Arts, Florida State University, 1998), 18–23; Jonathan Batkin, *Pottery of the Pueblos of New Mexico, 1700–1940* (Colorado Springs, CO: Taylor Museum of the Colorado Springs Fine Arts Center, 1982).

18. Frank, "Demographic, Social, and Economic Change in New Mexico," 50–51; Gutierrez, *When Jesus Came,* 76, 161.

19. Father Juan Agustin de Morfi, "Account of Disorders in New Mexico, 1778," quoted in Marc Simmons, *Coronado's Land: Essays on Daily Life in Colonial New Mexico* (Albuquerque: University of New Mexico Press, 1991), 130.

20. Jensen and Miller, *New Mexico Women,* 20.

21. Angelina Veyna, "'It Is My Last Wish That . . . ': A Look at Colonial Nuevo Mexicana through Their Testaments," in *Building with Our Hands: New Directions in Chicana*

Studies, ed. Adela de la Torre and Beatriz Pesquera (Berkeley: University of California Press, 1993), 96–97.

22. David J. Weber, *On the Edge of Empire: The Taos Hacienda of Los Martinez* (Santa Fe: Museum of New Mexico Press, 1996), 9–10, 27, 70.

23. On women and captivity in the Southwest, see Juliana Barr, *Peace Came in the Form of a Woman: Indians and Spaniards in the Texas Borderlands* (Chapel Hill: University of North Carolina Press, 2007); Brooks, *Captives and Cousins;* Gutierrez, *When Jesus Came;* Heather B. Trigg, *From Household to Empire: Society and Economy in Early Colonial New Mexico* (Tucson: University of Arizona Press, 2005).

24. Frank, "Demographic, Social, and Economic Change in New Mexico," 43–44.

25. Josiah Gregg, *Commerce of the Prairies,* ed. Max Moorhead (Norman: University of Oklahoma Press, 1954), 146.

26. Ross Frank, *From Settler to Citizen: New Mexican Economic Development and the Creation of Vecino Society, 1750–1820* (Los Angeles: University of California Press, 2000).

27. Rebecca McDowell Craver, *The Impact of Intimacy: Mexican-Anglo Intermarriage in New Mexico, 1821–1846* (El Paso: Texas Western Press, 1982), 10–12.

28. Amy Kaplan, "Manifest Domesticity," *American Literature* 70, no. 3 (1998): 581–606; Mary P. Ryan, *Empire of the Mother: American Writing about Domesticity, 1830–1860* (Philadelphia: Haworth Press, 1982).

29. María E. Montóya, *Translating Property: The Maxwell Land Grant and the Conflict over Land in the American West, 1840–1900* (Berkeley: University of California Press, 2002), 63. For women's declining status, see also Deena J. González, *Refusing the Favor: The Spanish-Mexican Women of Santa Fe, 1820–1880* (New York: Oxford University Press, 1999).

30. William DeBuys, *Enchantment and Exploitation: The Life and Hard Times of a New Mexico Mountain Range* (Albuquerque: University of New Mexico Press, 1985), 215–234; Suzanne Forrest, *The Preservation of the Village: New Mexico Hispanics and the New Deal* (Albuquerque: University of New Mexico Press, 1989), 17–31.

31. Margaret Jacobs, *Engendered Encounters: Feminism and Pueblo Cultures, 1879–1934* (Lincoln: University of Nebraska Press, 1999), 9; Joe S. Sando, *Pueblo Nations: Eight Centuries of Pueblo Indian History* (Santa Fe: Clear Light, 1992).

32. Henry J. Tobias and Charles Woodhouse, *Santa Fe: A Modern History, 1880–1990* (Albuquerque: University of New Mexico Press, 2001), 125–128.

33. Fabiola Cabeza de Baca, *We Fed Them Cactus* (Albuquerque: University of New Mexico Press, 1954), 139.

34. Sarah Deutsch, *No Separate Refuge: Culture, Class, and Gender on an Anglo-Hispanic Frontier in the American Southwest, 1880–1940* (New York: Oxford University Press, 1987), 55.

35. Charles F. Lummis, *The Land of Poco Tiempo* (New York: C. Scribner's Sons, 1893), 3.

36. For studies of "New Women" in Santa Fe, see Flannery Burke, *From Greenwich Village to Taos: Primativism and Place at Mabel Dodge Luhan's* (Lawrence: University Press of Kansas, 2008); Molly H. Mullin, *Culture in the Marketplace: Gender, Art, and Value in the American Southwest* (Durham, NC: Duke University Press, 2001); Louis Rudnick, *Utopian Vistas: The Mabel Dodge Luhan House and the American Counterculture* (Albuquerque: University of New Mexico Press, 1996); Marta Weigle and Kyle Fiore, *Santa Fe and Taos:*

The Writer's Era, 1916–1941 (Santa Fe: Ancient City Press, 1982, 1994); Chris Wilson, *The Myth of Santa Fe: Creating a Modern Regional Tradition* (Albuquerque: University of New Mexico Press, 1997).

37. Rudnick, *Utopian Vistas,* 37; Mary Austin, "Life at Santa Fe," *South Atlantic Quarterly* 31, no. 3 (July 1932): 263.

38. Quotes from the film *Georgia O'Keeffe,* directed by Perry Miller Adato, 1977.

39. Mary Austin, *Land of Journey's Ending* (New York: Century Company, 1924), 438.

40. Burke, *From Greenwich Village to Taos,* 139.

41. Wilson, *Myth of Santa Fe,* 144; Gregor Stark and E. Catherine Rayne, *El Delirio: The Santa Fe World of Elizabeth White* (Santa Fe: School of American Research Press, 1998).

42. De Vargas Company papers, Collection #AC19.207 and AC19.226, Catherine McElvain Library, School of American Research, Santa Fe; Tobias and Woodhouse, *Santa Fe,* 135.

43. De Vargas Company papers, Collection #AC19.318, Catherine McElvain Library, School of American Research, Santa Fe.

44. Letter to Mary Colten from Amelia White, December 22, 1926, Amelia White Papers, Collection #AC18.008, Catherine McElvain Library, School of American Research, Santa Fe.

45. Letter from Charles F. Lummis to Leonora F. Curtin, January 13, 1927, Letters to LFC, 1908–1927, Curtin-Paloheimo Collection, Acequia Madre House, Santa Fe.

46. Leonora Curtin Paloheimo, *La Loma,* typed manuscript, 1969, Curtin-Paloheimo Collection, Acequia Madre House, Santa Fe.

47. Native Market brochure, n.d., Curtin-Paloheimo Collection, Acequia Madre House.

48. Sarah Nestor, *The Native Market of the Spanish New Mexican Craftsmen, Santa Fe, 1933–1940* (Santa Fe: Colonial New Mexico State Historical Foundation, 1978); Marta Weigle, "The First Twenty-five Years of the Spanish Colonial Arts Society," in *Hispanic Arts and Ethnohistory in the Southwest,* ed. Marta Weigle (Santa Fe: Ancient City Press, 1983); tax records for Leonora Curtin Paloheimo and Native Market Association, box 119, folder 8, Pasadena Museum of History.

49. Jacobs, *Engendered Encounters,* 175; Richard L. Spivey, *Maria,* 2nd ed. (Flagstaff, AZ: Northland Publishing, 1989), 49, 58.

50. Virginia Scharff, *Twenty Thousand Roads: Women, Movement, and the West* (Berkeley: University of California Press, 2003), 115–135.

51. Wilson, *Myth of Santa Fe,* 146–158; Charles Montgomery, *The Spanish Redemption: Heritage, Power, and Loss on New Mexico's Upper Rio Grande* (Berkeley: University of California Press, 2002), 171.

52. Fabiola Cabeza de Baca, "Folklore," typescript, n.d., box 1, folder 16, Cabeza de Baca Papers, Center for Southwest Research, University of New Mexico Library, Albuquerque.

53. Maureen E. Reed, *A Woman's Place: Women Writing New Mexico* (Albuquerque: University of New Mexico Press, 2005), 239.

54. Pablita Velarde, interview by Las Cruces Television, 1979.

55. Velarde quoted in interview by Sally Hyer, "Aged Artists," *Art Journal* 53 (Spring 1994): 10.

56. Reed, *A Woman's Place,* 263.

57. Sandra d'Emilio and Sharyn Udall, "Inner Voices, Outward Forms: Women Painters of

New Mexico," in *Independent Spirits: Women Painters of the American West, 1890–1945*, ed. Patricia Trenton (Berkeley: University of California Press, 1995), 163–164; Matthew Martinez, "Pablita Velarde," New Mexico Office of the State Historian, www.newmexico history.org/filedetails_docs.php?fileID=417, accessed September 6, 2008.

58. Erna Fergusson, *Our Southwest* (New York: Alfred A. Knopf, 1940), 279.

59. New Mexico Commission on the Status of Women, www.womenscommission.state. nm.us/PayEquity.htm, January 9, 2008.

60. "Unmarried with Children," *Albuquerque Journal,* Dec. 2, 2007.

61. Ibid.

62. Nora Naranjo-Morse, *Mud Woman: Poems from the Clay* (Tucson: University of Arizona Press, 1992), 35–37.

2 | WOMEN IN MOTION ALONG THE FRONT RANGE

1. Elliott West, *The Contested Plains: Indians, Goldseekers, and the Rush to Colorado* (Lawrence: University Press of Kansas, 1998), 75–76.

2. For the early history of the Cheyennes, see George Bird Grinnell, *The Cheyenne Indians: Their History and Ways of Life*, vol. 1 (1923; reprint, Lincoln: University of Nebraska Press, 1972); Preston Holder, *The Hoe and the Horse on the Plains: A Study of Cultural Development among North American Indians* (Lincoln: University of Nebraska Press, 1970); E. Adamson Hoebel, *The Cheyennes: Indians of the Great Plains* (New York: Holt, Rinehart and Winston, 1960); John H. Moore, *The Cheyenne* (Indianapolis: Wiley-Blackwell, 1996).

3. Colin C. Calloway, *One Vast Winter Count: The Native American West before Lewis and Clark* (Lincoln: University of Nebraska Press, 2003), 267; West, *Contested Plains*, 46.

4. West, *Contested Plains,* 56.

5. For the impact on women of the rise of the Plains nomadic lifestyle, see Patricia Albers and Beatrice Medicine, *The Hidden Half: Studies of Plains Indian Women* (Washington, DC: University Press of America, 1983); Holder, *The Hoe and the Horse on the Plains;* Margot Liberty, "Plains Indian Women through Time: A Preliminary Overview," in *Northwestern Great Plains: Intermountain and Plateau Ethnography of Ethnohistory,* ed. L. Davis (Missoula: Big Sky Press, University of Montana, 1981); and Virginia Bergman Peters, *Women of the Earth Lodges* (New Haven: Archon Books, 1995).

6. Doris Cole, *From Tipi to Skyscraper: A History of Women in Architecture* (New York: George Braziller, 1973), 2–12; John C. Ewers, *The Horse in Blackfoot Indian Culture: With Comparative Material from Other Western Tribes* (Washington, DC: U.S. Government Printing Office, 1955), 81–90; Mary Jane Schneider, "Women's Work: An Examination of Women's Roles in Plains Indian Arts and Crafts," in Albers and Medicine, *The Hidden Half,* 101–122.

7. Gaylord Torrence, *The American Indian Parfleche: A Tradition of Abstract Painting* (Seattle: University of Washington Press, 1994); Winfield Coleman, "Art as Cosmology: Cheyenne Women's Rawhide Painting," in *Tribal Arts* 5, no. 1 (Summer 1998): 48–60.

8. Janet Spector, *What This Awl Means: Feminist Archeology at a Wahpeton Dakota Village* (St. Paul: Minnesota Historical Society Press, 1991); Sarah Nelson, *Denver: An Archaeological History* (University Park: University of Pennsylvania Press, 2001), 129.

9. John Mack Faragher, "The Custom of the Country: Cross-Cultural Marriage in the Far Western Fur Trade," in *Western Women: Their Land, Their Lives,* ed. Janice Monk, Lillian

Schlissel, and Vicki L. Ruiz (Albuquerque: University of New Mexico Press, 1988); Sylvia Van Kirk, *Many Tender Ties: Women in Fur-Trade Society, 1670–1870* (Norman: University of Oklahoma Press, 1980); Jacqueline Peters and Jennifer Brown, eds., *The New Peoples: Being and Becoming Métis in North America* (Lincoln: University of Nebraska Press, 1985); Lisa Maria Strong, *Sentimental Journey: The Art of Alfred Jacob Miller* (Norman: University of Oklahoma Press, 2008).

10. George E. Hyde, *Life of George Bent: Written from His Letters* (Norman: University of Oklahoma Press, 1968); Douglas Comer, *Ritual Ground: Bent's Old Fort, World Formation, and the Annexation of the Southwest* (Berkeley: University of California Press, 1996); David Lavender, *Bent's Fort* (New York: Doubleday, 1954).

11. Hyde, *Life of George Bent;* David Fridtjof Halaas and Andrew E. Masich, *Halfbreed: The Remarkable True Story of George Bent—Caught between the Worlds of the Indian and the White Man* (New York: Da Capo Press, 2004).

12. George Bird Grinnell Collection, ms. 5, folder 93, Braun Research Library, Institute for the Study of the American West, Autry National Center, Los Angeles; Alexander Barclay, letter to George Barclay, May 1, 1840, quoted in George Hammond, *The Adventures of Alexander Barclay, Mountain Man* (Denver: Fred Rosenstock, Old West Publishing, 1976), 26.

13. James Brooks, *Captives and Cousins: Slavery, Kinship, and Community in the Southwest Borderlands* (Chapel Hill: University of North Carolina Press, 2002), 225; Pekka Hamaainen, "The Rise and Fall of Plains Indian Horse Cultures," *Journal of American History* (December 2003): 833–862.

14. Virginia Scharff, *Twenty Thousand Roads: Women, Movement, and the West* (Berkeley: University of California Press, 2003), 35–63.

15. Susan Magoffin, *Down the Santa Fe Trail and into Mexico: The Diary of Susan Shelby Magoffin, 1846–1847,* ed. Stella M. Drumm (Lincoln: University of Nebraska Press, 1982), 62.

16. Ibid., 68.

17. West, *Contested Plains,* 145; William Wyckoff, *Creating Colorado: The Making of a Western American Landscape, 1860–1940* (New Haven: Yale University Press, 1999), 42.

18. Betty Moynihan, "Reminiscences of Mrs. Augusta Tabor," in *Augusta Tabor: A Pioneering Woman* (Boulder, CO: Johnson Books, 1988), 125.

19. *The Rocky Mountain Directory and Colorado Gazetteer for 1871* (Denver: S.S. Wallihan and Company, circa 1870), 257.

20. David Fridtjof Halaas, "The House in the Heart of a City: The Byers and Evans Families of Denver," in *Colorado Heritage* (Denver: Colorado Historical Society, 1989), 19.

21. Anne Farrar Hyde, *An American Vision: Far Western Landscape and National Culture, 1820–1920* (New York University Press, 1990), 63; D.W. Meining, "American Wests: Preface to a Geographical Interpretation," *Annuals of the Association of American Geographers* 62, no. 2 (June 1972): 159–184; Carlos Schwantes and James Ronda, *The West the Railroads Made* (Seattle: University of Washington Press, 2008).

22. Quoted in Katherine Harris, *Long Vistas: Women and Families on Colorado Homesteads* (Boulder: University Press of Colorado, 1993), 33.

23. Anna Dickinson, *A Ragged Register* (New York: Harper and Brothers, 1879), 30.

24. Ida Husted Harper, *The Life and Work of Susan B. Anthony* (Indianapolis: Hollenbeck

Press, circa 1898–1908), 1:493; Rebecca J. Mead, *How the Vote Was Won: Women Suffrage in the Western United States, 1868–1914* (New York: New York University Press, 2004), 54–57; Carolyn Stefanco, "Networking on the Frontier: The Colorado Women's Suffrage Movement, 1876–1893," in *The Women's West*, ed. Susan Armitage and Elizabeth Jameson (Norman: University of Oklahoma Press, 1987).

25. Gunther Barth, *Instant Cities: Urbanization and the Rise of San Francisco and Denver* (New York: Oxford University Press, 1975); Wyckoff, *Creating Colorado*, 119.

26. Robert H. Shikes, *Rocky Mountain Medicine: Doctors, Drugs, and Disease in Early Colorado* (Boulder, CO: Johnson Books, 1986), 63.

27. For a study of how communities responded to the new railroads, see William Deverell, *Railroad Crossing: Californians and the Railroad, 1850–1910* (Berkeley: University of California Press, 1994).

28. *Denver Times*, July 11, 1898; Anne Hyde, "Transients and Stickers: The Problem of Community in the American West," in *A Companion to the American West*, ed. William Deverell (Oxford: Blackwell Publishing, 2004), 321–322.

29. Quoted in Shikes, *Rocky Mountain Medicine*, 64.

30. Ibid., 63; Stephen J. Leonard and Thomas J. Noel, *Denver: Mining Camp to Metropolis* (Niwot: University Press of Colorado, 1990), 65; Samuel Eliot, *Proceedings of the National Conference of Charities and Correction at the Nineteenth Annual Session Held in Denver, Co., June 23–29, 1892* (Boston: Press of Geo. H. Ellis, 1892), Autry Library, Institute for the Study of the American West, Autry National Center, Los Angeles.

31. Marcia Tremmel Goldstein, *Denver Women in Their Places* (Denver: Historic Denver, 2002); Leonard and Noel, *Denver*, 69, 99, 122; *Organizational History of the National Jewish Hospital*, Ira M. Beck Memorial Archives, Special Collections, Penrose Library, University of Denver.

32. Jerome Smiley, *The History of Denver* (1901; reprint, Denver: Western Publishing, 1978), 53. For information on the growth of the first suburbs, see Dolores Hayden, *Building Suburbia: Green Fields and Urban Growth, 1820–2000* (New York: Pantheon Books, 2003); Kenneth T. Jackson, *Crabgrass Frontier: The Suburbanization of the United States* (New York: Oxford University Press, 1985).

33. Leonard and Noel, *Denver*, 57.

34. Hayden, *Building Suburbia*, 71–73; Leonard and Noel, *Denver*, 58; *Sears Roebuck Catalog: Modern Book of Homes*, 1908, www.searsarchives.com/homes/1908–1914.htm, accessed September 6, 2009.

35. Barth, *Instant Cities*, viii.

36. *Baist's Real Estate Atlas: Surveys of Denver* (Philadelphia: C. W. Baist, 1905), Autry Library, Institute for the Study of the American West, Autry National Center, Los Angeles.

37. Quintard Taylor, *In Search of the Racial Frontier: African Americans in the American West, 1528–1990* (New York: Norton, 1998), 192–221; George H. Wayne, "Negro Migration and Colonization in Colorado, 1870–1920," *Journal of the West* 15, no. 1 (January 1976): 102–120.

38. Quoted in Amy G. Richter, *Home on the Rails: Women, the Railroad, and the Rise of Public Domesticity* (Chapel Hill: University of North Carolina Press, 2005), 83.

39. Taylor, *In Search of the Racial Frontier*, 93, 331n.

40. *Denver Republican*, March 17, 1890; *Denver Times*, April 6, 1899.

41. For black home ownership, see Leonard and Noel, *Denver*, 192; Lynda F. Dickson, "The Early Club Movement among Black Women in Denver, 1890–1925" (Ph.D. diss., University of Colorado, Boulder, 1982), 97–98.

42. Dickson, "The Early Club Movement," 101–102, 134–135; Taylor, *In Search of the Racial Frontier*, 202–204; Lynda F. Dickson, "Lifting as We Climb: African American Women's Clubs of Denver, 1880–1925," in *Writing the Range: Race, Class, and Culture in the Women's West*, ed. Elizabeth Jameson and Susan Armitage (Norman: University of Oklahoma Press, 1997), 374.

43. Mark Harris, "The Forty Years of Justina Ford," *Negro Digest* (March 1950), 43.

44. *Denver Post*, June 1, 1998 (Denver Public Library clippings file); Harris, "The Forty Years of Justina Ford."

45. Thomas J. Noel and Barbara S. Norgen, *Denver: The City Beautiful and Its Architects* (1987; reprint, Denver: Historic Denver, 1993).

46. *Denver Post*, July 24, 1941.

47. Leonard and Noel, *Denver*, 92; Industrial Commission of Colorado, *Colorado Minimum Wage and Labor Laws for Women and Minors* (Denver: Eames Bros., 1917); Emily Clark Brown, *A Study of Two Groups of Married Denver Women Applying for Jobs* (Washington, DC: U.S. Government Printing Office, 1929), Open Collection Program, Harvard Women Working, Harvard Library, http://ocp.hul.harvard.edu/ww, accessed August 20, 2009.

48. Owen Gutfreund, *Twentieth-Century Sprawl: Highways and the Reshaping of the American Landscape* (New York: Oxford University Press, 2004); "Denver Tram Union Returns to Work," *New York Times*, August 10, 1920; "Guards Blamed for Strike Deaths," *New York Times*, October 24, 1921.

49. Gutfreund, *Twentieth-Century Sprawl*, 78; Jackson, *Crabgrass Frontier*, 170–171.

50. Virginia Scharff, *Taking the Wheel: Women and the Coming of the Motor Age* (Albuquerque: University of New Mexico Press, 1991), 131.

51. Wyckoff, *Creating Colorado*, 85.

52. Laura Gilpin, *Pikes Peak Region*, Autry Library, Institute for the Study of the American West, Autry National Center, Los Angeles; Martha Sandweiss, *Laura Gilpin: An Enduring Grace* (Fort Worth, TX: Amon Carter Museum, 1986).

53. Scharff, *Taking the Wheel*, 170.

54. Quoted in *Independent Spirits: Women Painters of the American West* (Los Angeles: Autry Museum of Western Heritage in Association with University of California Press, 1995), 230.

55. Gutfreund, *Twentieth-Century Sprawl*, 83–84; María E. Montóya, "Landscapes of the Cold War West," in *The Cold War American West, 1945–1989*, ed. Kevin J. Fernlund (Albuquerque: University of New Mexico Press, 1998).

56. Montóya, "Landscapes of the Cold War West," 11.

57. Alison R. Bernstein, *American Indians and World War II: Toward a New Era in Indian Affairs* (Norman: University of Oklahoma Press, 1991); Donald Lee Fixico, *Daily Life of Native Americans in the Twentieth Century* (Westport, CT: Greenwood Press Group, 2006), 20–22; Christine Conte, "Changing Woman Meets Madonna," in *Writing the Range: Race, Class, and Culture in the Women's West*, ed. Elizabeth Jameson and Susan Armitage

(Norman: University of Oklahoma Press, 1997); Alan Sorkin, "Some Aspects of American Indian Migration," *Social Forces* 48, no. 2 (December 1969): 243–250.

58. Philip J. Deloria, *Indians in Unexpected Places* (Lawrence: University Press of Kansas, 2004), 154; Nancy and Theodore Graves, "Adaptive Strategies in Urban Migration," *Annual Review of Anthropology* 3 (1974): 119–122.

59. Diane Wray, *The Arapahoe Acres Historic District* (Denver: Historic Denver, 2004); Annmarie Adams, "The Eichler Home: Intention and Experience in Postwar Suburbia" in *Gender, Class, and Shelter: Perspectives in Vernacular Architecture V* (Knoxville: University of Tennessee Press, 1995); *Exhibition, 2900 South Marion, Arapahoe Acres* (n.p., Southwest Research Institute, Revere Quality House Division, 1950), visitors' brochure, private collection of Diane Wray, Colorado.

60. Ruth Schwartz Cowan, *More Work for Mother: The Industrial Revolution in the Home* (New York: Basic Books, 1983), 100.

61. *Model Home Questionnaire* (n.p., Southwest Research Institute, Revere Quality House Division, 1950), private collection of Diane Wray, Colorado.

62. Hayden, *Building Suburbia*, 185. See also Scharff, *Twenty Thousand*, 180–193.

63. Quoted in Elizabeth Carney, "Suburbanizing Nature and Naturalizing Suburbanites: Outdoor-Living Culture and Landscapes of Growth," *Western Historical Quarterly* 38, no. 4 (Winter 2007): 478–479.

64. Robert Adams, *Robert Adams: Landscapes of Harmony and Dissonance* (Los Angeles: J. Paul Getty Museum, 2006), exhibition gallery guide.

65. John Rebchook, "Woman Who Saved Larimer Square Celebrates 50 Years in Denver," *Rocky Mountain News*, October 23, 2004; Judy Morley, *Historic Preservation and the Imagined West: Albuquerque, Denver, and Seattle* (Lawrence: University of Kansas Press, 2006), 54–65.

66. Berny Morson and Deborah Frazier, "For Years, Brown Cloud Fouls Denver Image," *Denver Rocky Mountain News*, December 7, 1999.

67. "Owens Signs Anti-Sprawl Legislation," Office of the Governor, press release, May 24, 2000, archived at www.state.co.us/owenspress/05-24-00a.htm, accessed October 14, 2009; Eric Johansen, "Growth Initiative Concerns Area Leaders," *Denver Business Journal* (August 4, 2000).

68. "Denver in Focus: A Profile from Census 2000," in *Living Cities: The National Community Development Institute* (Washington, DC: Brookings Institution Center on Urban and Metropolitan Policy, November 2003); Kate Reid, "What Do We Know about Denver Women?" Denver's Women's Commission, 2000, www.denvergov.org/women, accessed August 27, 2009.

3 | WATERSCAPES OF PUGET SOUND

1. On precontact populations, see Hermann Haeberlin and Erna Gunther, *The Indians of Puget Sound* (Seattle: University of Washington Press, 1930); R. Douglas Hurt, *The Indian Frontier, 1763–1846* (Albuquerque: University of New Mexico Press, 2002), 83; and Charles M. Nelson, "Prehistory of the Puget Sound Region," in *Handbook of North American Indians,* ed. William Sturtevant (Washington, DC: Smithsonian, 1978–), 481–484.

2. Smithsonian Museum of the American Indian, *Listening to Our Ancestors: The Art of Native Life along the North Pacific Coast* (Washington, DC: National Museum of the American Indian, Smithsonian Institution, in association with National Geographic, 2005), 20.

3. J. M. Adovasio, Olga Soffer, and Jake Page, *The Invisible Sex: Uncovering the True Roles of Women in Prehistory* (New York: HarperCollins, Smithsonian Books, 2007), 206–208.

4. Coll Thrush, *Native Seattle: Histories from the Crossing-Over Place* (Seattle: University of Washington Press, 2007); Suquamish Museum, *The Eyes of Chief Seattle* (Seattle: Suquamish Museum, 1985); Wayne Suttles and Barbara Lane, "Southern Coast Salish," in *Handbook of North American Indians*, 485–502; Haeberlin and Gunther, *The Indians of Puget Sound.*

5. For the history of place names in Puget Sound, see the appendix by Nile Thompson and Coll Thrush in Thrush, *Native Seattle.* For Vancouver's renaming, see Edmond S. Meany, *Vancouver's Discovery of Puget Sound: Portraits and Biographies of the Men Honored in the Naming of Geographic Features of Northwestern America* (New York: Macmillan, 1907), Autry Library, Institute for the Study of the American West, Autry National Center.

6. Alexandra Harmon, *Indians in the Making: Ethnic Relations and Indian Identities around Puget Sound* (Berkeley: University of California Press, 1998); Hurt, *The Indian Frontier,* 93; Sylvia Van Kirk, *Many Tender Ties: Women in Fur Trade Society, 1670–1870* (Norman: University of Oklahoma Press, 1983).

7. Arthur Denny, *Pioneer Days on Puget Sound* (Seattle: C. B. Bagley, Printer, 1888); Harmon, *Indians in the Making,* 60–63; Coll-Peter Thrush, "Creation Stories and Native Seattle," in *More Voices, New Stories: King County, Washington's First 150 Years,* ed. Mary C. Wright (Seattle: University of Washington Press, 2003).

8. Thrush, *Native Seattle,* 44.

9. Phoebe Goodell Judson, *A Pioneer's Search for an Ideal Home* (1925; reprint, Lincoln: University of Nebraska Press, 1984), 107.

10. Matthew Klingle, *Emerald City: An Environmental History of Seattle* (New Haven: Yale University Press, 2007), 29; Linda Peavy and Ursula Smith, "Sarah Burgert Yesler," in *Women in Waiting in the Westward Movement* (Norman: University of Oklahoma Press, 1994), 132–178; Clarence Boyle, "Chief Seattle and Angeline," *Washington Historical Quarterly,* 22, no. 4 (1931): 243–275.

11. Harmon, *Indians in the Making,* 119. See also Russel Lawrence Barsh, "Puget Sound Indian Demography, 1900–1920: Migration and Economic Integration," *Ethnohistory* 43, no. 1 (Winter 1996): 65–97.

12. Boyle, "Chief Seattle and Angeline," 243–275; Sharon Boswell and Lorraine McConaghy, "Indian Images Altered," *Seattle Times,* January 21, 1996, http://community.seattletimes.nwsource.com/archive/?date=19960121&slug=2309964, accessed August 26, 2009; Thrush, *Native Seattle.*

13. Boyle, "Chief Seattle and Angeline," 273.

14. Quoted in Victor Boesen and Florence Curtis Graybill, *Edward S. Curtis: Photographer of the North American Indian* (New York: Dodd, Mead, 1977), 15. See also Sara Day, ed., *Heart of the Circle: Photographs by Edward S. Curtis of Native American Women* (San Fran-

cisco: Pomegranate Books, 1997), 102–103; Barbara A. Davis, *Edward S. Curtis: The Life and Times of a Shadow Catcher* (San Francisco: Chronicle Books, 1985); Christopher M. Lyman, *The Vanishing Race and Other Illusions: Photographs of Indians by Edward S. Curtis* (New York: Pantheon Books, 1982).

15. *Tacoma and Vicinity* (Tacoma, WA: Nuhn & Wheeler, 1888), Rosenstock Collection, Museum of the American West, Autry National Center; 90.253.3032.

16. Harmon, *Indians in the Making;* Carl Abbott, "Footprints and Pathways: The Urban Imprint on the Pacific Northwest," in *Northwest Lands, Northwest People: Readings in Environmental History,* ed. Dale D. Goble and Paul W. Hirt (Seattle: University of Washington Press, 1999), 114–115.

17. Richard D. Scheuerman, "Washington's European American Communities," in *Peoples of Washington: Perspectives on Cultural Diversity,* ed. Sid White and S. E. Solberg (Pullman: Washington State University Press, 1989); Patsy Adams Hegstad, "Scandinavian Settlement in Seattle: Queen City of the Puget Sound," Norwegian American History Association Online, vol. 30, www.naha.stolaf.edu/pubs/nas/volume30/vol30_02.htm, accessed August 27, 2009.

18. Odd S. Lovoll, "For the People Who Are Not in a Hurry: The Danish Thingvalla Line," *Journal of American Ethnic History* 13 (1993).

19. Janet Rasmussen, *New Land, New Lives: Scandinavian Immigrants to the Pacific Northwest* (Seattle: Norwegian-American Historical Association and University of Washington Press, 1993); Janice Reiff, "Scandinavian Women in Seattle," in *Women in Pacific Northwest History: An Anthology,* ed. Karen Blair (Seattle: University of Washington Press, 1988).

20. United States Immigration Commission, *Reports of the Immigration Commission* (Washington, DC: Government Printing Offices, 1911).

21. L. E. Bragg, *More Than Petticoats: Remarkable Washington Women* (Helena, MT: TwoDot, 1998), 141.

22. Murray Morgan, *Puget's Sound: A Narrative of Early Tacoma and the Southern Sound* (Seattle: University of Washington Press, 2003).

23. Gail Nomura, Sid White, and S. E. Solberg, eds., *Peoples of Washington: Perspectives on Cultural Diversity* (Seattle: Washington State University Press, 1989); Roger Daniels, *Asian America: Chinese and Japanese in the United States since 1850* (Seattle: University of Washington Press, 1990); Paul R. Spickard, *Japanese Americans: The Formation and Transformations of an Ethnic Group* (New York: Twayne, 1996).

24. Shotaro Frank Migamoto, *Social Solidarity among the Japanese in Seattle* (Seattle: University of Washington, 1939), 88.

25. Monica Sone, *Nisei Daughter* (1953; reprint, Seattle: University of Washington Press, 1979), 12.

26. Migamoto, *Social Solidarity among the Japanese in Seattle,* 93.

27. Carole Ann Hatsuko (Koura) Kubota, "Growing Up Japanese on Bainbridge Island," oral history published in *Bainbridge Island Japanese American Community Newsletter,* Summer 2004, www.bijac.org/newsltr2.html, accessed January 19, 2007.

28. Richard White, *Land Use, Environment, and Social Change: The Shaping of Island County, Washington* (1980; reprint, Seattle: University of Washington Press, 1992); Stan Flewelling, *Shirakawa: Stories from a Pacific Northwest Japanese American Community* (Seattle:

University of Washington Press, 2002); Gail Dubrow and Donna Graves, *Sento at Sixth and Main: Preserving Landmarks of Japanese American Heritage* (Seattle: Seattle Arts Commission, University of Washington Press, 2002).

29. Sylvia Junko Yanagisako, *Transforming the Past: Tradition and Kinship among Japanese Americans* (Stanford, CA: Stanford University Press, 1985).

30. Flewelling, *Shirakawa*, 35, 50; Evelyn Nakano Glenn, "The Dialectics of Wage Work: Japanese American Women and Domestic Service, 1905–1940," *Feminist Studies* 6 (Fall 1980).

31. Judy Mattivi Morley, *Historic Preservation and the Imagined West: Albuquerque, Denver, and Seattle* (Lawrence: University Press of Kansas, 2006), 92–95; Alice Shorett and Murray Morgan, *The Pike Place Market: People, Politics, and Produce* (Seattle: Pacific Search Press, 1982).

32. Quoted in Catherine Lee, "Prostitutes and Picture Brides: Chinese and Japanese Immigration, Settlement, and American Nation Building" (working paper, February 2003), 32–33.

33. Whatcom Museum of History and Art, *Enduring Legacy: Women Painters of Washington, 1930–2005* (Seattle: University of Washington Press, 2005).

34. Quoted in Jean Ward and Elaine Maveety, eds., *Pacific Northwest Women, 1815–1925: Lives, Memories, and Writings* (Corvallis: Oregon State University Press, 1995), 58.

35. "Now Long-Gone Fish Traps Drove Fisheries," *Bellingham Herald*, October 20, 2003; *Women in the Fruit-Growing and Canning Industries of the State of Washington* (Washington, DC: U.S. Government Printing Office, 1926), Harvard University, Open Collections: Women Working, http://ocp.hul.harvard.edu/ww/, accessed January 19, 2007; Barbara Radke, *Pacific American Fisheries, Inc.: History of a Washington State Salmon Packing Company, 1890–1966* (Jefferson, NC: McFarland and Company, 2001).

36. Advertisement for "Iron Chink," *Pacific Fisherman* 5, no. 11 (November 1907): 30, Center for the Study of the Pacific Northwest, University of Washington.

37. Charlene J. Allison, Sue-Ellen Jacobs, and Mary A. Porter, *Winds of Change: Women in Northwest Commercial Fishing* (Seattle: University of Washington Press, 1989), 71.

38. Richard White, *The Organic Machine: The Remaking of the Columbia River* (New York: Hill and Wang, 1995); Chris Friday, *Organizing Asian American Labor: The Pacific Coast Canned-Salmon Industry, 1870–1942* (Philadelphia: Temple University Press, 1994); Radke, *Pacific American Fisheries*, 122.

39. *Women in the Fruit-Growing and Canning Industries*, 122, 125.

40. John M. Findlay, "A Fishy Proposition: Regional Identity in the Pacific Northwest," in *Many Wests: Place, Culture, and Regional Identity*, ed. David Wrobel and Michael Steiner (Lawrence: University Press of Kansas, 1997).

41. John C. Putnam, *Class and Gender Politics in Progressive-Era Seattle* (Reno: University of Nevada Press, 2008); "The Eight Hours Day for Wage Earning Women: United States Supreme Court Upholds the California Law," Women in Industry Series no. 14 (Washington, DC: National Consumers' League, December 1916), Harvard University, Open Collections: Women Working, http://ocp.hul.harvard.edu/ww/, accessed January 19, 2007.

42. Dana Frank, *Purchasing Power: Consumer Organizing, Gender, and the Seattle Labor Movement, 1919–1929* (New York: Cambridge University Press, 1994), 6.

43. Sandra Haarsager, *Bertha Knight Landes of Seattle: Big-City Mayor* (Norman: University of Oklahoma Press, 1994), 53; Doris Pieroth, "Bertha Knight Landes: The Woman Who

Was Mayor," in *Women in Pacific Northwest History*, ed. Karen Blair (Seattle: University of Washington Press, 1989).

44. Bertha Knight Landes quoted in *Seattle Times*, March 2, 1922.

45. "Landes for Mayor," campaign flyer, Collection of Museum of History and Industry, Seattle.

46. Haarsager, *Bertha Knight Landes of Seattle*, 138.

47. Bertha K. Landes, "Steering a Big City Straight," *Woman Citizen* 12 (December 1927).

48. City of Seattle, *Department of Lighting Annual Report* (Seattle: Gateway Printing, 1925), Museum of the American West, Autry National Center.

49. David E. Nye, *Electrifying America: Social Meanings of a New Technology* (Cambridge: MIT Press, 1991); Suellen Hoy, *Chasing Dirt: The American Pursuit of Cleanliness* (New York: Oxford University Press, 1995); Ruth Schwartz Cowan, *More Work for Mother: The Ironies of Household Technology from Hearth to the Microwave* (1983; reprint, New York: Basic Books, 1985).

50. Mayor's annual report, quoted in Haarsager, *Bertha Knight Landes of Seattle*, 150.

51. *War Production in Washington* (January 1943), quoted in James Warren, *The War Years: A Chronicle of Washington State in World War II* (Seattle: History Ink/University of Washington Press, 2000), xvi.

52. Karen Anderson, *Wartime Women: Sex Roles, Family Relations, and the Status of Women during World War II* (Westport, CT: Greenwood Press, 1981), 75.

53. Sone, *Nisei Daughter*, 158. For the impact on other Japanese American communities in Puget Sound, see Mary Matsuda Gruenewald, *Looking Like the Enemy: My Story of Imprisonment in Japanese American Internment Camps* (Troutdale, OR: NewSage Press, 2005); David Neiwert, *Strawberry Days: How Internment Destroyed a Japanese American Community* (New York: Palgrave Macmillan, 2005).

54. Ikuko Amatatsu Watanabe [O.H. 1363], Japanese American History Collection, Center for Public History, California State University Fullerton; *Bainbridge Review*, April 2, 1942.

55. Japanese Evacuation Report #8, Joseph Conard, box 3, notebook, April 1942, Hoover Institution Archives.

56. *Report of the American Red Cross Survey of Assembly Centers in California, Oregon, and Washington*, U.S. Commission on Wartime Relocation and Internment of Civilians (part 1, numerical file archive, reel 10 0696), reprinted at www.lib.washington.edu/exhibits/harmony/exhibit/housing.html, accessed September 6, 2009.

57. Anderson, *Wartime Women*, 28.

58. Eugenie Thrapp Collection, Veterans' History Project, American Folk Life Center, Library of Congress; Freda Philbrick, quoted in Anderson, *Wartime Women*, 29.

59. David Peterson Del Mar, *Beaten Down: A History of Interpersonal Violence in the West* (Seattle: University of Washington Press, 2002), 156.

60. Elizabeth Dean Collection, Veterans' History Project, American Folk Life Center, Library of Congress.

61. Kenneth William Townsend, *World War II and the American Indian* (Albuquerque: University of New Mexico Press, 2000); Alison R. Bernstein, *American Indians and World War II: Toward a New Era in Indian Affairs* (Norman: University of Oklahoma Press, 1991).

62. Mildred Tanner Andrews, *Woman's Place: A Guide to Seattle and King County History* (Seattle: Gemil Press, 1994); Charles Wilkinson, *Messages from Frank's Landing: A Story of Salmon, Treaties, and the Indian Way* (Seattle: University of Washington Press, 2000); *Activism,* video by Ramona Bennett on Seattle Civil Rights and Labor History Project, www.dept.washington.edu/, accessed February 12, 2008.

63. On Japanese American redress in Washington, see Robert Sadamu Shimabukuro, *Born in Seattle: The Campaign for Japanese American Redress* (Seattle: University of Washington Press, 2001).

64. "Uncertain Futures: The Real Impact of the High-Tech Boom and Bust on Seattle's IT Workers," executive summary, 2003, www.washtech.org/reports/UncertainFutures/ UncertainFuturesExecSumm.pdf, accessed January 6, 2009.

65. World Trade Organization History Project, online digital initiative, University of Washington, Harry Bridges Center for Labor Studies, and Center for Communication and Civic Engagement; "Seattle Declaration," reprinted in Valentine M. Moghadam, *Globalizing Women: Transnational Feminist Networks* (Baltimore, MD: Johns Hopkins University Press, 2005), appendix C.

66. Toxic-Free Legacy Coalition, *Pollution in People: Executive Summary* (Seattle: Toxic-Free Legacy Coalition, 2006).

67. On the eco-mom movement, see www.ecomomalliance.org; Patricia Leigh Brown, "For 'EcoMoms,' Saving Earth Begins at Home," *New York Times,* February 16, 2008; Boston Consulting Group, "Three Faces of Eve: Women Seeking Harmony, Value, and Connection," in *Opportunities for Action in Consumer Markets,* 2006, www.bcg.com/impact_expertise/ publications, accessed October 8, 2007.

JAPANESE AMERICAN WOMEN IN THE PACIFIC NORTHWEST

Epigraph: Tsuruyo Takami quoted in Kazuo Ito, *Issei: A History of Japanese Immigrants in North America,* trans. Shinichiro Nakamura and Jean S. Gerard (Seattle: Japanese Community Services, 1973), 247–248. The original work, written in Japanese, was published in the 1960s.

1. Ibid., 279.

2. Ibid., 253.

3. Ibid., 249.

4. See, for example, Yoshi Iwase's narrative in ibid., 272.

5. Ibid., 250.

6. Ibid., 258.

7. Ibid., 283.

8. Ibid., 268.

9. Ibid., 252.

10. Ibid., 259.

11. Ibid., 280–281.

12. Ibid., 249.

13. Ibid., 261.

MAPS

Over the years that we have worked on this project, we have benefited from the sponsorship, encouragement, and involvement of many people at the Autry National Center and in the community of scholars and supporters who have come to regard the Autry as a wellspring of scintillating ideas, cutting-edge research, and compelling exhibitions and programs. So we begin by acknowledging those who created a space for women's history, and for thinking hard about gender, at the Autry: founders Jackie Autry and Joanne Hale. We came to the Autry as a result of its 2002 merger with the Women of the West Museum, of Boulder, Colorado. We thank visionary WOW trustees Jane Butcher, Jerrie Hurd, Joyce Thurmer, and Tish Winsor, along with Marcia Semmel and Selma Thomas, for their pioneering work with the WOW Museum.

An extraordinary exhibition team kept the Home Lands project moving forward: Andi Alameda, David Burton, Clyde Derrick, Eric Gaard, Erik Greenberg, Marlene Head, Robyn Hetrick, Alicia Katano, Paula Kessler, Ann Marshall, Angie McGrew, Cheryl Miller, Christopher Muniz and Tim McNeil of M/M Design, Zach Putnam, and Laureen Trainer. This project would not have been possible without their creativity, talent, and good humor over the years. We also had the good fortune to have the research assistance of Linda Frank, Dahlia Guajardo, Fiona Potter, and Laura Redford in Los Angeles, and Sarah Payne and Amy Scott in New Mexico and New Haven. Many other Autry staff also assisted with the Home Lands exhibition and this book, and we thank Peg Brady, Marva Felchlin, Elizabeth Kennedy, Marilyn Kim, Laleña Lewark, Richard Moll, Belinda Nakasato-Suarez, Anna Norville, Sandra Odor, Kim Walters, and Lisa Woon for all their help.

One of the most exciting aspects of this project has been the opportunity to develop grade school curricula based on the content of this book and accompanying exhibition. Gary Nash and Marian Olivas of the National Center for History in the Schools guided us through this process and gave us the immense benefit of their time and expertise. We thank the teachers who created the curricula: Heather Dahl, Erik Greenberg, Karen Hoppes, Allis Jason-Fives, and Rachel Stutzman. We also thank Zevi Gutfreund for his superb work.

From sessions in front of the exhibition storyboard to Autry Western History workshops, Home Lands benefited from the suggestions and observations of an intellectually lively group of trustees, guests, docents, and workshop participants. In particular, we

thank our supporters and advisors, including David Cartwright, Susan Countner, Simona and Marvin Elkin, Mary Kay Hight, Sonia Rosario, Lisa See, Elizabeth Short, Cam Starrett, and John Sussman. We are grateful to those who gave us the opportunity to speak and write about the exhibition: Cindy Ott and Michael Fox at the Museum of the Rockies, Katy Barber and the Portland State University Friends of History, Colleen O'Neill and David Lewis of the *Western Historical Quarterly*, Michelle Hoffnung of Quinnipiac University, Colin Divall and the University of York and National Railway Museum of Great Britain, Harriet Rochlin and Women Writing the West, Jay Gitlin and the Lamar Center at Yale University, Brian Q. Cannon and the Charles Redd Center at Brigham Young University. We were delighted to participate in panels at the Western History Association and the Berkshire Conference on Women's History.

We were privileged to work with an extraordinary group of scholar advisors. The essays in this book by Gail Dubrow, María Montóya, and Elliott West reflect their inspired commitment to the project from beginning to end. We also benefited immensely from the advice and involvement of Jennifer Denetdale, Vicki Ruiz, Marni Sandweiss, and Chris Wilson. We are ever aware that our efforts would not be possible without the burgeoning body of scholarship on the history of women in what has become the American West. We cannot thank all those who have contributed to that work, but we express our respect and gratitude to those who broke the path: Susan Armitage, Elizabeth Jameson, Joan Jensen, Darlis Miller, Janice Monk, Vicki Ruiz, and Lillian Schlissel.

Home Lands: How Women Made the West is, of course, an exhibition as well as a book. We are grateful to those who generously allowed us to borrow and acquire the objects that are at the heart of our attempt to tell the story of the Western past with women at the center. The Autry National Center Gold-Level Members Acquisitions Committee made possible the purchase of several of the objects that appear in the Home Lands exhibition and book. The Philip Anschutz Collection, Lee Maxwell, James R. Parks, Elisabeth Waldo, and Diane Wray also generously loaned important pieces from their collections for this exhibition. The staff at many museums and libraries also opened their collections and expertise to us: Bunny Huffman at the Acequia Madre House; Margaret Koch at the Missouri History Museum; Louise Stiver at the Palace of the Governors, Museum of New Mexico; Mary Montgomery at the Museum of History and Industry; Robert Fisher at the Wing Luke Asian Museum; LaWanna Larson of the Black American West Museum; Moya Hansen and the Colorado Historical Society; and the staff at the Japanese American National Museum, the Alan Chesney Medical Archives, the Johns Hopkins University and the Walters Art Museum, the Burke Museum, the Navy History and Heritage Center, the Wichita Art Museum, the University of Washington, New Mexico State University's Hobson-Huntisinger Archives, and the Whitney Museum.

We are grateful that this book found a home at the University of California Press. We thank our editor, Niels Hooper, for all his encouragement and good ideas and feel very lucky to have had the useful criticism of Ramón Gutiérrez and Phoebe Krupp as manuscript referees. Thank you also to Nick Arrivo and production editor Jacqueline Volin for

guiding us through manuscript preparation and production at the University of California Press, to copyeditor Bonita Hurd, to designer Nola Burger, and to Marlene Head for her assistance at the Autry. Generous support by Tally and Bill Mingst for the Institute for the Study of the American West helped make this and future Autry publication projects possible through the Caryll and William Mingst/the Mildred E. and Harvey S. Mudd Publications Fund. Unified Grocers, Cam Starrett, National Endowment for the Humanities, and Eastman Kodak helped make the exhibition possible through their support.

Carolyn personally thanks Sal Johnston and Elizabeth Sage for being friends who turned into willing readers in the early phases of writing, and David Paddy for everything: *diolch yn fawr*. Virginia thanks Elaine Koster for making the writing of this book possible in the face of other commitments, Amy Green and Daniel and Jack Aron for a home away from home, and Sam and Annie Swift and Patty and Steve Bort for their love and support of her work in women's Western history. Thanks to Melissa Bokovoy, Cathleen Cahill, Andew Sandoval-Strausz, and Jane Slaughter, all in New Mexico. And thanks always to Chris Wilson for his patience, inspiration, and exuberance. Finally, we are grateful to three men who have brought imagination, dedication, and deep insight to our work and have given us the opportunity to share a collaboration that has been a joy and a revelation to both of us. They have been cheerful and challenging intellectual companions on this journey and have made the Autry the remarkable place it is today: John Gray, President and CEO of the Autry; Jonathan Spaulding, Vice President of Exhibitions and Executive Director and Chief Curator of the Museum of the American West; and Stephen Aron, Executive Director of the Autry Institute for the Study of the American West. We can't thank you enough.

coverture, doctrine of, 23, 44–45

Cowan, Ruth Schwartz, 81

craftwork: Anglo promotion of, 28, 31, 33, 37; Cheyenne parfleche, *54*; Cheyenne robe, *53*; depicted in portrait, 57, *58*; painted paddle, *pl. 16*, 95; of Plains peoples, 54–55; as souvenirs, 24, 31, 33; Spanish colcha embroidery, *pl. 4*, 21; in trade among Native and white women in Puget Sound, 100–101, 102. *See also* adobe architecture; baskets and basketry; carvings; clothing; pottery; weaving

Crawford, Dana, 84

cul-de-sacs, *pl. 15*, 81–82, 85

Curtin, Leonora Frances (later Paloheimo), 29, 30, 31, 33, 37

Curtin, Leonora Muse, 29, *29–30*, *30–31*, 31

Curtin, Thomas E., 30

Curtis, Edward S., *pl. 18*, 12, 102

Dakota people, 50

Dalles Dam, 121

Day of Remembrance, 127

Dean, Elizabeth, 125, 127

DeBoer, Saco Reink, 77

Deerborne Bakery (Seattle), 108

deforestation, 11, 13, 23–24

Deloria, Philip, 81

Denish, Diane, 40

Denny, Arthur, 100

Denny, Louisa Boren, 100

Denny, Mary Ann, 100

Denver: African Americans in, 69, 71–73, 74; automobile culture in, 77, 79; boosterism of, 63–64, 67–68, 81; Cherry Creek area in, 63, 66, 68, 75, 86; City Beautiful Movement in, 75–77, 84; diverse population of, 66, 86; first child born in, 61; Five Points subdivision of, 69, 71–73, 75; growth of, 66, 82, 84; map of, 70; Native Americans in, 61, 80; railroad's role in, 66, 67; State Capitol in, 76; suburban development in, 81–82; trolleys and cable cars of, 69, 75, 77; urban renewal in, 84–85; women's reform efforts in, 68; working-class and poor neighborhoods in, *pl. 13*, 66–68, 86; working women in, 76–77, 80, 85, 87–89; WWII as reshaping, 80

Denver Artists Club, 76, 86

Denver Art Museum, 76, 86

Denver Civic Plaza, 75, 76

Denver Post (newspaper), 75

Denver Public Library, 76

Denver Republican (newspaper), 72

Denver Times (newspaper), 67–68, 72

Denver Tramway Company, 69, 77

DePriest, Ida, 72

De Vargas Development Corporation, 27–28

Dewitt, John, 122

Diablo Dam (Skagit River), 119

Dickinson, Anna, 64

Direct Action Network, 128

Diverse Women for Diversity, 128

divorce: in Colorado, 87, 88–89; in New Mexico, 29–30, 39, 45; in WWII, 121

Dodge, Mabel (later, Lujan), 26

domesticity. *See* home

domestic servants: African Americans as, 59; captives as, 15; foreign born as, 106; Hispanic and Native women as, 16, 19, 24, 27, 100; tasks of, 103

Drewelowe, Eve, *pl. 14*, 79–80

droughts, 13, 23–24

Dubrow, Gail, 130–34

Dunn, Dorothy, 36

Duwamish people, 94, 101–2

Duwamish River, 95, 128

earth: as paint pigment, 36; symbolism of, 26, 37; women's uses of, 7–13. *See also* adobe architecture; pottery

Eastern Association of Indian Affairs, 28

eco-moms, 129

Egashira, Sumako, 133

electricity, 119, *120*, 121

Elting, Elizabeth "Buff," *pl. 15*, 85

embroidery, Spanish colcha, *pl. 4*, 20, 21, 31

encomienda system, 16

Ensley, Elizabeth, 72

environmental issues: automobile and factory pollution, 84–85; damming rivers for power, 121; deforestation, 11, 13, 23–24; in Denver, 67–68, 84; land degradation, 23–24, 33; naturalist's writing on, 113–14; pollution of Puget Sound, 128–29

Environmental Protection Agency, Superfund sites, 128–29

Equal Suffrage Association (Denver), 72
equestrian revolution, 15. *See also* horses
Evans, Anne, 75–76, 77
Evans, John, 63–64, 69, 75
Evans, Margaret, 63, 64
Executive Order 9066, 122–23, 127

families: berry and vegetable farming enter-
 prises of, 111–12; *coyota* (child) of Indian and
 mestiza, 19; depiction of *mestiza, pl. 1,* 16–
 17; diverse relationships among, 2; hybridity
 of, *pl. 11,* 56–62, 98, 100–102; as instru-
 ment of U.S. conquest, 62–63; seasonal
 rhythms of, 95, 97; single mother's diary
 about, 87–89; as stabilizing force on north-
 ern frontier, 16–17; war work balanced with
 care for, 123–27
farming. *See* agriculture and farming
Fay, Robert, 100
Fényes, Adalbert, 30
Fényes, Eva Scott Muse, 28–30, *29, 30–31*
Ferguson, Miriam, 118
Fergusson, Erna, 39
Fidalgo Island Canning Company, *pl. 20*
Findlay, John, 114
Fitzgerald, Zelda, 28
folk traditions: modernization combined with
 respect for, 33–39. *See also* craftwork
food and food preparation: colonial and indige-
 nous adaptations in, 21–22; competition
 for, 14–15; electrical appliances for, 121;
 gathering and harvesting, 8, 95, 111;
 increased diversity of, 8, 21; of Japanese
 immigrants, 109, *110,* 134; modern equip-
 ment for, 33–34, *35;* parfleches for, 54; rice
 steamer baskets for, 109, *110;* salmon recipes,
 116; wartime and, 124–25, *126. See also* con-
 tainers; grinding stones (metate); pottery
Ford, Henry, 77
Ford, John, 72–73
Ford, Justina (née Warren), 72–73, *74*
Fort Langley, 98
Fort Larson, 80
Fort Nisqually, 98, 100, 101
Foss, Thea, 106–7
Foss Maritime Company, 106–7
Frank, Dana, 117
Fred Harvey Company, *37,* 39, 84

French, Daniel, 88, 89
French, Emily Rood, 87–89
French, Marsena, 87–88
French, Olive, 88, 89
frontier: concept of, 56
Fuji, Mount, 130–31, 132
fur trappers and trade: ranching and farming
 as replacing, 61–62; women's roles in,
 pl. 11, 22, 56–62, 98

Garcia, Adeline Skultka, 127
Garcia, Sheila, 40
Gast, John, *pl. 12,* 63
gender role changes: in adobe building con-
 struction, 9, 11, *12,* 22, 25; in bison and
 horse economy, 51–55; due to political and
 legal shifts, 23, 44–45; mobility and tech-
 nological changes linked to, 49; New
 Women engaged in, 26–33; in westward
 railroad expansion, 64, 66; in WWII war
 production, 123–27
genizaros, 19
Gentlemen's Agreement (U.S.-Japan), 108, 111, 112
German immigrants, 66, 69, 106
G.I. Bill, 80
Gilpin, Laura, *78,* 79
Gilpin High School (Five Points, Denver), 71
global market: problems in, 135; response to,
 40–42; romantic images in, 37, 39; trade
 liberalization in, 128. *See also* tourism
Golden West (magazine), 82
gold rushes: Alaska-Yukon, 103; Colorado, 60–
 61, 63, 86
Gorge Dam (Skagit River), 119, *120*
Grant, Zephra, 73
The Great Plains (Webb), 93
Gregg, Josiah, 21
Gregoire, Christine, 129
grinding stones (metate): early example of, 8,
 9; new types of, 21–22; slab metate, 13
Grinnell, Elizabeth C., *pl. 10*
Guadalupe Soberanes, Maria Antonia Juana
 Ygnacia, 44
Guadalupe Vallejo, Mariano, 44
Guerrier, Ed, 62

Haffer, Virna, *pl. 21,* 121
Haida people, 98, *99,* 127

maritime interests: Native vs. American, 113–14; steamships and, 104, 106–7. *See also* Puget Sound; salmon

marriage: of Americans and Mexicans, 22; of Coastal Salish people, 97, 98; depiction of, *pl.11*, 56; fur trade diplomacy and, 56–62, 98; independence vs., 104; intermarriage banned, 101; of Japanese immigrants, 108; property rights and, 23, 44–45; social status gained in, 43–44. *See also* divorce

marriage chest, *pl. 2*, 18–19, *43*, 43–45

Martin, José, 19

Martin, María Gertrudis, 19

Martínez, María, *pl. 6*, 33

Martínez, Mariana, 39, 45

Martínez, Servino, 19

Maxwell, Lucien, 45

Maxwell, Luz, 45

Meem, John Gaw, 31

metate. *See* grinding stones (metate)

Mexican-American War (1846–48), 44, 59

Mexican and Mexican American women: coverture and, 44–45; marriages of, 22, 59–60

Mexico: trade restrictions lifted by, 22

Microsoft, 128

Miera y Pacheco, Bernardo de, *18*, 20

Miller, Alfred Jacob, *pl. 11*, 56

Mimbres people, 8

miners and mining: oxen and cattle of, 61; woman's suffrage campaign in camps, 64, 66; women's work in camps, 60. *See also* smelters (ore)

Minidoka Relocation Center, 123

Mis-stan-sta (Owl Woman), 56–57, *58*, 59, 61–62

mobility: automobiles as symbol of, 77, 79; in horse and bison economy, 50–55; new means of, 49; pollution caused by, 67–68; suburban development and, 81–82; trolleys and railroads facilitating, 69, 71–73, 75; in westward railroad expansion, 62–66. *See also* suburban developments; transportation

Mogollon people, 8, *9*, 13

Montóya, María E., 23, 43–45, 80

Moore, Robinson, 62

Morfi, Juan Agustin de, 17

Mosness, Katherine (Tink), 114

motorcars. *See* automobiles

"Mud Woman's First Encounter with the World of Money and Business" (Naranjo-Morse), 40–42

municipal housekeeping concept, 117–19

Muse, Eva Scott (later, Fényes), 28–30, *29*, *30–31*

Muse, Leonora (later, Curtin), *29*, 29–30, *30–31*, 31

Muse, William, 29

Museum of New Mexico, 31

Nakagawa, Sueko, 132

Naranjo-Morse, Nora, *pl. 8*, 40–42

National Consumers League, 117

National Defense Highway Act (1956), 80

National Jewish Hospital (Denver), 68

National War Labor Board, 127

Native Market, 31, 33

nativism, 107, 108, 112–13, 122–23

Natsuhara, Sen, 112

Navajo people: banded blanket of, *pl. 3*, 20; homeland of, 7; language of, 31; migration of, 13, 20; raiding by, 15, 19; vocational training and relocation of, 80

Neff, Wallace, 30

Negro Digest (periodical), 73

New Mexico: maps of, *6*, *18*; migrations into, 13–15; poverty in, 39; U.S. takeover of, 23. *See also* Rio Arriba (region); Santa Fe; Taos

New Mexico Territorial Court, 45

"New Women," 26–27, 28, 37

Niguma, Tomiko, 132

Nisei Daughter (Sone), 122

Nootka Sound, 98

Northern Pacific Railway, 104

Nuevo Mexicanas and Mexicanos, 17–19. *See also* Hispanic people; Hispanic women

odometer for wagons, 61

Office of Price Administration, 125, *126*

Ohio & Mississippi Railway, 65

Okasaki, Gin, 132

O'Keeffe, Georgia, *pl. 5*, 26–27

Old Santa Fe Association, 27

Olesen, Andrew (later, Andrew Foss), 106–7

ollas, *pl. 6*, 16, *21*

Olmstead, Frederick Law, 75

Ono, Kimiko, 112, 131, 133
Oregon Donation Land Act (1850), 100–101
Owaki, Shige, 108
Owens, Bill, 84
Owl Woman (Mis-stan-sta), 56–57, *58*, 59, 61–62

Pacific Northwest, dams of, 119, *120*, 121. *See also* Coastal Salish people; Puget Sound; Seattle; Tacoma
Pacific Railway Act (1862), 63
Paguate adobe house, 11, *12*
paintings and drawings: buffalo hunt, *51*; iconography of West, *pl. 12*, 63; indigenous women, *pl. 11*, 56, *58*; landscapes, *pl. 5*, *pl. 13*, *pl. 14*, *pl. 15*, 26–27, *86*; *mestiza* families, *pl. 1*, 16–17; Pueblo life and ritual, *pl. 7*, 36, 37; Santa Fe house, *30–31*; seascape, *pl. 19*
Paloheimo, Y. A., 33
parfleches, *54*
Pearl Harbor attack, 121–22
Pecos Pueblo: consolidation of, 13; slaves at trade fairs in, 19–20; Spanish arrival at, 15; as trade center, 14
Peña, Tonita, 28
Penstock Tunnel (Gorge Dam), *120*
Philbrick, Freda, 124
photographic subjects: adobe construction and maintenance, *12*, *25*; African American woman doctor, *74*; cannery workers, *115*; clam digging, *pl. 18*; Gorge Dam Powerhouse tunnel, *120*; high school students, *71*; learning to use pressure cooker, *35*; net fishing at Celilo Falls, *pl. 21*, 121; New Mexican schoolhouse, *34*; Pikes Peak, *78*, *79*; raising tipi poles, *pl. 10*; suburban isolation, *83*; tourism promoted via, *78*, *79*; woman reformer, *118*; women carrying water, 102, *103*; women in Santa Fe Plaza, *29*; WWII women workers, *125*
"picture brides," 108, 131–32
Picuris Pueblo, 14, 20
Pike Place Market (Seattle), 112, 127–28, *129*
Pikes Peak, *78*, 79
Pioneer Monument (Denver), 76
Plains Indian peoples: flowering of culture, 49; painted robe of, *53*; women's artistic expression among, 54–55. *See also* Arapaho people;

bison; Cheyenne people; Comanche people; horses
plants and herbs: berry and vegetable farming, 111–12; cattails and cedar, uses of, 95, *96*, 97; domestication of, 8–9; ixtle, uses of, *pl. 4*, 21; Japanese women's narratives on, 132–33; learning about new, 21–22; medicinal types of, 30, 31. *See also* agriculture and farming; weaving
Platte River, *pl. 13*, 67, 68, 69, *86*
Plessy v. Ferguson (1890), 72
poetry, 40–42, 132–34
Point, Susan, *pl. 16*
Polanski, Roman, 93
politics: African American women in, 72; Salish marriage system linked to, 97; shifting control of, 22–23, 44; women in, 40, 118–19, 121, 129. *See also* Manifest Destiny; suffragists
pottery: market for, 20, 24; poem about, 40–42; purchases from sales of, 33; tribute collection and, 16; value of, 39; women's development and innovations in, 9, 13–14
pottery, specific: bowl, 13–14, *14*; cooking pot, 9, *10*; figurine, *pl. 8*; seed jar, 9, *10*; ollas, *pl. 6*, 16, 21
Prairie Point (Washington), 100
pressure cookers, 33, 35
property rights, 17–19, 23, 44–45
Puebloans: cash economy faced by, 24; current challenges for, 40–42; depictions of, *pl. 7*, 36; displacement of, 17; land and water rights of, 28; land degradation faced by, 23–24; modern cookery methods of, 33–34, 35. *See also* ancestral Puebloans; Rio Grande Puebloans; Tesuque Pueblo culture
Pueblo Bonito, 11
Puget, Peter, 97
Puget Sound: bird's-eye view of, *107*; booming growth of, 102–3; environmental challenges facing, 128–29; fishing and lifeways of, 94–97, 111; industrial development of, 113–18; Japanese American internment in, 122–23, 127, 132–34; Japanese immigrants in, 107–13; map of, *92*; mapping and place-names of, 97–98; marine highway of, 106–7; Native and white people cohabiting in, 98, 100–102; Scandinavian immigrants in,

pollution in, 128–29; WAVES stationed in, 125, 127; women's reform efforts in, 117–19, 127; women working in WWII, 124, 127; World's Fair in, 127

Seattle City Council, 118–19

Seattle Declaration (manifesto), 128

Seattle Federation of Women's Clubs, 117

Seattle Star (newspaper), 112

seaweed gathering, 109, 111

Sergeant, Elizabeth Shipley, 26, 27

Shields, Mary, 64

Shoko (poet), 132

Sia corn mother myth, 8

Sibong, Dolores, 127

Silko, Leslie Marmon, 8

Skagit River, 119, *120*

Skarstedt, Ernst, 104

slaves, 19–20, 59. *See also* women: abduction and captivity of

smelters (ore), 67, *pl.13*

Smiley, Jerome, 69

Smith butchering machine, 114

Sociedad Folklorico de Santa Fe, 34, 36

Sone, Monica, 109, 122, 127

Southwest: first people in, 7–13

Southwest Museum (Los Angeles), 31

Spanish colcha embroidery, *pl. 4*, 20, 21

Spanish Colonial Arts Society, 30

Spanish people: colonization under, 16–17; horses introduced by, 50; language of, 31, 34, 36; women brutalized by, 15–16; on women building shelter, 11. *See also* Hispanic people; Hispanic women

Speer, Robert, 75–76

Stacey, Judith, 2

steamships, 104, 106–7

Sternberg, Eugene, 81

Stewart, William Drummond, 56

St. Vincent's Catholic Orphanage (Denver), 68

suburban developments: environmental effects of, 39, 84–85; fire concerns in cul-de-sacs, 81; isolated nature of, 82, *83, 84*; promotion of, 81–82; railroads and, 69, 71, 75. *See also* automobiles; mobility

suffragists, 27, 64, 66, *66*, 72, 117

Sunset (magazine), 82

Suquamish people, 94, 101

Suyama, Sakiko, 132, 134

Sweet Medicine (prophet), 50

Tabor, Augusta, 60, 64

Tacoma: bird's-eye view of, *107*; Chinese forced out of, 108; commercial growth and development of, 102–3; Japanese Americans relocated from, 122–23; maritime entrepreneurs of, 106–7; Scandinavian immigrant women in, 104; water pollution in, 128–29; WAVES stationed in, 127; women working in WWII, 124

Tafoya, Joseph, 24

Tail Woman (Owl Woman's mother), 56

Takami, Tsuruyo, 130

Taos: arts community in, 26–27; as trade center, 14, 19–20, 56

technological changes: electrical appliances as, 121; gendered expectations and, 49; in household, 81; Seattle's role in, 128. *See also* automobiles; railroads and railroad development

Terrell, Mary Church, 72

Tesuque Pueblo culture, *21*

Thrapp, Eugenie, 124

tipis, *pl. 10*, 52, 54, 55

tools: as expression of women's pride, 55; inheritance of, 18–19; innovations in, 13; metal vs. stone, 55

tools, specific: fish hooks, 94; grinding stones, 8–9, *9*, 13, 21–22; hide-scraper, 55; spiral grooved axe, 13; wagon wheel odometer, *61*. *See also* food and food preparation

tourism: automobiles and, 77, 79; brochures for, *38, 78, 79*; catering to, 37, *38*, 39; railroad, 24; souvenirs for, 24, 31, 33. *See also* global market

trade: in captives, 15, 19–20, 55; carved figurines for, 98, *99*; centers of, 14, 56; economies of raid and, 51–55; in horses, 50; Mexican restrictions lifted, 22; among Native and white women in Puget Sound, 100–101, 102; necessity for home, 2; trans-Pacific, 108, 128. *See also* fur trappers and trade; Hudson's Bay Company

transportation: canoes, *pl. 16*, 94–95, *95*; debate over public, 77; gold rush and, 60–61, *63*, 86; highway development, 80, 81–82; map,

This book is published in conjunction with the exhibition Home Lands: How Women Made the West, organized by the Autry National Center of the American West.

Autry National Center, Los Angeles
April 15–September 6, 2010

Missouri History Museum, St. Louis
October 15, 2010–January 15, 2011

Gilcrease Museum of the Americas, Tulsa
February 15–May 15, 2011

Palace of the Governors and New Mexico History Museum, Santa Fe
June 15–September 15, 2011

University of California Press, one of the most distinguished university presses in the United States, enriches lives around the world by advancing scholarship in the humanities, social sciences, and natural sciences. Its activities are supported by the UC Press Foundation and by philanthropic contributions from individuals and institutions. For more information, visit www. ucpress.edu.

University of California Press
Berkeley and Los Angeles, California

University of California Press, Ltd.
London, England

"Mud Woman's First Encounter with the World of Money and Business" from *Mud Woman: Poems from the Clay* by Nora Naranjo-Morse. © 1992 Nora Naranjo-Morse. Reprinted by permission of the University of Arizona Press.

Designer: Nola Burger
Text: 9.5/14 Scala; 8.25/14 Benton Regular
Display: Base Nine
Compositor: Integrated Composition Systems
Indexer: Margie Towery
Cartographer: Jennifer Shontz, Red Shoe Design
Printer and binder: Friesens Corporation

Library of Congress Cataloging-in-Publication Data

Scharff, Virginia.
 Home lands : how women made the West / Virginia Scharff and Carolyn Brucken.
 p. cm.
 Includes bibliographical references and index.
 ISBN 978-0-520-26218-8 (cloth : alk. paper)
 ISBN 978-0-520-26219-5 (pbk. : alk. paper)
 1. Women—West (U.S.)—History. 2. Frontier and pioneer life—West (U.S.)—History. 3. Women—West (U.S.)—Social conditions. I. Brucken, Carolyn, 1966– II. Title.

 HQ1438.W45S337 2010
 305.40978—dc22 2009046327

Manufactured in Canada

19 18 17 16 15 14 13 12 11 10
10 9 8 7 6 5 4 3 2 1

This book is printed on Cascades Enviro 100, a 100% post consumer waste, recycled, de-inked fiber. FSC recycled certified and processed chlorine free. It is acid free, Ecologo certified, and manufactured by BioGas energy.